DESIGN IN ASIA
THE NEW WAVE

A Design Anthology Book
Foreword by Aric Chen

d/a

North Asia

South Asia

The designers in this book all come from various parts of Asia. Most are in their 20s to 40s, and many of them studied abroad. Like the countries they hail from, however, they represent a diversity of backgrounds and perspectives — a dynamic array of approaches that's shedding new light on the possibilities of furniture, product and interior design in an ever-shifting global landscape.

These talents — covering a geographic arc spanning from Korea, China and Japan to Indonesia, Singapore, Malaysia and India — are expanding the boundaries of design as they formulate new vocabularies in a field that, to many, seemed until recently to be at risk of stagnation. In their own ways, they've drawn from the habits, traditions, sensibilities and cues that inform the contexts that have shaped them — and that they're increasingly helping to shape. They've embraced openness and the border-crossing circulation of ideas and creativity while charting their own trajectories, reinforcing the notion that there isn't one way of being 'modern' or 'international', but many.

To be sure, a curious phenomenon is unfolding. In design, as in other fields, it's no longer possible to speak of a centre and a periphery. Instead, the growing multipolarity of global discourse has created a more vibrant, complex terrain in which we all occupy the centre and periphery at once. (This book places its centre in Asia Pacific, but the premise of course applies to other regions as well.)

In other words, to the extent that the designers here are shaped by their culture and locality — though their often-peripatetic lifestyles and hybrid identities make both concepts increasingly fuzzy — their work can no longer be seen simply as local derivations of trends set in the traditional bastions of Europe and the United States. Instead, these designers take the narratives and proclivities, and the capacities and crafts, of where they are and contribute to a global discussion on their own terms.

That this is happening now is no accident. While Japan had a half-century head start, give or take, design as we consider it here is a young field in Asia. The relatively recent — and, in some cases, ongoing — industrialization of the region's economies, alongside growing wealth and confidence, have tilled the ground for the emerging design scenes we see today. In particular, the globalization of the 1990s and 2000s saw a proliferation of design weeks and other events, amplified by the Internet and an increasingly international media, that redrew and created new transnational networks just as design education was continuing to globalize as well. To varying degrees, national and local governments, seeing economic and cultural opportunities, brought design under the unfurling banner of the creative industries.

By and large, the designers in this book were formed by these developments, and it's a credit to *Design Anthology* — and its founders Suzy and Phil Annetta — that their voices, viewpoints and stories are being documented here at this formative moment. When *Design Anthology* first launched as a magazine published on paper in 2014, many considered print media to be all but dead. Instead, the publication has thrived in all its tactility, proving, among other things, that there is always room for new perspectives and a job well done. The same can be said of the designers so thoughtfully chronicled in its pages.

Aric Chen, Independent Curator and Writer

Long before Phil and I founded *Design Anthology* in 2014, we'd talked about starting a publishing company. You see, aside from growing up in small-town Australia, another thing we have in common is our love of print. We both grew up as bookworms, and our book-buying and reading habits perhaps only became more like addictions as we progressed into adulthood. So, it's with much pride and excitement that we announce the very first Design Anthology book — the first of what we hope will be many.

Since founding *Design Anthology* to focus on the design scene in Asia, much of my time has been spent travelling around the region, and in the last few years I've had the absolute privilege and pleasure of meeting some of the great talent working in this expansive and diverse continent. Via conversations with these emerging and established creators — many of whom are featured in the coming pages — I've learnt a great deal about the traditions, materials, education and technology behind the work that's being produced, and I'm excited to share this with our readers.

This volume, or anthology if you will, is a compilation of 97 furniture and product designers or collectives working across the region, from Indonesia to India to Japan. It's not an exhaustive list by any means, but we feel it's representative of the diverse individuals working at varying stages of their careers. We've arranged the designers by locale, from the historically more industry-focused north to the more craft-focused south, and what we hope you'll notice, as I did from my discussions, are the striking similarities and yet vast differences in how they work and the products they eventually create.

The book has been some time in the making. We compiled a list as we worked and travelled through the region, and sent each designer a series of questions on topics such as what led them to choose their path, their educational and work experiences, their challenges, what they hope to convey through their work and their influences. Some responses have been translated from their original languages, and all have been edited for length and clarity, but we've done our best to preserve their authentic voices.

One final but important note is the ongoing dialogue about identity. In these changing and in some cases postcolonial times, many of the countries we've featured are still challenged by what it means to be, for example, Indonesian or Korean. The endeavours of many young designers become an opportunity for them to explore these questions through their work and how they bring materials, traditional craft techniques, colours and forms into the 21st century.

We sincerely hope you enjoy discovering this wealth of talent as much as we did.

Suzy Annetta, Editor-in-Chief, *Design Anthology*

North Asia

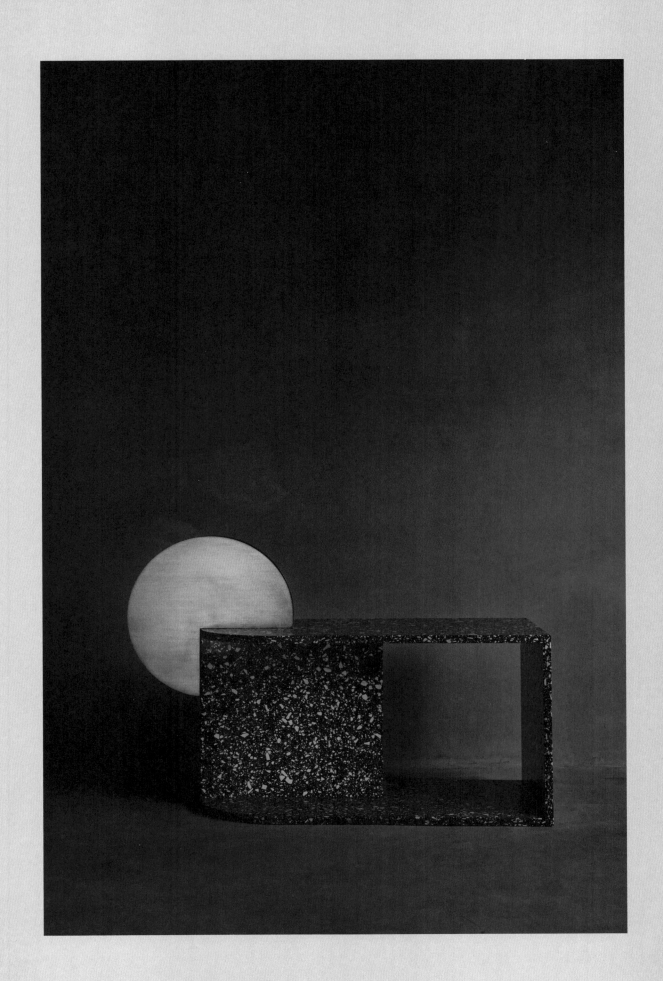

Lea Chen

I started out as a designer when I entered university — I studied architecture at the Central Academy of Fine Arts. It was actually my family's decision for me to start drawing, which brought me to architecture. But when I began real architectural design work, I had to relearn from scratch everything I'd learnt at school.

I established my studio after I graduated, and went to the China Academy of Building Research two years later. I joined the design department to learn about large-scale public building construction and shop design, but I only completed pre-project planning in the end. The principal used to say that many people could provide back-end and technical support, but only a few could understand art and its function while also being competent planners, so I committed myself to doing a lot of large-scale building planning.

The biggest challenge in running my own studio has been scaling and ensuring I can work on projects myself. The question was, what was the studio for? Was it to create artworks? Or to be a place of work? In the end, I decided to limit the number of staff to 20 so I could personally take part in designing. In line with our values, every project is treated like an artwork.

In China, the national supply chain requires cooperation between various professions. The most challenging variable is quality, since perceptions of it vary. My work is creative, and many people don't want to work with me because they haven't done this type of work before, and new endeavours are time-consuming and difficult. People prefer working on things they can mass produce within a fixed technical scope. This is why every breakthrough brings new problems that we have to solve ourselves.

In 2018, I partnered with Italian luxury brand VG on a homeware collection. I found that Italians completely respect the artist and the designer. They won't change your designs, and they gave me their full support through their exceptional craft. I also worked with BMW's head office to craft high-end car interiors.

I have several goals for my designs. The first is to solve the client's practical problems. The second is to make the piece distinctive in terms of quality and features, a process that begins in the studio. The third is to convey social concepts and ask philosophical questions. I studied art and architecture, so I include some ideas that are personal to me. I hope people who interact with my works will experience all three.

As an architect, I don't rely too much on symbolism in my designs. Architectural design is about using space and light, with minimal support from materials when expressing a design philosophy. I also draw inspiration from sources like literature, music, philosophy, fashion and art. As I get older, my works become more influenced by my own experiences and how I interpret history. Most of these influences are art-related, or linked to random moments in my life. You can learn a lot about life just by listening to a conversation between two people on the street. A dream would be pure cultural projects — my doctorate was in art museum studies, after all. I'd prefer to work on cultural projects for the rest of my life — projects like art museums, libraries, kindergartens and schools.

As for personality and nationality, my philosophy is that they shouldn't be central to the creative process. Many Chinese designers believe it's important to express their own character. My view is more international, where ethnicity and nationality are irrelevant. People are people. When you express yourself honestly, your works naturally exhibit your personality, nationality and geographical location. I think this organic, grounded approach is more attractive and expressive. Catering to local traditions or customs is also not important to me. What's more important is that I express an understanding of the subject, because the philosophy and knowledge behind the design will come to the fore and will be easier to understand for people in the future.

There are so many inspirational designers, but most of my influences have come from other fields. Of course, my earliest idol was Louis Kahn, who led me into the world of architecture and taught me what space and architecture actually were. Then there was Mies van der Rohe, and the Memphis Group, whose breaking down of space guided me from modernism to deconstructionism. But Marina Abramović, Vivienne Westwood and Louise Bourgeois taught me how the creative process is a search for origins, exploring humanity, psychology and sociology.

As for works that represent China or Chinese culture, while I don't strive to do that, many of my works do because I was born and grew up here at a certain time in history. With my homeware collection Instinct and the 'I am a Brick' art exhibition I was in search of forgotten elements of Chinese history. The Oriental Treasures collection for VG incorporates a traditional lifestyle in the hope of introducing it overseas. Spatial projects would include the Sui Jianguo Art Museum, which expresses indoor tension through the concept and form of canvases, with the alleys transformed by my designs to capture the warmth of everyday life.

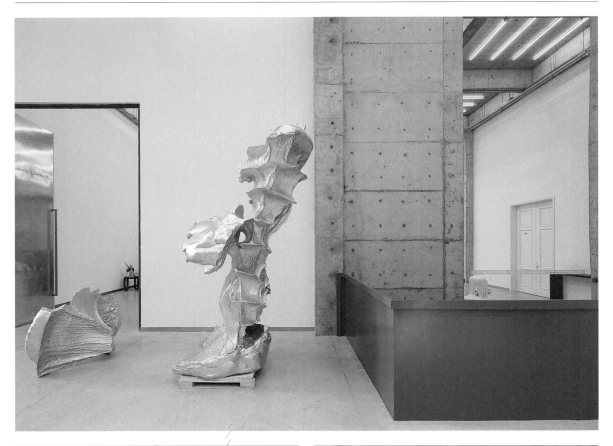

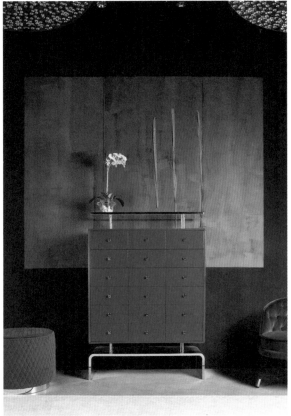

Facing page
Artist Sui Jianguo's studio
and personal gallery, Beijing

This page
Auspicious Dresser (above)
and Royal Medicinal Cabinet
(below) from the Oriental
Treasures collection for VG

Frank Chou

I chose this career because I was born with an interest in all things creative, and product and furniture design lend themselves to creativity. If I had to pinpoint when I fell in love with it and made the decision to move forward, it would have to be at the point I gained a certain degree of understanding about social structure, history, economics, culture and design.

I studied at Beijing Forestry University, and my studies certainly have been of use. While school courses couldn't include everything, they helped us understand how products are made and the processes involved — this gave me the foundation for my career.

Before I set up my own studio, I worked in furniture manufacturing, design and related trades in Europe. I gained a lot of industry experience, which was important to the establishment of my studio. As for influences, I think everyone in my life could have been an influence at some time. My inspiration comes from a range of things, including music, movies and even games. These are advanced industries with advanced models of thought and sources of inspiration.

However, more of my design comes from abstract inspirations occurring in everyday life.

My studio emphasizes a specific design philosophy: designing in a universal language and creating elegant, aesthetically pleasing works with a sense of time. This language must be widely recognized, and the designs must target the majority of people and humanity's common traits. We don't want to limit ourselves to a certain region or culture, but of course we don't want to forget our background either. So, while I don't regard my works as traditional Chinese designs, I do think they exhibit a Chinese spirit. Similarly, I regard expression of personality or nationality as a stylistic limitation, both of these being labels we're assigned after evaluation. Personally, we don't emphasize style — maybe that is our style. We emphasize the possibilities of design, for designing is creating. If we set stylistic limitations, we would be limiting our design possibilities.

I'd like my works to prompt people to reflect and feel a state that doesn't yet exist but is bound to happen. A dream project would be space architecture.

Facing page, top
Poker screens, and Kuan
armchairs and bar stools for
Fnji

Facing page, bottom
Cube sofa and Romeo's Ring
lamp for Fnji

This page, top
Armchairs and side table
from the Bold series for
HC28

This page, bottom
Fan side table

Wang He

I knew I wanted to do something related to art and design when I was quite young; I started painting when I was five. But it wasn't until university that I realized what I really wanted to be was a designer, not an artist. Compared with artistic self-expression, I feel design is more like problem solving. After undergraduate study in Beijing, I did a master's in industrial design at Central Saint Martins, where I felt like my potential to be a designer was fully realized.

Like an architectural work is built from a single brick, I believe what I've learnt has played a key role in my development as a designer. As students we used to have lots of crazy ideas, but I'd say the skill of connecting the great idea to the real world is the key. For example, when I worked on a John Lewis bathroom furniture project at Theo Williams Studio in London, we took inspiration from children's stationery, extracting the simplicity and the playfulness to create a special design language.

I also worked for Tomoko Azumi in London and ZaoZuo in Beijing. I stayed at ZaoZuo for two years as an in-house designer, and saw the fast growth of a contemporary furniture brand in China. What I learnt most is that being a designer is not only about design — you should have a view of the whole business from the brand to R&D, marketing strategy and even logistics. This built a solid foundation for my later development.

I launched my studio in early 2018, and the biggest hurdle was the lack of clients and the high cost of living in Beijing. I believe this is a common situation for many studios at the beginning. Market challenges are obvious — first and foremost would be the lack of originality by some. To overcome this you have to have quick R&D and make your own statements. On a positive note, China is known for its manufacturing industry, and we can easily find places to have pieces produced. Also, now the main consumer is the young middle-class, those born after 1995 and who are willing to pay for design and aesthetics.

Our work is divided into two parts — the studio and our new furniture and accessories brand GOUTU. In the studio part, we take on projects from product to furniture and space design. Recently, we've started to focus more on GOUTU, through which we'd like to promote young design talent in China.

In my work, I like to share my understanding of Chinese culture through investigation into young people's everyday lives. For instance, in the Childhood series, I brought a 'Beijing drifter' living room to London, and invited the audience into the lifestyle of China's urban youth.

As for materials and techniques, I think the right material helps to express the idea while the technique makes it producible. In the Childhood series, we chose metal and wood as the main materials, to encourage furniture to be taken when moving rather than discarded. Metal helps with easy assembly and flat packing, while wood brings a sense of warmth.

My dream project is to have the opportunity to collaborate with brands like Alessi, Vitra and Tom Dixon, or to create an open design community where talented young designers can get their concepts produced and share their voices with a wider audience.

I believe a designer should have their own attitude, either a form of language or a design motif. I think the core of Chinese culture is restrained expression, so I never try to express my nationality through a certain form, but something behind it. In the age of contemporary design, things are becoming more simplified and symbolized. How to share your design voice through a cultural symbol, material print or even a kind of lifestyle is very important and a challenge for us. I believe the new should be based on the old, but it depends on how. For instance, our Marshmallow sofa from the Childhood series includes a movable low table for playing cards or having drinks. This is a traditional social activity reflected in a modern way. Local traditions should be kept, as they're a form of cultural identity. But I believe how they're kept is more important than keeping them for the sake of it.

A designer who had a great influence on me was the architect Liang Sicheng. He and his wife Lin Huiyin were the first in China to study and visit the West, and to work to protect China's ancient architecture. They examined ancient towers, yards and gardens, and published books on them. What inspires me most is not only the architecture itself, but Liang's research spirit. This might be the best way of keeping tradition alive.

An object that I think represents Chinese design or culture would be the Quan chair. From sitting on the ground to sitting on the *mazha* stool and then on the chair, the meaning is not only the change of gesture, but the social norms and the status behind them. In the old times, only the host or master of the house could sit on the main chair, with guests on the others, reflecting their social status. In modern China, things have changed. The Quan chair is no longer a symbol of status but a symbol of culture. But its cultural connection to Chinese people still exists.

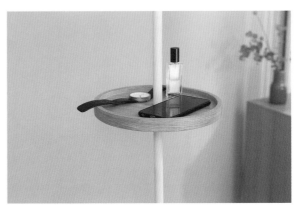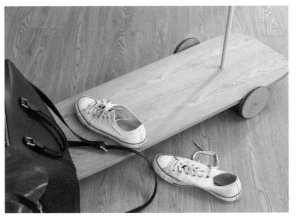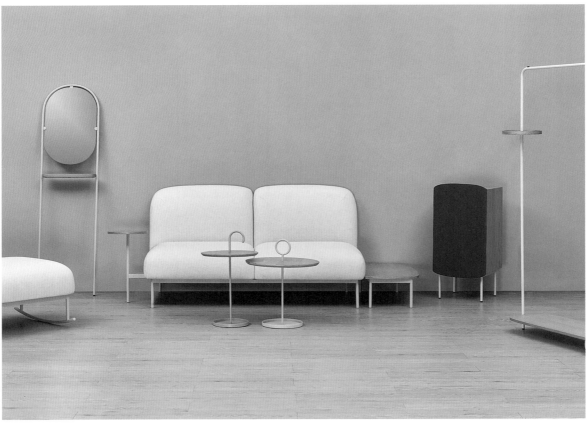

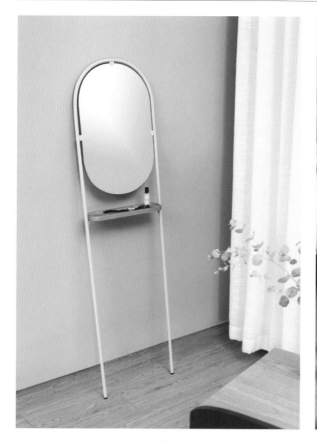

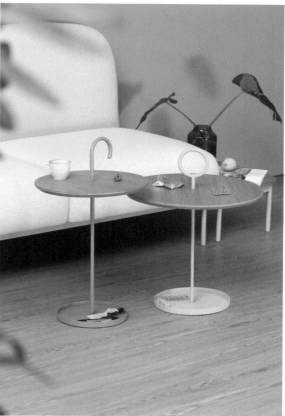

Facing page, top
Skateboard coat rack

Facing page, bottom
Childhood series

This page, top left
Arch floor mirror

This page, top right
Lollipop side tables

This page, bottom
Hide&Seek sideboard

Bingqi Lee

I studied for my bachelor's degree in home product design at the China Central Academy of Fine Arts. Then I went to Central Saint Martins for my master's degree in jewellery, furniture and ceramics. While I was at Central Saint Martins, my understanding of the profession deepened and my personal style began to form. This gave me a clear career goal: to become an independent designer of furniture and homeware.

As the independent designer I hoped to be, I think learning at school was an important period in my life, especially since it was overseas. It enhanced my professional skills, helped me develop a personal style and, most importantly, brought me into contact with people from different cultures who think and live differently to me. These are all elements that influenced me. In addition to that, before I launched my own studio I worked at another designer's studio, and I've worked at a furniture company. Through these experiences, I learnt how to communicate and about the importance of teamwork and execution.

Running a studio in China has brought two major challenges. First, the Chinese market changes quickly. People have little patience for brands — they want them to mature rapidly, which puts designers under tremendous pressure to rush out new designs. Second, I had to learn to manage the connection between design and production, and consider the business aspect too. In the past, I only had to focus on design.

But because China is developing quickly, we're moving from 'made in China' to 'created in China', and this is a valuable opportunity for designers. Independent brands are blooming on every corner, though it remains a challenge to commercialize a brand to ensure long-lasting vitality. The government has also set up a commercial chain across southern Chinese cities, integrating furniture design, production and sales. We were invited to try out the exhibition platform and directly connect with factories interested in transforming their brands. This type of initiative brings us new opportunities.

The studio is still in its early stages, and I split my time into 30 per cent thinking and building a business and operating model, 30 per cent communicating with different people, and 40 per cent focusing on product design, research and development.

I hope people will realize that Chinese designers are really developing. We come from a specific era, and we have our own thoughts on Chinese culture and the country's global status. We're digging into traditions and trying to connect the past with the present. At the same time, people born in the 1980s and 1990s are slowly becoming the most important domestic consumer group. They find traditional wooden furniture dull, and they want to break away from the past. I hope to give this new generation of consumers diversity in terms of fun and stylish designs.

I love traditional Chinese art. I'm mesmerized by our beautiful traditional architecture, antiques, decorations and jewellery. However, many now consider these aesthetics to be outdated. They aren't recognized or used anymore. I have experience living and studying in the East and the West — I can see the common ground between traditional Chinese art and modern design, and can reinterpret traditions from a contemporary perspective. This instils modern energy into past creations, creating a new style that's showcased through furniture and homeware. This is what I wish to accomplish — it's my passion. I think furniture should be experienced. A dream project would be to apply my philosophy to a physical location, such as a hotel, restaurant, bar, coffee shop or retail space, so I can craft my ideas and aesthetics and then promote them.

So, expressing my personality and nationality is essential. I try to use a common contemporary design language to interpret traditional aesthetics and create something new. Preservation of traditions is also important to me, and it requires development and innovation based on traditions.

On that, my idol is Ettore Sottsass. He started the Memphis Group collective, jumping out of rational and monotonous modernism while drawing inspiration from 1960s pop art, Eastern art, Latin and African traditional art, and postmodernism. The group was daring and absurd — they transformed classic architecture and decorative elements into designs, emphasizing fun in daily life and providing more existential value. This inspired me a lot — they did that in the 1980s within an Italian context, and I'm doing the same thing with a Chinese cultural backdrop. And on Chinese design, I think if there was a piece that exemplified it, it would be the Ming dynasty armchair — they exhibit exceptional craft, as well as the wisdom and aesthetics of ancient times.

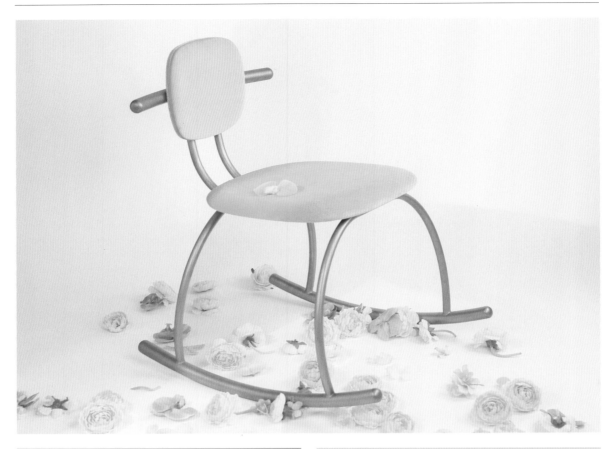

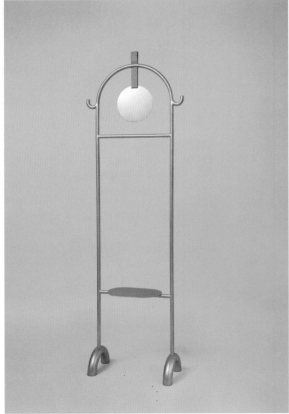

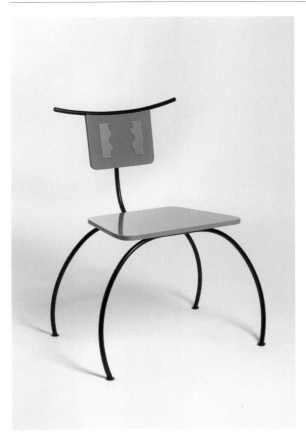

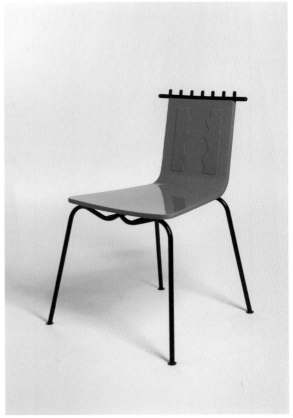

Facing page, top
Rollce chair

Facing page, bottom left
MoonSong clothes rack

Facing page, bottom right
Chair from the minimal 'Yi'
series and Fomo cabinet
(above) and Rollce chair
and Alin cabinet (below),
with DIo side table and
MoonSong clothes rack

This page
Chair from the Minimal 'Yi'
series

Bowen Liu

I studied for my first degree at Beijing Forestry University, then went to graduate school to study furniture design at Rochester Institute of Technology in New York, graduating in 2016. My family was very supportive, and I'm grateful to them.

I found my time at RIT to be very useful. I learnt traditional fine woodworking techniques, which have become a solid foundation of my work and my business. It also opened my eyes to design and culture all over the world. I studied in Copenhagen for several weeks in that time, and the experience of living and studying there has had a big influence on my work.

Through years of designing and making, I developed my own design sense, and it helped me know myself better as a person, a designer and an artist, so I was confident enough to start my own studio right after I graduated. I did do two short internships, though, and learnt about processes at two good studios.

My two main challenges at the moment are to increase sales and let more people know about my brand. Though I'm based in New York, I think these challenges exist everywhere. The advantage of being here for me is that I like to absorb information and knowledge, and here I have multicultural influences, which is good for my learning and development. It helps me create new designs that I feel truly matter to life. And I enjoy my life here — my peers, the design and art community, and the working environment are very vibrant and supportive. I'd like to travel to more countries to learn about their cultures, people and different making techniques and technologies.

I see my role as creating a unified body of work for Bowen Liu Studio's collections. The studio also provides design development and prototyping services aimed at enhancing the quality and ambience of the contemporary dining and living experience. We focus on materiality, tactility, detail and durability in our furniture and objects. My goal is to provide a comfortable and peaceful environment for people, and I'd like them to experience the delicacy of my work, in both design and artisanry. My current dream project is to design a living environment for my family.

As for materials and techniques, I primarily work with wood because wood is natural. It's been a traditional furniture material for centuries. As I was learning techniques and honing my skills, I found that wood had many possibilities in form and construction. I often incorporate wood bending — I enjoy creating gentle curvilinear forms. After sanding and finishing it, I find the feel of the wood very satisfying.

I think it's important that my work expresses my personality. It reflects who I am because I make all the decisions. It also refines me because I always learn so much about design and myself through creating it. I'm interested in traditions all around the world too. It's the culture, the lifestyle. How people live their lives inspires me all the time.

I don't really have a Chinese designer role model. I learnt my making skills in the US, and I started to gain my own design sense though my trip to Copenhagen, so I'm more influenced by American and Scandinavian design culture. I admire Michael Thonet, who made bentwood furniture famous around the world, Le Corbusier, Alvar Aalto, Marcel Breuer, Bruno Mathsson and Poul Kjærholm. And while I believe works represent the person or people who designed and made them, there isn't one particular work that represents Chinese design to me.

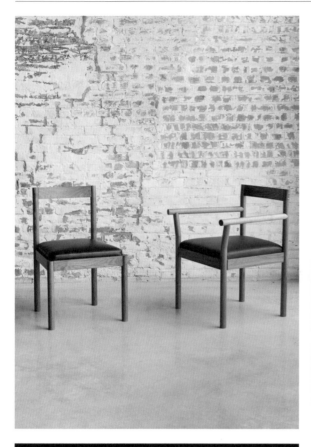

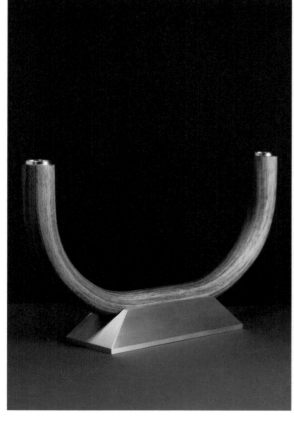

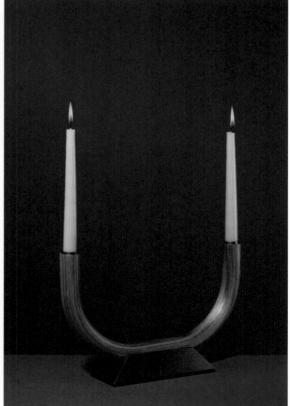

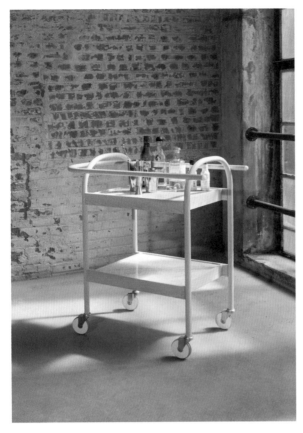

Previous page
Image by Shane Lavalette

Facing page, top left
Feast dining chairs

Facing page, top right
Feast armchair
Images by Lance Brewer

Facing page, bottom left
Woo candelabra in brass

Facing page, bottom right
Woo candelabra
Images by Jiaxi & Zhe

This page, top
U3 bar cart and serving trolley

This page, bottom
Feast dining collection
Images by Lance Brewer

Chiho Cheon

I dreamed of being a designer from when I was 14 years old, but my family didn't support the idea at first. I studied it independently until I was 18, then went to Sangmyung University to learn design when I was 20.

I learnt basic design knowledge, and most of the classes were about learning how to think in terms of design. I kept working on that and trying to make an identity for my work. During university and after I graduated, I didn't work for another designer — I spent my time creating that identity while others were doing internships.

Living in Korea is an advantage. I think in our culture, there's a unique opportunity for me to express my own identity. I've had some collaborations — I created some outdoor furniture for the garden of one of Daemyung's resorts. I was inspired by the nature surrounding the resort's outdoor garden, and tried to express the boundary between processed and unprocessed natural objects. But the overall art and design market is very small, and as an independent designer it's difficult to travel abroad to fairs.

I create designs that express my thoughts and feelings as materials. In general, I work with corrugated carboard, cement and Korean lacquer. I try to create a new perspective on the things I encounter in my daily life, and I hope people see the harmony of materials and shapes through my concepts and work.

My individuality comes from my environment, and my nationality can also be part of my identity. Despite that, I don't think design has to fit in with a local tradition, but I do think tradition can inspire my design because there are traditions in the environments where I've lived. I think the *soban* tray table is a representative Korean design.

Inspirational Korean creators to me would be Chulan Kwak, Kwangho Lee and Jiwon Kim.

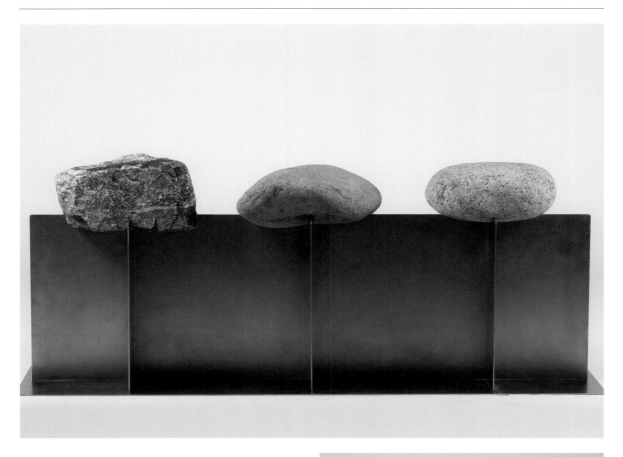

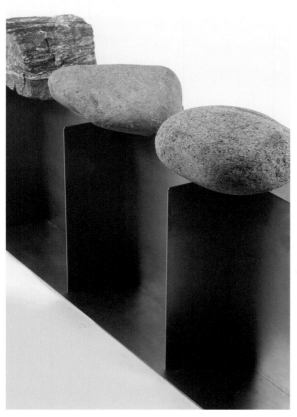

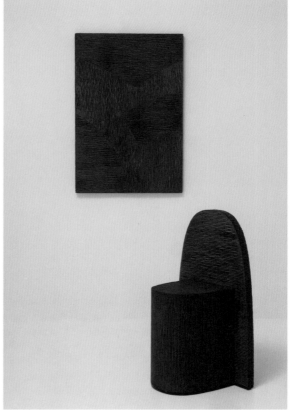

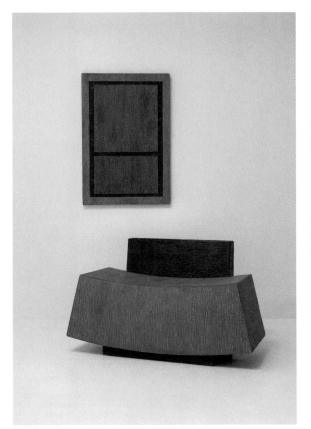

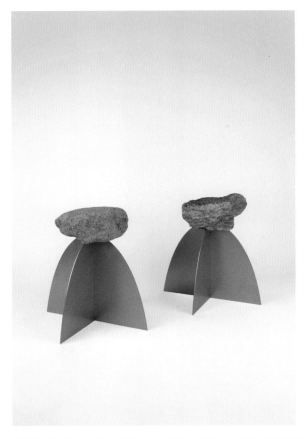

Facing page, top and bottom left
Boundary bench

Facing page, bottom right
Criteria chair and wall hanging

This page, top left
Criteria chair and wall hanging

This page, top right
Criteria chair detail

This page, bottom
Boundary stools

Nina Cho

I studied painting when I was young, but realized that I was more interested in three-dimensional structures and space. I started to explore the relationship between things of different scales, such as bodies and furniture, fashion, objects and architecture. I grew especially interested in creating objects for people to live and interact with.

My first degree was in woodworking and furniture design at Hongik University, then I did an MFA in 3D Design at the Cranbrook Academy of Art in the US. The programme at Hongik was very different from an industrial design programme. We were encouraged to tell our own stories and taught to create unique pieces based on our identities.

At Cranbrook, I found the freedom to continue to develop my process, and I started building my career. There were no credits or assignments, so I operated my studio like a professional independent designer. I developed each aspect of my process, from dreaming up my inspiration or initial concept to prototyping small-scale or full-scale models and producing the final piece. It helped me gain confidence in my creative thinking and prepared me as an independent designer.

The biggest challenge is to maintain an active practice and not give up. It's not an easy field, and design is more than just a job. You can make it if you're serious, dedicated and love creating your own work. After three or four years, I feel like I'm still on my way to 'making it'. I hope to continue to create work and for the work to have longevity.

As I didn't have a chance to run my design studio in Korea, I'm not sure what it's like to work in Asia, but I'm always excited about the diversity of American design. There are fewer criteria or limitations to the discussion that surrounds design. This gives me the freedom to explore new ideas, so my work reflects an American experience without losing my own cultural identity.

Working and living in a different country from where I grew up has changed my perspective and attitude. Since English is not my first language, there are limitations in communicating exactly what I want to say. That's made me focus more on visual language, and I also give myself more time for introspection before I speak. I believe the added self-reflection has led me to express my identity and philosophy through my work in a more sophisticated way.

My recent work is focused on reductive and unexpected forms that blur the line between art and design. By eliminating the extraneous, I aim to simplify not only form, but the fabrication process as well. I hope people can see a subtle beauty in my work that leaves them with a lasting impression. I hope my work evokes a sense of tranquillity, of contemplation and maybe introspection. I hope it's more than just a product or object, and that it has a unique identity and aesthetic.

I want to be working on multiple scales including small products, larger furniture, installation or even space design. If it's about objects and space, and their relationships, I'd like to broaden my practice with it. One of my favourite experiences was working with New York brand Souda, which mass-produced my card holder and made it more affordable. I like the idea of presenting some of my designs at a more accessible price.

My material varies with each project. For the Bent mirror series and the Cantilever table, I explored planar materials like sheet metal to develop my ideas about folding and bending to create three-dimensional forms. The transparent materiality in Layering Transparency reveals overlapping positive and negative space created from the process of blowing glass.

There's an old Korean saying, 'It is modest but not humble, and impressive but not extravagant.' I admire this as an attitude and as an aesthetic. I'd say my Korean heritage has been influential. My background led me to a reductive aesthetic, in which I merge Eastern philosophy with experimental forms. This concept of emptiness is a traditional Korean aesthetic, which respects the emptiness as much as the object. The voids welcome in air, their surroundings and the spirit of a space; the empty spaces also invite users to creatively complete the work.

I think I'm naturally influenced by local tradition and culture, and it's important to understand them and keep traditions alive. However, we need to explore new ideas for new generations, to make new things and experiment. Choi Byung Hoon, a designer and my former professor, is an inspiration to me. He actively creates new work and has done extensive research in furniture design and crafts. Compared to conventional design schools, the programme at Hongik was special.

Ioseon white porcelain or white ware called *baekja* I think represents Korean design. I especially like moon jars — to me, they represent the spirit of the traditional Korean aesthetic and attitude, which is modest and pragmatic. The white porcelain shows a subtle use of colour, simple yet elegant form, minimal decoration and a lack of pretention.

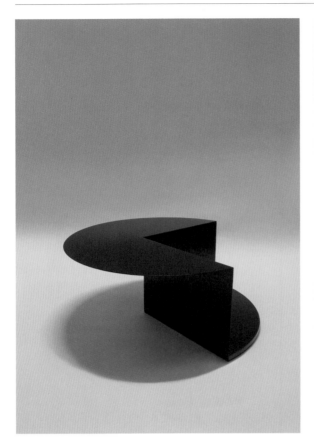

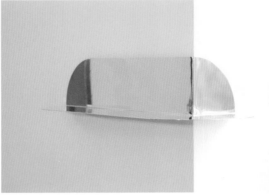

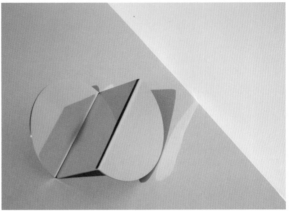

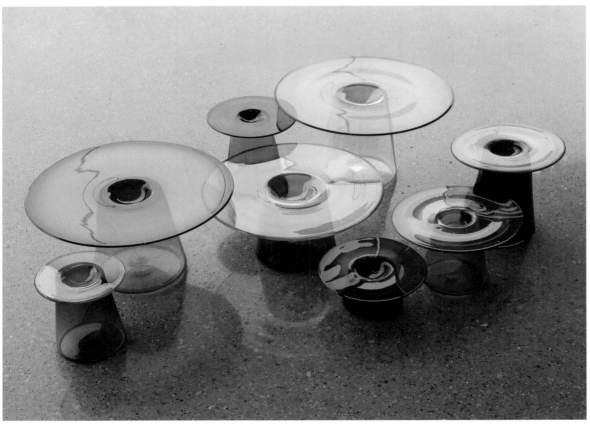

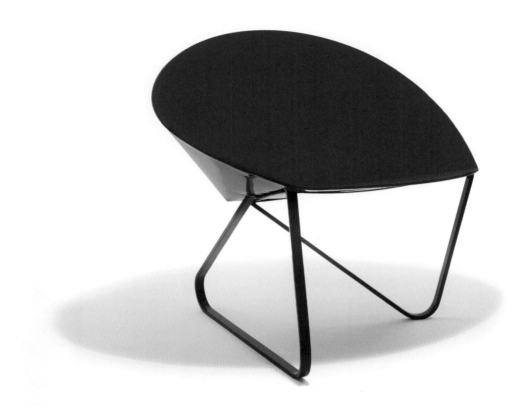

Facing page, top left
Cantilever table

Facing page, top right
Corner shelf (above), Wave
business card holder for
Souda (below)

Facing page, bottom
Layering Transparency series

This page, top
Curved chair

This page, bottom
Constructivist Mirror Series
— Circle

Hyungshin Hwang

When I was at high school, I vaguely thought I wanted to do art-related work in the future. But once I was at university, I met some artistic friends and they got me thinking about becoming a designer. Although my parents worried about designers living unstable lives compared to office workers, they still supported my decision and my commitment to pursue my goals.

I studied at Hongik University, where I received both bachelor's and master's degrees in woodworking and furniture design. What I learnt varied from class to class, and there were many things that were beneficial for my growth as a designer. One of the most valuable lessons that I continually apply in my work is to look from different perspectives, especially those of my peers and teachers. Actually, the artist Choi Byung Hoon, who coincidentally was my teacher, has been a great inspiration to me.

I didn't work for other designers before starting up my studio. In the early stages, it was challenging to keep the studio going because there were only a few projects and the monthly income wasn't fixed. But currently, I'm more focused on making decisions that grow the value of my work.

I think Korea has become a good place to work as a designer, especially compared to four or five years ago. As people begin to take an interest in 'living culture', sales and project opportunities have increased dramatically. Clients have also started to appreciate good design, which means there are fewer restrictions on project duration, cost and the implementation of ideas. We do have some government support as well: I was selected by the Korea Crafts & Design Foundation for a programme supporting crafts and cultural products, and received initial funding for production.

I typically create objects that fall into the category of furniture. I apply my daily experiences and thoughts to my work, and I tend to repeat this process. It's enough for me that people appreciate my work rather than have an experience through it. And rather than dream of an enormous goal or a huge project, I hope I'll be able to create things that I want to make for a long time to come.

I don't prioritize particular materials — when I work with self-determined thoughts and choices, I feel like I've expressed myself adequately, and it brings a great sense of accomplishment. It's very significant to have your own personality in design. A design has worth and value when it's completely distinguishable from others. I don't think it's necessary to express my own nationality though. The starting point of my work is mainly my own experiences and memories, so there's no direct connection with tradition. There are several designers who deal with tradition, so I'd rather focus on personal interests. And we do have a design tradition — for example, many media sources and experts refer to the traditional tray as representative, and I wholeheartedly agree with them.

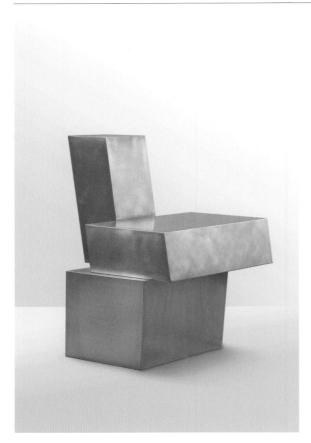

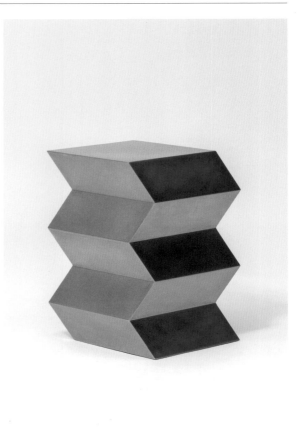

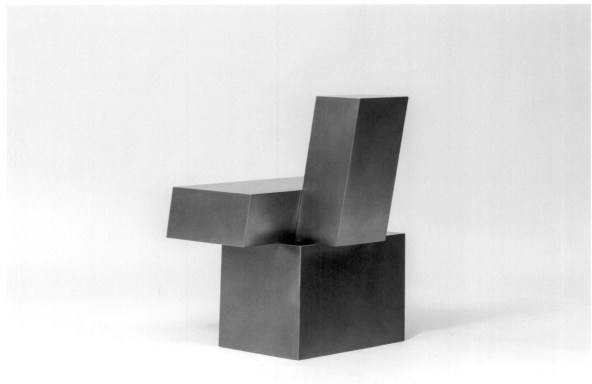

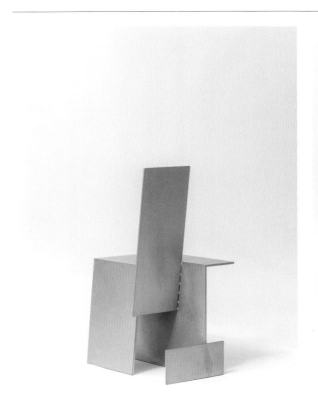

Facing page, top left and
bottom
**Layered chair in stainless
steel**

Facing page, top right
**Layered stool in stainless
steel**

This page
Layered chair in zinc

Jinsik Kim

During my childhood, watching my grandfather and father making home improvements and doing DIY was a daily routine. The experience of living with them created the basis for me to choose this career. I can still clearly recall my Korean rural-style childhood home, which was very impressive.

I worked for a furniture company for three years after completing my bachelor's degree in industrial design in Korea. After that, I got into Design Academy Eindhoven to study contextual design. While working on projects there, I felt that the courses were different from what I wanted to pursue, so I changed to ECAL's graduate school in Lausanne.

While studying at Design Academy Eindhoven and ECAL, I realized the importance of the physical model. When I'd learnt design in Korea, I'd focused on the story and images on a computer monitor. But in Europe, I had the chance to improve my understanding of user experience design. I believe that quality is more than just a matter of taste, and modelling is the most important step to reach that goal.

I worked at Studio Minale-Maeda in Rotterdam, and I was able to have in-depth conversations with Mario Minale. I realized how design outcomes are affected by various tests during the process. For young designers, if you like a studio, I recommend that you experience their design process for at least three to six months through an internship.

I think the struggles young designers face in running a studio are probably the same for most of us. The greatest challenge is the operating cost. Next is project management. While I was working at Minale-Maeda, people would always tell me that a designer must work hard for at least ten years after opening their own studio.

Seoul is the capital city of Korea, with the densest concentrations of industry and culture. There are material and tool suppliers in Eulji-ro, Jongno and Dongdaemun, and the city is a convenient place to create and experiment. And since the number of commercial and cultural spaces like design shops, cafes and restaurants that show the unique style of the owners is increasing, there are many opportunities for designers to work on large and small projects. Although it can be hard to find a project that reflects and respects the designer's opinion, I believe everyone must work together to make this happen in the long run. There are also various government funding programmes for crafts, design, new technology start-ups and so on, which I've been involved in as a mentor and adviser.

I established my studio in 2013. It's a studio that embraces design, sculpture, installation and art direction. We work on complex design projects, but we try to find the pure elements of design by contemplating the essence of materials and patterns. I hope people can expand their intellectual curiosity through my designs. I try to show that design can express spiritual values including life, culture and people's ability to think. Design is more than a means of solving problems: I'm interested in putting our spatial experience into objects, even if it's a very small space. I want to find different experiences in the width, height and depth of a three-dimensional space and apply them in an object.

I try to find the appropriate materials and techniques for each project, and I do my best to reflect the characteristics of the materials. I personally like stones. They're formed in layers and solidify over a long period, creating implicit images and patterns. I'd like to carry out land art with architectural elements in Daegwallyeong or other less-known places in Korea. I hope to be remembered as someone who tried hard to find his own design language. I try to create poetic work, filled with subjective experiences and thoughts. I hope design and culture can embrace diversity and continue to develop in a broad way instead of embracing uniformity.

In my foreign collaborations, I've been impressed by European brands' attitudes towards their designers: they really respect the designers' opinions. When I worked with Swedish flooring brand Bolon in the Wallpaper* Handmade project, I saw that they showed trust and respect towards their designers, for which I was really grateful.

I think tradition should be the foundation of development, not something that should be preserved. I don't want to reinterpret a design by adopting past techniques to create something new. I try to understand why the traditional design was created, what the advantages are of that tradition when compared to the current production process, and what kind of consensus the traditional design can make with the user and how that can be transformed in a modern way to reach that consensus.

I'm very interested in the environment I live in. Rather than being inspired by someone in particular, I'm inspired by the ways and the attitudes of my seniors. Similarly, I don't think a single object can represent a culture, but the *jigae*, the Korean A-frame carrier I used in my childhood, is a good representation of the life of Korean farmers in the past. It's impressive that it can carry goods that are heavier than your weight even though the structure is made of tree branches and straw, which are easily found in rural areas.

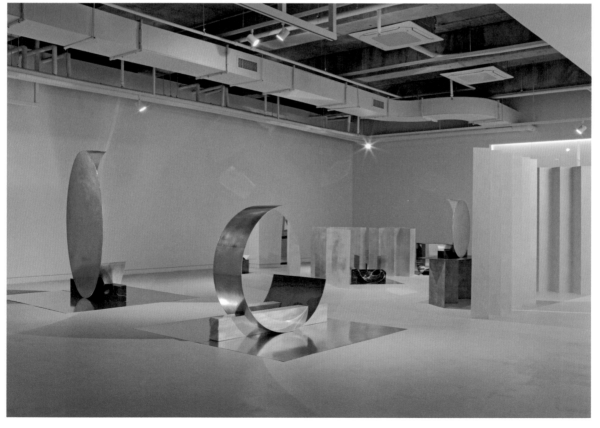

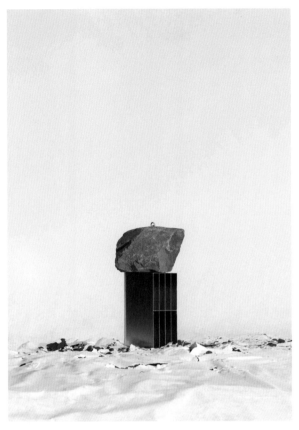

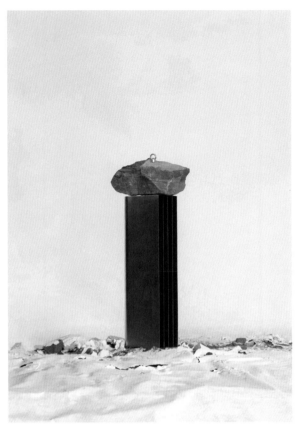

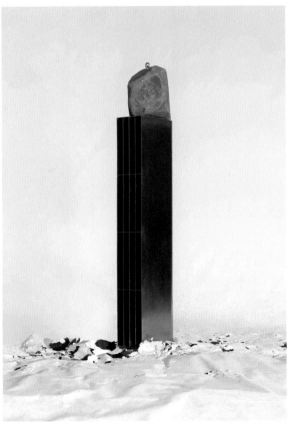

Facing page, top
Pieces from the Weight collection

Facing page, bottom
Balance from a Line exhibition

This page
Pieces from the Weight collection
Images by Sangpil Lee

Jiyoun Kim

When I was a child, I wanted to become a fine art artist — I liked drawing, and that people could see my work. My family always supported my passion, for which I'm forever grateful.

I majored in product design at Hongik University, and later did an MBA at Sungkyunkwan University. In addition to running Jiyoun Kim Studio, I'm an adjunct professor at the Department of Industrial Design at Konkuk University. Taking my MBA course after I had some practical experience was more helpful for me than my first degree — there was 'what' and 'how', but 'why' was missing. During my MBA, I worked as a product designer at a mobile-phone manufacturing company. I thought a lot about the relationship between design and industry and what I could and should do as a designer, so studying business administration helped me to define my role in the industry.

I worked for about ten years before becoming an independent designer, including for the phone company and as a product planner and brand consultant at an advertising agency. I also worked as a design director for a consulting firm while I completed my MBA, so I think my career as an industrial designer is quite unique.

Working at a manufacturing company has been helpful for solving production problems, and mass production has had a lot of influence on my designs. Product design and planning are the first stages of a manufacturing process, while advertising, a communications strategy, is the last. In our studio, we talk about communication-based design, a design methodology based on brand and communication strategies, and these experiences formed its theoretical basis.

The difficult part for me is administration, like tax issues and personnel management. Also, as I worked independently for a long time before I opened the studio in 2018, it was a challenge to work in a team. Of course, now our team has stabilized to some extent and it's creating synergy.

Korea has a vast manufacturing infrastructure, and I think opening a studio in a massive capital city like Seoul is important for stability. I also think Korea has many cultural assets that haven't been defined, which is attractive for me. I'd say this is the case for most Asian countries, and the discussion about 'Korean design' has continued for some time. The role of the younger generation is to figure out an answer.

We see ourselves as a design consulting agency. We work on branding, product design, furniture, space consulting, art objects and the like. I think 'communication-based design' explains a lot about our work: whether a client project or an exhibition, we focus on the communication point at the interface between objects. We ponder what we want users to recognize in our work and what we can use to convey our message — this is sort of a context. When these thoughts meet commercial projects, they become brands; when they meet art projects, they become artist's statements. I hope people can find a message within our work, and feel the joy of experiencing the end product or formation of our work that connects to a story within the context.

Our works are like business solutions, so we look at materials or techniques as means of coming up with a solution. Every project has a business goal: to create maximum utility by using limited resources, where utility includes qualitative values such as a brand or user experience. We try to apply communication and make decisions based on context.

I've worked with overseas companies. With the development of digital networks, people around the world are becoming increasingly like-minded. However, the most challenging part is communicating: designers must identify the client's initial thoughts and response to our ideas, but we can't easily do this through a conference call.

As for expressing personality and nationality, the goal of our designs is to build a brand for our studio and blend our clients' brand philosophies with ours. This is what makes our message stand out. In that sense, I think it's important.

Designers also express themselves by utilizing their native cultural assets, which is wonderful, but I think we should be cautious: instead of merely pursuing local traditions, we must distinguish whether they can blend with the individuality of the designer to create a powerful context. I think Korean designs aren't made, they're expressed. For example, our Dokkaebi stool is art furniture that transforms stainless steel into a super-mirror. Although the materials and processing are far from traditional, we used optical illusion and legendary Dokkaebi creatures as a context.

For me, a representative Korean design isn't an object — it's the Han River in Seoul. There are parks around it where people relax, connecting throughout the city. I can't say the parks have been designed impeccably, but I think they're important venues that create cultural content. Similarly, it's hard to name a specific inspirational designer. I'm inspired by the designers of my generation in Korea — I think we're building a reputation for creating a new design culture.

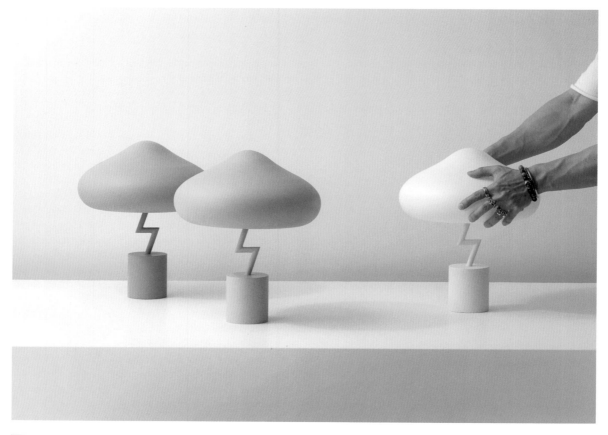

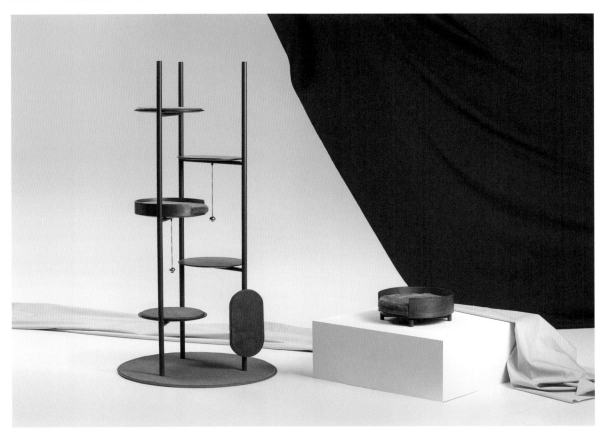

Facing page, top left
Skin Light Therapy II
designed with Dokyoung Lee
for Amorepacific

Facing page, top right
Head Collage: Ception 2016
Limited Edition (above),
Pleasia toothbrush for
Amorepacific, designed with
Chanhong Park (below)

Facing page, bottom
Lightning lamps

This page, top
Three Poles cat tower
designed with Hannah Lee
for Milliong

This page, middle
Head Collage: Ception series

This page, bottom
Dokkaebi stools
commissioned by the Seoul
Metropolitan Government for
Hangang Art Park

EJ Pak

In my second year of university, I was travelling in New York and visited the Guggenheim to see a Frank Gehry exhibition. It was very inspiring, and got me interested in architecture and structure. My parents didn't support me at first because they didn't understand what designers do. I had to prove myself, and I did.

I studied woodworking and furniture design at Hongik University, then moved to the US to study a master's degree in interior architecture at the Rhode Island School of Design.

At Hongik, I made things by myself and learnt every process for making wooden objects, including furniture. I dealt with structure, form, material, finish, joints and so on. In the field, when I had a chance to use other materials besides wood, I intuitively knew how to manipulate the materials. Craft is a very important quality for designers, and I nurtured it through the production classes. At RISD, I was more focused on developing conceptual ideas. I felt having a unique perspective was very important for producing results beyond the ordinary. I still write, draw, make physical models, photograph, collage and so on for concept development.

I worked for several architectural firms before going independent. I really enjoyed working with Wise Architecture. We did a retail shop and built a design guideline for the client. The company was very supportive of experimenting with new materials and new ways, and the working environment was very open and liberal. I also interned with Luxury Living Group in Forlì, Italy. They produce home collections including furniture and textiles for Fendi Casa, Bentley Home, Trussardi Casa and others. It was a good experience to work with luxury brands, which deal with high-quality material and fine details.

As a small studio with only one creative, I need to take care of everything. I play several roles: intern, senior designer, accountant, contractor, drafter and modeller. Sometimes it's overwhelming. But I've mainly worked in Seoul, and the advantage of working here or in Korea is that there are convenient production facilities in the capital. There's a place called Eulji-ro, where there are many small and large factories as well as material suppliers, working with materials like metal, metal moulds, wood and textiles. I'm sure many designers working in Korea have been going to this place since their school days, and they'd be very familiar with it.

I focus on furniture and interior design, and I try to create a sense of freshness for people to experience, as well as a sense of comfort and the familiar. I consider the relationship of object and space to be very important in designing things, and I make 'scenes of space' that are created through those unique and logical relationships. For me, a project with challenges or difficulties inspires my creative energy.

Since 2017, I've been working with a unique material called a lenticular lens for product skins. This material is usually used for advertising, fashion items and playing cards. I think it has a lot of potential for furniture and interior objects thanks to its interactive analogue features. As I move around the object, I notice it changes. The changes can be dramatic or elegantly subtle. And since the lens is print-based, I can express unlimited visual effects.

I don't think it's natural for me to overtly display my individuality in my designs — I think my individuality permeates my designs without me knowing it myself. When I'm working on a project, I make design decisions at every step. From materials and shapes to deadlines, the process varies from designer to designer, and every time I make that decision, I think my individuality is revealed. As for tradition, I don't think we can intentionally plan things to last a long time in this fast-changing world. I never thought about doing something related to a local tradition either. I don't pursue design as an intentional act — I prefer to be interested in an area and naturally reveal what I find through a design.

I have a couple of inspirations. Some are friends; one of the closest is Hyunjin Seo of Studio Orijeen, an old university friend. Talking about each other's projects over a casual lunch can be a major source of inspiration. There's also my old teacher Choi Byung Hoon — he's a pioneer of 'art-furniture' in Korea. Through him I gained a new perspective on furniture and objects as an art beyond practicality.

A representative Korean design would be the *soban*. This traditional portable dining table is symbolic of our sedentary lifestyle, and has endured until today without being pushed or promoted by anyone. It's also become a necessity for the growing number of one-person households, the *honbab*-ers, or those who eat alone. Nowadays, there are many designers applying various materials and structures to it. It's very interesting.

Facing page, top
Layered table series

Facing page, bottom
Printed L low table

This page, top
L Forest lamps

This page, bottom
**Printed Light stool / side
table**

Wonmin Park

Thinking about it now, as a young kid I liked making and assembling things, and I think this motivated me to pursue a career in design. As I grew up, I became more interested in aesthetics and beautiful things, so I started learning design.

My family supported me so that I could focus on my studies at Design Academy Eindhoven. When working on my designs now, I always try to develop what I learnt at school; I found it was a good starting point for a career in design.

Before I started Studio Wonmin Park, I interned at Studio Makkink & Bey, led by designer Jurgen Bey, where I learnt about design processes and running a design studio.

As for challenges, since my studio is small, I need to share the design process with others when we work on a big project, which is hard for me. But living in Paris as I currently do is an advantage in that it's geographically close to Europe and the US, which are some of the most creative places in the world in terms of design and the arts. The disadvantage is that there are also challenges in being a foreign artist.

The Korean government has supported me. I was selected for a programme called Global Star Designer in Korea, and received funding for my early works.

When I work, I invest a lot of time in creating design concepts and sketch models, and on material research. Though I find that when I use the materials I'm most familiar with, the chances of failure are slim since I can, to some extent, predict the outcome of my work. I'd say in my design I want to share new possibilities, my thoughts and my preferences.

My actual dream is to live in a place filled with my own creations, ranging from the building itself to everything inside. And I think it's important for me to express my individuality and identity in my designs. As for nationality, my design might imply it, but it shouldn't be expressed in an obvious way, and my style isn't related to a specific local tradition.

Though he's not a designer, I'm inspired by Lee Ufan. And for a representative Korean piece, I think it would be the *bandagi*, a simple Korean cedar chest that reflects Koreans' sedentary lifestyle.

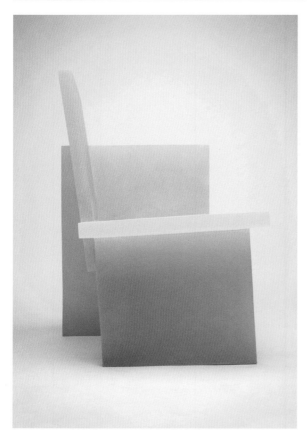

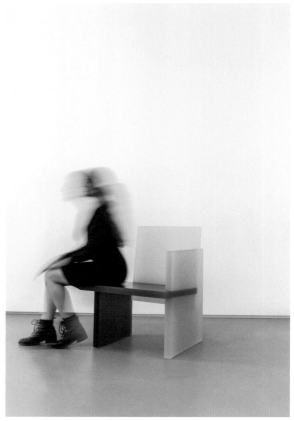

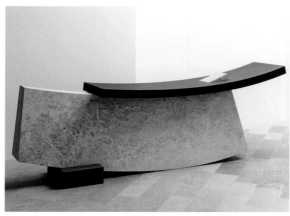

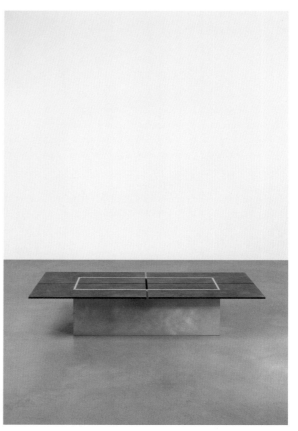

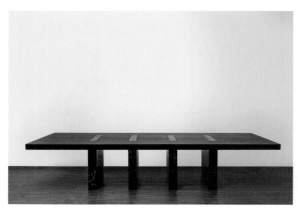

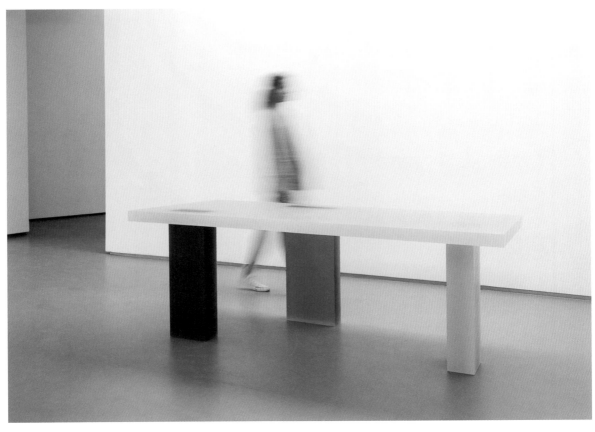

Previous page
Image by Wouter Kooken

Facing page, top
Haze chair
*Right image courtesy of
Carpenters Workshop Gallery*

Facing page, bottom left
(above)
Curved desk
Image by Carl Kleiner

Facing page, bottom left
(below)
**Wooden table with marble
legs**

Facing page, bottom right
Plain Cuts_4 plates low table
*Image courtesy of Carpenters
Workshop Gallery*

This page, top
Desk with three legs
*Image courtesy of Carpenters
Workshop Gallery*

This page, bottom
Unfocused table

Jeonghwa Seo

I knew I wanted to become a designer from my second year of high school. At first, I thought I should become an industrial designer with a major company, which my family supported. I majored in metal art and design at Hongik University and contextual design at Design Academy Eindhoven in the Netherlands.

I mainly work on designing from what I've learnt at school. Since I graduated, I've experienced direct control of a series of processes from designing to planning and completing a project. And in my graduate course, I was able to express my research logically in my design to deepen its context. These two experiences have been the most important for my design practice.

As a designer, it's a challenge creating new ideas with tight production schedules. But I think Korea is a country that appreciates the value of intangible culture, which is an advantage for designers who carefully contemplate the form and concept of their design. Also, since Korea is a country with rapidly changing consumption trends, it's not easy to continually introduce new work. Although this could be considered a disadvantage, I believe it's an advantage for designers, as we can get ideas from that rapidly changing culture and produce new designs out of it.

There are also government programmes. I took part in various contests organized by the Korea Crafts & Design Foundation, and they sponsored some expenses for my design projects and education — thanks to them I was able to come up with several pieces. I've also participated in design and craft projects held by non-profit organizations, which led to some meaningful outcomes.

My studio designs objects and spaces. I've worked on furniture since 2010, and have worked on smaller objects since before that. I started combining spaces, furniture and objects together in 2018. In addition to producing for my own studio, I've created a vase for Aesop and furniture for Facebook and Fontana Milano 1915. I'm currently making furniture for Louis Vuitton. I hope people get a sense of good form and material value from my work.

If I was ever given the chance, I'd like to design and build a building in a location I choose and create all the design and structural elements. I think it would be interesting to plan for actions and events that take place in that space.

I think it is important to express personality and nationality in my designs, but I don't think I should simply follow local traditions. Traditional materials are some of the most accessible for me, though, and I try to make the most of them. At the same time, my favourite material or technique is my own observation. I think current material cultures are formed through efforts in creating certain forms and using certain materials by those who made traditional objects, so I'm grateful to them. In giving back to the people who have created that culture, I try to understand the traditional cultural elements and interpret them to take them forward.

I admire the work of Kwangho Lee and Hyungshin Hwang. Though they're the same age as me, they're the designers who really inspired me to become an independent designer when I finished graduate school and started working. As for something that expresses Korean culture, I think the work of Lee Ufan best shows Korean people's conceptions of material.

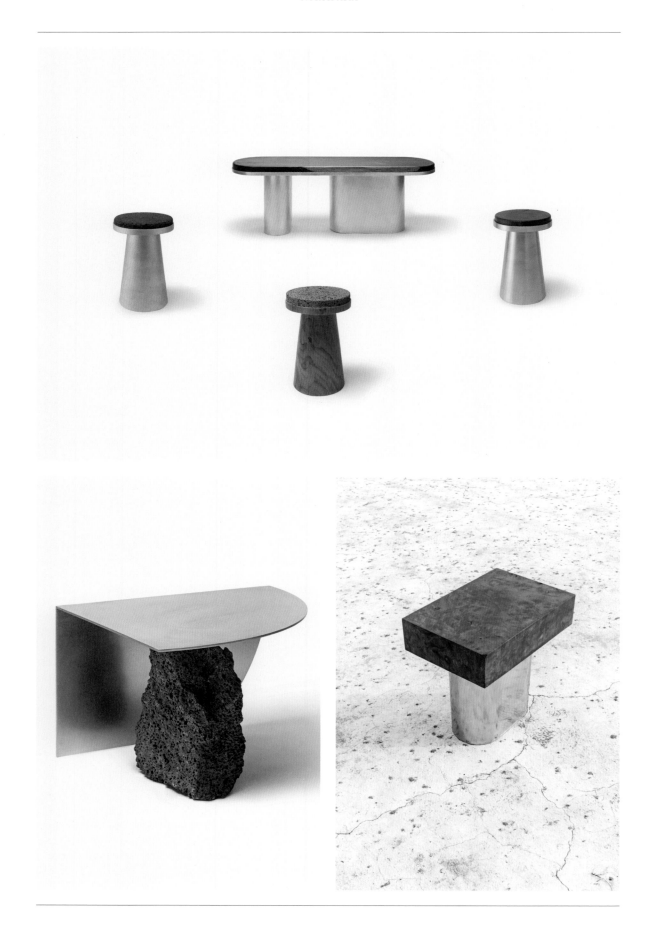

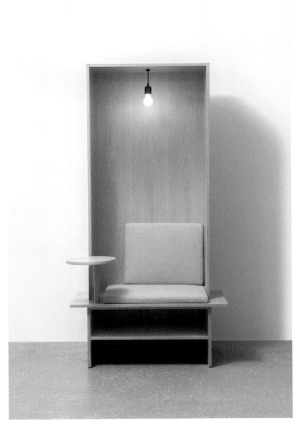

Facing page, top
**Material Container bench
and stools**

Facing page, bottom left
Primitive Physics table

Facing page, bottom right
**Aged Blocks table / stool for
Hue**
Image by Unreal Studio

This page, top
Space for ChosunMedia
Images by Unreal Studio

This page, bottom
Space for Et Cetera
Image by Unreal Studio

Hee Kyung Sul, Cleverclaire

I became interested in design in my late 20s, and decided to study abroad in England. Doing that at that age wasn't easy, but I overcame those challenges thanks to the support of my family. I did my bachelor's degree in furniture design at Birmingham City University, then I came back to Korea and did my master's degree specializing in furniture design at Hongik University.

I studied product design for three years at BCU. I also completed courses in woodworking, metalworking, ceramics, glass and so on. Although I didn't study all the courses in depth, my learning experiences helped me to better understand and integrate my design with different disciplines.

After graduating from university, I honed my skills for two and a half years at a furniture company that mainly manufactured custom products. I covered everything from 3D modelling to drawings and factory orders. I had to work long hours, and I wondered why I had to do all of this by myself. I found myself regularly frustrated. However, I now believe that these experiences helped me greatly in becoming an independent designer. I've learnt to work independently, and although it was tough it was a valuable lesson.

Since my works are mainly craft works, they can only be produced in small quantities. On top of that, they can only gain exposure through local and international exhibitions, but maintaining a continuous flow of work and the necessary business relationships at the same time is very difficult. A disadvantage of being in the design field in Korea particularly is that the market is small. Although people's appreciation of local designer products has improved a lot, I think that local consumers still prefer mass-produced commercial furniture to custom furniture. That means the trend among designers today is to export their works and do business abroad. The advantage is that since the market is small, it makes it easier for furniture or craft designers to connect with people.

'Amusing', 'enjoyable', 'happy', 'fun' — these words are what I want my clients to associate with my works. It feels so rewarding to see my clients happy and excited when I set up their spaces with these colourful objets of mine. I hope I can continue designing works that bring happiness and joy to people.

I usually make furniture that can be used as a stool or a table. It's manufactured with laminated epoxy resin, which incorporates colour into moulds. Colours are mixed each time a piece is made, and Cleverclaire's products are characterized by the fact that each one is unique.

Epoxy resin becomes hard as stone when mixed with a liquid hardener, so if you have the mould of your desired shape, you can manufacture it in any form. I mainly use the method of laminating and hardening the epoxy resin by pouring it. There are two processes in lamination: laying up different colours to show them in different layers, and pouring different colours at the same time so they flow naturally into one another.

I think it's more important to express my individuality than my nationality. Sometimes I feel that Korean craft or design somehow makes designers incorporate elements that are very Korean. There's a notion that designers must express an authentic Korean style in their work, but I personally don't agree with this. I think just being myself is being very Korean already. For instance, designers who adopt traditional techniques or who are inspired by traditional patterns, lines and colours may be recognized and admired by many. However, it's not the case for me — I think the idea of incorporating traditional design when it's against the designer's will is nothing more than an imitation. I grew up in a Korean culture, and so I can proudly say that the colour I create is very Korean. I've actually been studying and applying a lot of traditional colours and arrangements, but I don't think there's a specific Korean designer who has inspired me.

To me, a representative Korean design would be the *soban*, a small tray-like table used for meals or tea. In this modern world, every household has a sofa and a coffee table, but some Korean people still dine on the floor. Many young furniture artists have reinterpreted the *soban* and modernized it in their own styles.

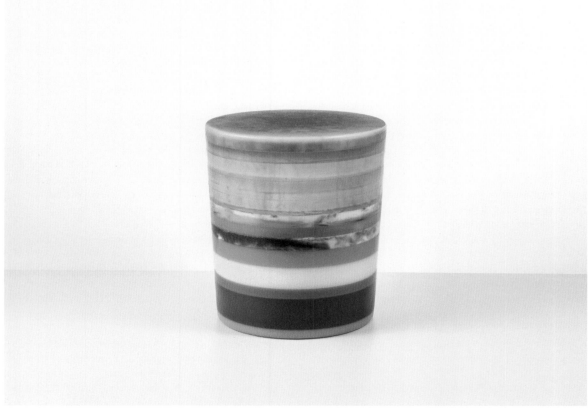

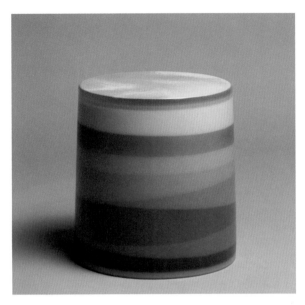

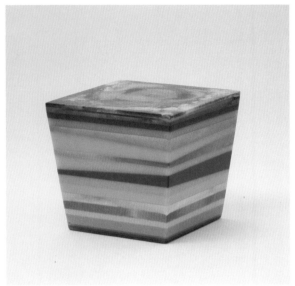

Facing page, top
Technicolor #6 stool / side
table

Facing page, bottom
Technicolor #7 stool / side
table

This page, left
Technicolor #18 stool / side
table

This page, right
Technicolor #11 stool / side
table

Jeong Yong

I really enjoyed drawing as a child, so I went to different art academies. When I had to choose a university major related to arts, I realized that industrial design might be the best choice. After that, I dreamed of becoming a designer. My mother always supported me, but my father was more conservative and initially didn't want me to become an artist or a designer. However, once he understood my passion and saw my accomplishments, he gave me his support.

I studied at Konkuk University, and while I was a student I also learnt a lot through a gathering called Designers Party. I got to meet a lot of Korean designers there. In my course, I learnt basics such as the design process, design skills, moulding and so on. That created the basis for my work, and still plays a vital role in my design. However, I think it's equally important to create your own identity and philosophy for your works in order to become a good designer.

I didn't work for another designer before I opened my studio, but I did work for a company that values employee autonomy and responsibility. That meant I had to find out and solve a lot of things on my own, which helped me to find my own design style. I think design is a journey of self-discovery.

For me, finances are the most challenging part — my income isn't stable. But people in Korea are becoming increasingly interested in design, which is a good thing. And since Korea doesn't have many renowned designers like Japan does, I think it's a good market for young designers like me to become known.

Our studio mainly works on furniture, products and branding design. We try to break stereotypes of existing objects and strive to offer people comfort, new experiences and inspiration through reinterpreted designs. I'd like to work on an architectural project some day. I want to express the colour and inspiration we usually apply to furniture or products in a huge space.

I hope people can experience new and fresh feelings when they look at my work, and I hope they can sense my unique identity. I think it's very important to express my individuality in my designs. I think that whatever the elements or definition of that individuality may be, there's no merit to working as a designer if you don't have it. Like most things, a designer's work is highly valued when there's scarcity. If anyone could do it, my clients wouldn't have a reason to entrust me with design work. Whether you're a company or a designer, establishing your own individuality is self-branding, and I think it's extremely important.

My favourite material is wood. It has both a natural and a human-produced feel to it, and a lot of people feel a sense of familiarity with it. However, we like to use materials in many different ways, and we try to use new materials as well.

Specific local traditions are likely to be different between designers, so many designers prefer to draw on those localities and traditions as a way of differentiating themselves. I think it's one of the many sources of your own individuality. And I believe it's important to revive traditions themselves even if you don't revive them through your design — tradition is beautiful in its original state. But for me, I don't think it's necessary for my design to blend with local traditions. Having said that, I think my Queen and King chairs are a contemporary and appropriate representation of the beauty of traditional Korean homes and furniture, which adopt concise and understated lines in three dimensions.

Designer Joongho Choi was my senior at school. He inspired me and has helped me a lot since I was at university, and he's still the designer I admire most today.

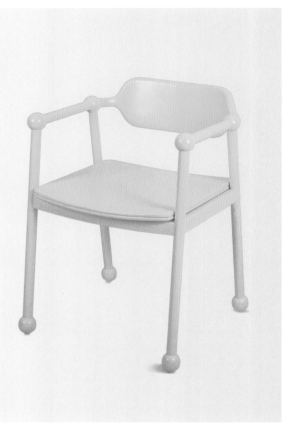

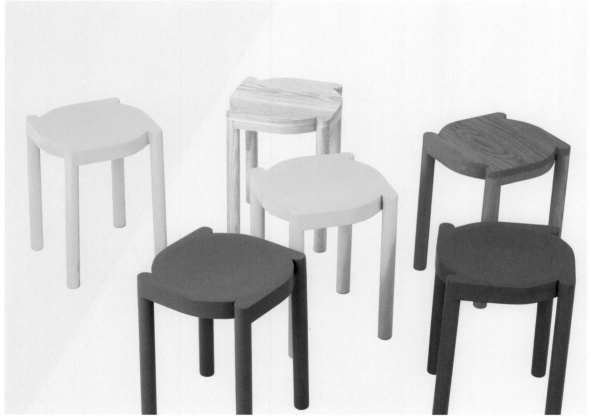

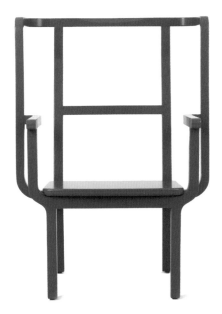

Facing page, top
Candy chair

Facing page, bottom
Dori stools

This page, top left
Queen chair

This page, top right
King chair

This page, bottom
DORA CD player

Saerom Yoon

My first major at university was chemistry. But later, when I served in the military, I became interested in furniture. So, I decided to change my major and learn furniture design after I left the military. My family has been my biggest support.

I studied furniture design at Hongik University. Everything I learnt and experienced at school has been helpful, including things that didn't seem to help at first. Studying design trends was most helpful — I learnt that designers need to know about history in order to look at the present and predict trends. I think about things I learnt at school so I can be at the forefront of the present era.

I worked in artist Bae Se-hwa's studio for a while. I was into woodworking and learnt a lot, and the experience drove my passion in woodworking to a whole new level. Working in a design studio and being able to work with the artist I admire most was helpful in so many ways. Witnessing the entire design process of your favourite work and knowing the proper level of finishing are things you can't learn at school. In addition, observing how a studio is run is also helpful in running your own personal studio. I don't do woodworking now, but it's still my favourite craft.

The main challenge is that I need to do a lot of things on my own. I never have enough time because I work on artworks, interviews, meetings, publicity and sales. But the main advantage of working in Korea is that it's a very trendy and fashionable country. Since it's very open to foreign cultures, you can experience and learn various things, which is a plus for all designers. However, designers in Korea are still discouraged from pursuing the profession due to lack of recognition. More people in Korea appreciate the work of local designers than before, but we still need to fight for recognition so people realize the value they're paying for when they buy our work.

Through my designs, I want to share new forms of visual stimulation and the sources of my inspiration. I use acrylic to make furniture, objects and installations. I don't only design — I deal with the entire production process on my own. Currently, I'm working on dyeing acrylic. Since there aren't any design works that have been created with dyed acrylic, it will be very visually stimulating when people first see it. Sometimes I feel that it has an even greater impact than I anticipated, so I'm thrilled and excited whenever I start on a new project.

I don't really know how I can grow further as a designer, what I can do and what projects await me, but I hope it can be better than I've imagined, and I feel like that's happening for me now. This is the reason I love my job.

I think individuality is very important, and designers need to constantly develop ways to express their own individuality. I think I can produce my best work when I know myself better. It's important for me to know what I like and who I really am. I don't think I need to adopt local traditions in my design — I've never considered it. However, I think that the education I received along with the social environment, culture, history and traditions that I've experienced influence my work. I would prefer to create new culture through my work rather than reflecting local traditions.

If I had to choose a representative Korean design piece, it would be Goryeo celadon. It displays luxurious beauty but it also demonstrates modesty, and this I believe is a perfect representation of Korean culture.

One Korean designer who has inspired me is Choi Byung Hoon. He's both my mentor and teacher. I love his works and above all, I get a lot of inspiration from the energy he puts into them.

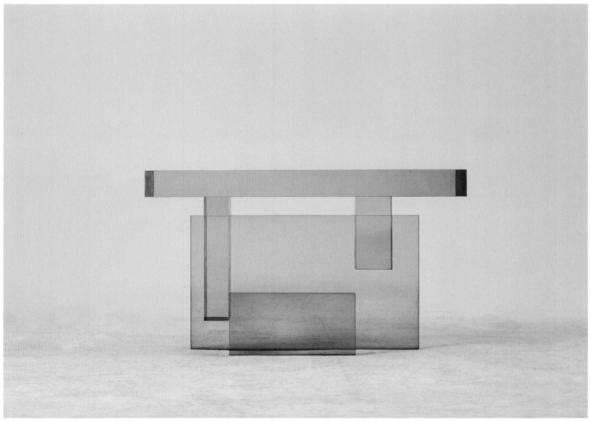

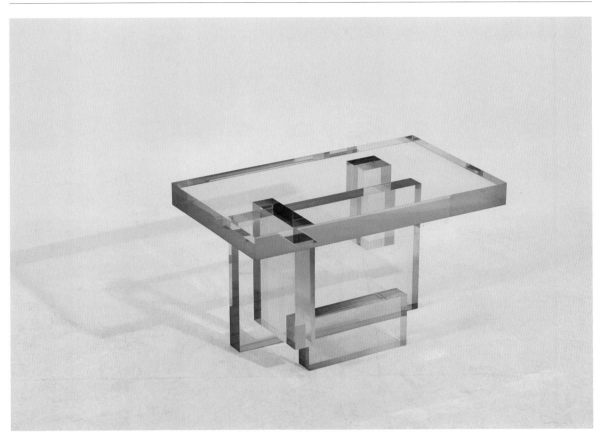

Facing page and this page, top
Table 04 from the Crystal series

This page, bottom
Vase from the Crystal series

Shigeki Fujishiro

I decided to become a designer at around 23 or 24 years old. My family didn't mind me going into the field. I studied at Kuwasawa Design School, and I think a few things I learnt there have been useful.

Before starting as a freelance designer, I worked at a furniture company. There were so many chances to encounter international designers — that's been the standout experience of my career so far.

Being based in Tokyo, I think the size of available spaces is a challenge — I'd like to have a larger space. But it's very convenient to get any kind of material and to make things quickly. I do want to try to work in another country and experience a different setting though.

I mostly design furniture and interior accessories. Designing a chair that sells for over 50 years would be a dream. I've worked with brands such as Hermès petit h, HAY, Adidas, 2016/Arita and Camper. I'm happy when the fun of making by hand is transmitted to the user. I like working with paper — I always use paper and a cutter to make my mock-ups.

I think it's necessary to express personality in designs but not nationality. I regard Sori Yanagi and Yoshio Akioka as inspirations from Japan, and I think tatami and the wooden Japanese-style bath are representative as design objects, but when it comes to keeping to tradition in my own designs, it depends on the project.

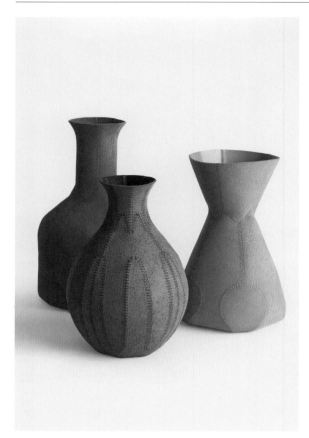
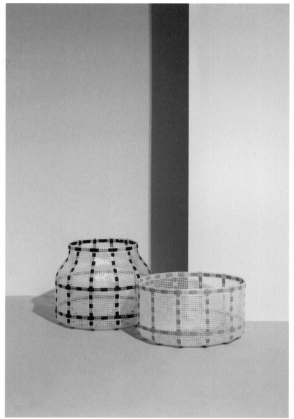
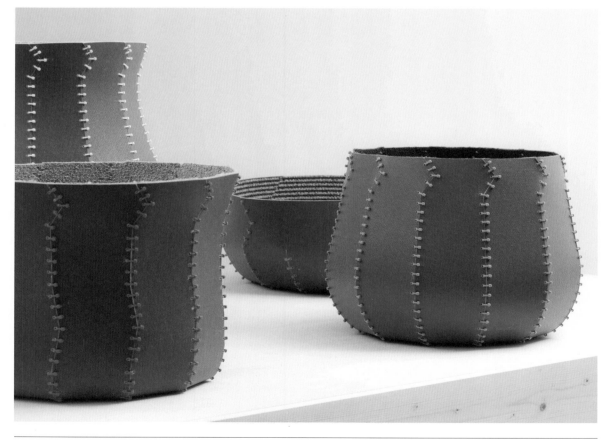

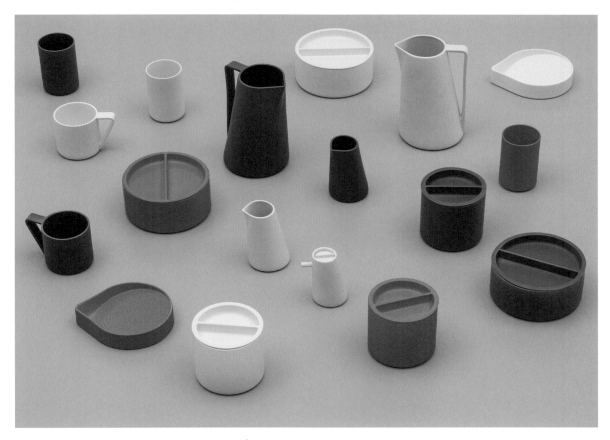

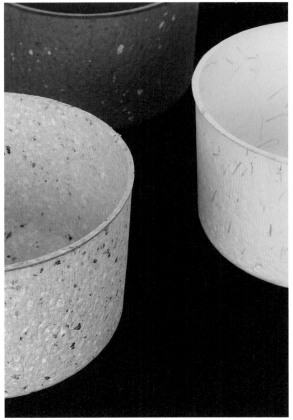

Facing page, top left
Flacons Zigzag series for Hermès petit h

Facing page, top right and bottom
Baskets collection designed with Carlo Clopath and Noelani Rutz
Top image by Charlie Shuck
Bottom image by Gottingham

This page, top
Porcelain ware for 2016/
Image by Yasunori Shimomura

This page, bottom
Mix paper containers

Kunikazu Hamanishi

My father, who is an artist, influenced my career choice from when I was five years old. My family has been fully supportive.

I studied at Tama Art University in Japan and Krabbesholm in Denmark. I was trained to brainstorm answers to questions based on the school's exploratory culture. I've found the ideology and process thinking more useful in my work than the technical skills I learnt.

Before I started my own studio, I was an in-house designer for an interior design company for about seven years. I've found the main challenge as an independent designer to be securing multiple regular clients for a stable income. We only have a handful of major customer projects, as our design studio is relatively small — there are only a few clients who are bold enough to engage us. We've had some official support, like when we received funding from the city of Yokohama for renovation works in our new office.

We focus on product and interior design for client projects, which is about 80 per cent of our work, and submitting designs to foreign furniture brands. It would be a dream to design products or spaces for international events such as Salone del Mobile.

We aim to provide designs that are refreshing and able to stir emotions based on limitless ideas and an experimental mindset. We enjoy the moment of potentially creating something that's unexpected through repeated experimentation with a combination of various materials and technology.

I treasure my unique ideology and manner of expression, but I don't pay much attention to my nationality in my designs. Even though I mostly draw inspiration from Japanese traditions, it's not that important to me to integrate them into my work. A designer I've found influential is Tokujin Yoshioka, while Isamu Noguchi's Akari series I find very representative of Japanese design.

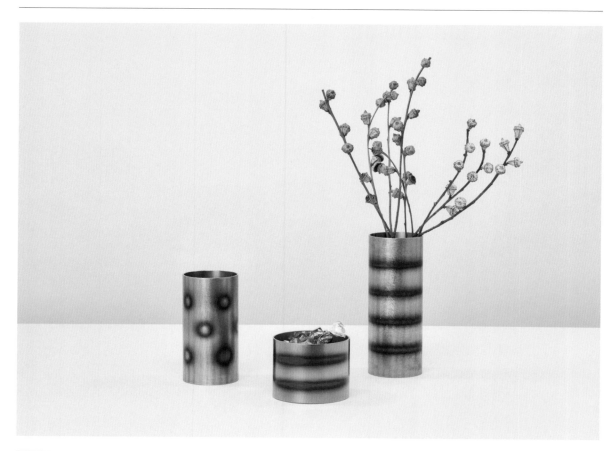

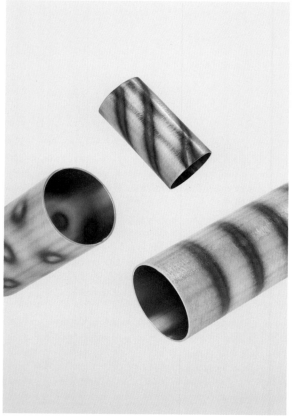

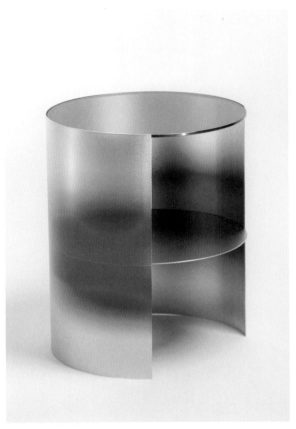

Facing page, top and botom left
Graffito containers

Facing page, bottom right
Pillar floor lamp

This page, top
Tig side table

This page, bottom
Flame pendant

Noriko Hashida

My parents have always been interested in the arts, and have been supportive of me drawing and making things ever since I was a child. They also supported me in pursuing an arts course in the design faculty at the Tokyo University of the Arts.

University was very useful to me, as subjects like anatomy and various expression techniques can't be learnt through self-study. Model making was also helpful at the start of my career.

Before I opened my studio, I worked at TOTO, and it was a rewarding job handling different products and design materials. As an independent designer, time management is difficult; I also teach and lead my Emotional Design Lab project, so I need to coordinate with the other teaching staff at my university. There is some government support available for designers. For example, I held a solo exhibition at the Consulate-General of Japan in New York, and rental of the venue was free.

I think about products that make life enjoyable and provide comfort. I don't have a fixed genre in mind. My main objective is that the users feel comfortable physically and visually. A good design will be able to meet both needs. I usually work in plastic, wood, paper, felt, glass and ceramic.

My own personality and nationality should appear naturally, but I don't think it's necessary to include them every time. For example, functions like compact storage and multipurpose application are great Japanese-style designs. As for particular representative products, I'd choose the *zaisu* floor chair, the Washlet and the Japanese-style bathtub.

And although I have a lot of respect for traditions, I don't want to be bound by them. I do feel that Sori Yanagi, Shiro Kuramata, Isamu Noguchi, Naoto Fukasawa and Motomi Kawakami are inspirations when it comes to Japanese designers.

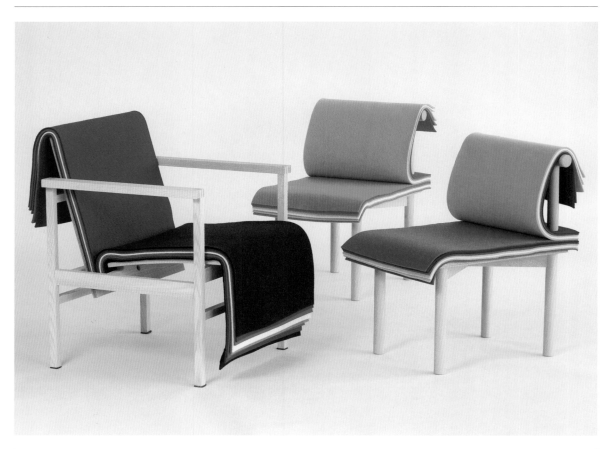

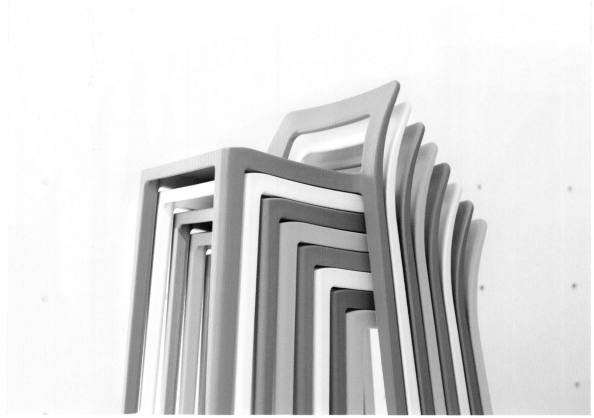

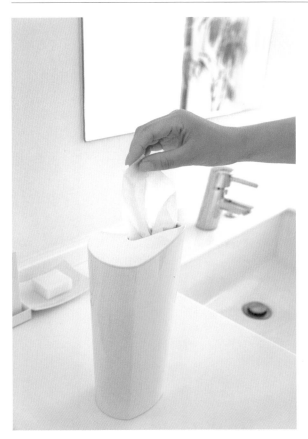

Facing page, top
Pages 1 and Pages 2 chairs

Facing page, bottom
ENOTS Minimal chairs

This page, top left
TAOG tissue case

This page, top right
Bew kitchen mat

This page, bottom
Retto A-line chair

Satoshi Itasaka, the design labo

I loved to draw and make things from a young age, and learnt about designing through the beauty of nature. My family encouraged me and helped me improve my skills, and I went on to study architecture at university.

I apply what I learnt there in my work, as well as the knowledge I've gained through self-study outside of school. And before starting my own studio, I worked in the residential planning division of an architecture and planning company.

The challenge as an independent designer is to achieve a balanced approach between creating products to sustain the business and creating challenging work to bring better opportunities in the future. But in Japan, there are many designs that draw inspiration from Japanese culture and traditions, which I see as an advantage.

About 60 per cent of our work is architectural designs. Product designs are about 30 per cent and the remainder is artwork. In terms of architecture, we design residential, commercial and cultural properties. We work on a broad range of products from conceptual work with overseas brands to traditional local products. As for our artwork, we're constantly trying new things. Recently, we presented a creation that adopts AI technology.

Recently, it seems that there are designs that continue to use techniques and materials that are disappearing through modernization. I think it's enjoyable and an honour to be able to inherit these cultural elements and convey them. I worked with a French brand a few years ago; similarly, some great techniques and materials in France were also disappearing, and I was very excited to be involved in designs that integrated technologies and materials from both countries.

I want to express the feelings of joy and elegance and a sense of discovery through my designs. It's my dream to be involved in architectural projects such as hotels and art museums. Most of my inspiration is drawn from the early works of Kenzō Tange.

Even though I have no intention of expressing them in a proactive manner, it seems like my designs are rather Japanese-looking. I feel traditions are important though. They can help me create products that have a long-lasting presence.

To me, paper lanterns are a representative Japanese product. They're traditional objects in which candle flames are shielded by paper and thin pieces of wood. They're a product through which you can glimpse Japanese-style delicacy and beauty.

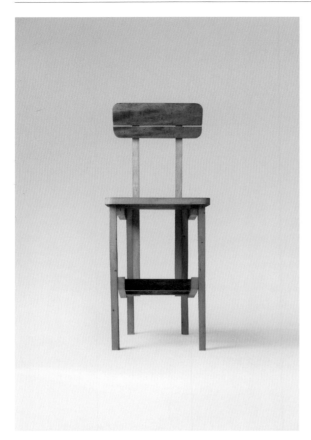
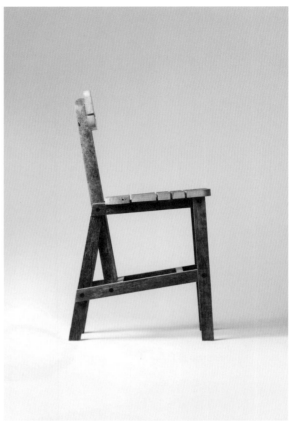
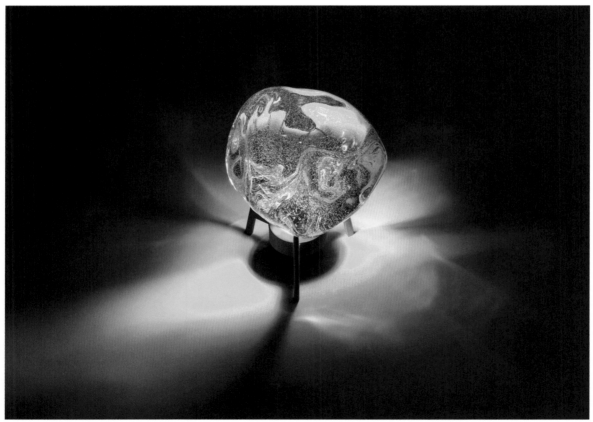

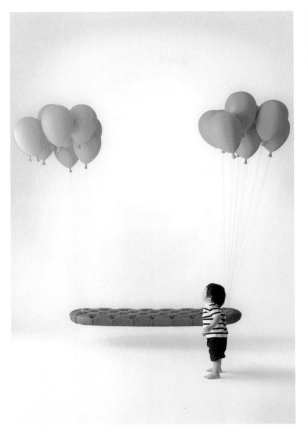

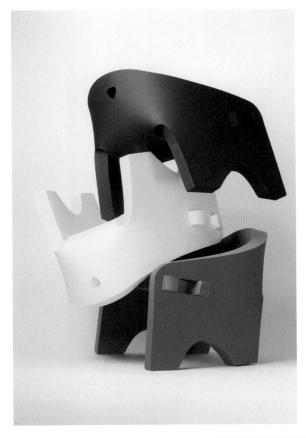

Facing page, top
Neba chair

Facing page, bottom
Afterimage of CRT lamp

This page, top
Balloon bench

This page, bottom
Owl chairs

Yota Kakuda

I decided I wanted to be a designer when I was about 18 years old, starting with an interest in fashion design before shifting towards retail design and visual merchandising. I think my interest grew from when I was about three, through frequent visits with my mother to a particular shop specializing in traditional mingei crafts. My family really helped me a lot.

I went on to study at Tokyo Zokei University and the Royal College of Art, where I received my master's in design products. The experiences were a little different: I think I learnt the importance of creating things through the hands-on approach at Tokyo Zokei University, and art appreciation at the RCA.

I worked for others for a while before starting my own studio. I learnt computer skills in Ross Lovegrove's office and about physical mock-ups in Shin & Tomoko Azumi's office. Being involved in Ron Arad's art and designs was also a valuable experience. I noticed how fast-paced European companies are from the moment the designs are approved to the product launches.

As for being based in Japan, maybe an advantage is the opportunity to listen to fine music and be exposed to different genres of movies, art and fashion. It's also great for enjoying cuisines from around the world. Cultures are generally built on these aspects. I've received support from the government as well, to study at the RCA.

My studio focuses on interior design and art direction, centring on product and industrial designs. I don't try to give end users a specific experience, but I'm glad if I can bring a little joy to their lives. Personally, I enjoy the breathtaking moment of seeing a completed prototype design for the first time. I feel like a dream project might be discovering the ultimate style of something.

I don't really aim to put my own personality or nationality, or Japanese traditions, into my designs. But of course, I have been influenced by many Japanese creators, particularly Ryuichi Sakamoto, Yanagi Sōetsu and Shiro Kuramata. I think the Panasonic SL-PH7 'P-Case' is a fine example of Japanese design.

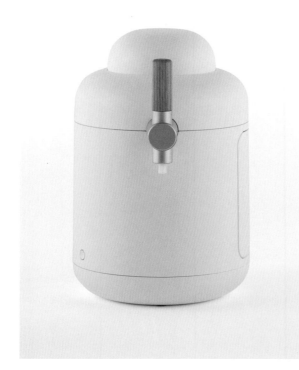

Facing page, top
KIRIN Home Tap
*Images by Takumi Ota (left)
and Junichi Kusaka (right)*

Facing page, bottom
**Lines clock and Numbers
clock for Lemnos**
Image by Junichi Kusaka

This page
**Common tableware
collection for Tokyo Saikai**
Images by Junichi Kusaka

Yuma Kano

I wanted to become a designer from the time I was in primary school, and my family was very supportive. I studied at Tokyo Zokei University, and learnt things like the rationale behind creating a 'chair' rather than the method. It was more about design than technical aspects, and I still find this knowledge particularly useful today.

Before I opened my studio, I was an assistant to contemporary artist Yasuhito Suzuki. I learnt a lot in areas such as the creator's attitude towards their creations, as well as ways to create and display them.

For me, the main challenges are the economic aspects, time management and office space. The advantage of setting up in Japan is that there are many wonderful studios across the country, as well as professionals in woodworking, metal processing, glass, textiles and so on. I've had a number of opportunities to showcase my works in Europe, though a disadvantage is that the transportation from Japan is expensive and time-consuming.

Apart from conceiving designs and ideas for brands, we also create personalized projects and we showcase new ideas and designs during Milan Design Week every year. In this world, there are still many beautiful and obscure things that have been overlooked and are waiting to be discovered. I think my mission is to turn these discoveries into beautiful products and convey them to the world. The joy of making new discoveries drives me — it's very satisfying to gain new knowledge. My dream project is to create products for brands that have world-class craftspeople, such as Hermès and Baccarat. I'd also like to design the interiors of their stores.

I don't design with a specific theme or purpose, as I want my designs to have a natural look. And although it may be important to integrate traditions into designs, they have to be constantly updated in order to keep up with the times. While I think it's difficult to choose one design that represents Japan, I'm inspired by two Japanese designers in particular: Rei Kawakubo of Comme des Garçons, who inspires me with everything she creates, and graphic designer Shigeo Fukuda — he's the reason I love to design.

Facing page, top
Frankenstein's chairs for IDÉE
Image by Keisuke Tanigawa

Facing page, bottom
Balloon Bulb pendant
Images by Satoru Ikegami

This page, top
Rust Harvest cabinet
Image by Gottingham

This page, bottom
On bicycle stand for Nemoto Shipyard
Image by Satoru Ikegami

Daisuke Kitagawa, DESIGN FOR INDUSTRY

I launched my practice around 2010, and started showing my designs in exhibitions from late 2011. But I didn't rush into creating my own label after that — I took my time and finally went solo in 2015 while continuing to participate in exhibitions in the meantime. By then, my family had come to support my choice.

I studied at the Kanazawa College of Art, where I specialized in product design for four years. Looking back at things I might not have fully comprehended at that time, I think I'm able to understand them better now. I think the attitude towards designing is more meaningful to me than the technical aspect of it. I haven't had a specific mentor, but I did learn a great deal from many senior and fellow designers in my previous job of almost ten years.

In terms of challenges, I think I have yet to master and understand the true value of design as a career. I believe that designers are entrusted with responsibilities, and I hope I can convey that value one day. As for the advantages of being in Japan, I think we have a robust culture of creating a broad range of products through modern manufacturing industries as well as crafts and the arts.

My company works domestically and internationally on projects such as concept developments, branding, creative direction, planning and technical development with R&D institutes centring on furniture, daily goods, home appliances and robots. Outside Japan, we've collaborated with Austrian lighting company XAL and Polish furniture and product company tre. Through my work, I like to create opportunities to share joy with people.

I tend to select materials that have never been used before when I showcase my work, and I enjoy learning new things when working on my designs. If I could choose a dream project, I'd like to be involved in work related to areas such as space, deep sea and the Arctic — with things like rockets, spacesuits, space stations and submarines. I'd also like to try designing for mass tourism.

Even without expressing personality or nationality intentionally, I think my background, which forms my personality, is expressed naturally in my work. As for other Japanese designers and creative people who inspire me, there are many: Hon'ami Kōetsu, Sen no Rikyū, Sori Yanagi, Keisuke Serizawa, Shiro Kuramata, Hiroshi Sugimoto, Tokujin Yoshioka, as well as all my fellow designers of the same generation.

When it comes to incorporating local traditions into my designs, I consider it if it's in line with the project requirements and it's necessary, but I think it's more important for the design to be appropriate for the region. One thing I think exemplifies Japanese design is the national flag: it's about minimalism — a single red circle on a plain white background — as well as the meanings behind the red and white colours.

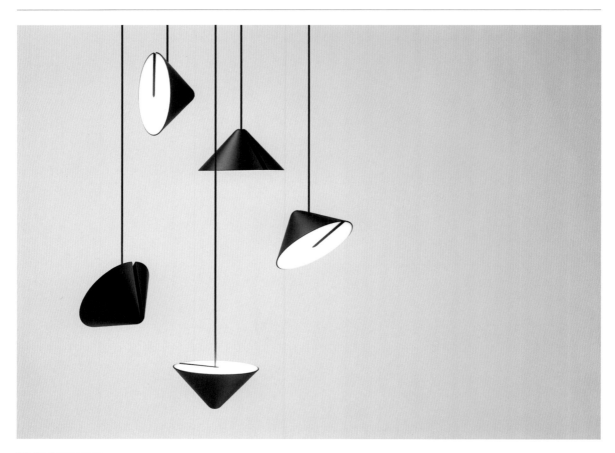

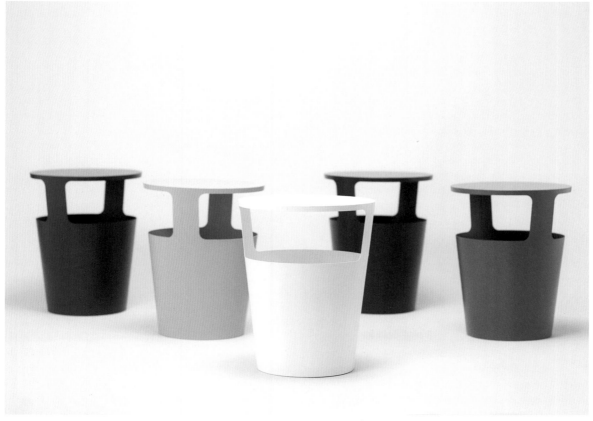

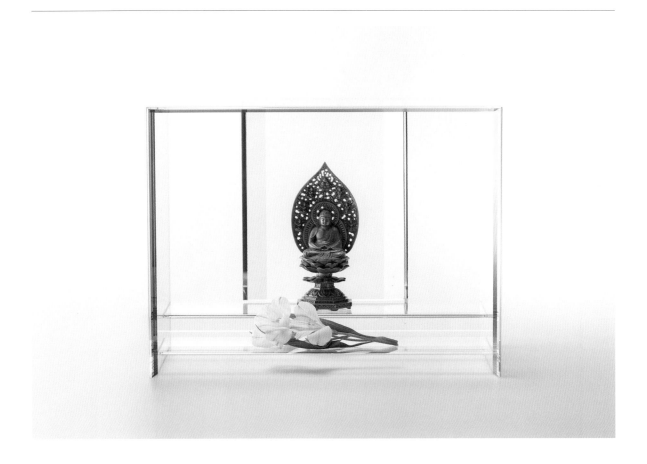

Facing page, top
Nod pendants for XAL
Image by Hisashi Kudo

Facing page, bottom
trifle side tables for TIME &
STYLE
Image by Masashi Akiba

This page, top
Sumidan altar for MANAKA
Image by Hisashi Kudo

This page, bottom
Romance chair for Odakyu
(above), Fluct clock for
Lemnos (below)

Mikiya Kobayashi

I happened to read a magazine article about chairs when I was 18 years old. The article was about a chair and its creator — who later became my teacher at university — and had a lot of information like the history of chairs that I hadn't known about before. This was where I learnt about the long hours that people spend sitting down and about a profession that creates supportive 'tools' for people in their daily lives. I went on to study interior design at Musashino Art University in Tokyo.

Japanese calligraphy is another aspect that serves as the background of my designs, as my grandmother was a calligrapher. In calligraphy, the depth of the words can be felt through different shades of the ink. Even the surrounding empty space looks amazing in the presence of the elegant lettering. It's the same for my interior design work — for example, the space surrounding beautiful furniture appears to be more elegant and makes people feel comfortable.

Similarly, although we mainly design furniture, homewares and mobile items, we also take into account factors like the surrounding space and the usage time. As interior design is about designing spaces where people spend time, I think this is also applicable to product design.

I started my career with a major design company called Field Four Design Office under the mentorship of Yoshiharu Shimura. He's still my role model today — I admire his business etiquette and design and presentation skills.

Since I started my own studio, I haven't come across any specific challenges. But I do think about pursuing new challenges, and am grateful to have capable staff and good clients. I do feel that there's a need to create an English-speaking environment since there are few opportunities to communicate in English.

Our studio does design work for local and overseas clients, as well as our in-house brand, IMPLEMENTS. I worked with a manufacturer that was engaged by heritage French brand Maison Drucker to produce a custom chair. The result was Massena, which we launched in 2018. It was a challenge for both Drucker and me as it was the first project they'd worked on with a foreign counterpart. I think we did a good job on the design while staying true to Drucker's traditions.

If our designs bring joy to users, I couldn't be happier. We're always trying to understand peoples' lifestyles and striving to create designs and products that customers want. I think it's extremely difficult to choose a particular material or technique, as they're all wonderful. It would be great to use them well for new challenges.

Some day, I'd like to design gardens and parks. I often visit Moerenuma Park in Sapporo, which was designed by Isamu Noguchi. The size of the park wouldn't matter — I just want to be a part of that type of project.

I haven't given much thought to reflecting my own personality or nationality in my designs. I feel that a design's natural look and its nationality should be reflected in the way it works with different lifestyles, its features and cultural elements rather than materials and shapes. But traditions are very important to me. I think it's also important to pursue challenges while staying true to them.

Chopsticks might be a good example of a representative Japanese design. Even though the culture of using chopsticks came from China in the sixth century, different varieties of chopsticks have been created in countries such as Japan, Korea and China based on their respective food cultures. Japanese chopsticks have been personalized in a way that the tapered tips make it easier to pick up food items. And chopstick holders are also used in Japan, as it's considered impolite to place chopsticks on the plate. With this cultural background in mind, I designed a matching set of chopsticks and holder called Uki Hashi.

Isamu Noguchi and Sori Yanagi are two Japanese designers I consider influences. I'm inspired by their original, simple yet rich styles of expression.

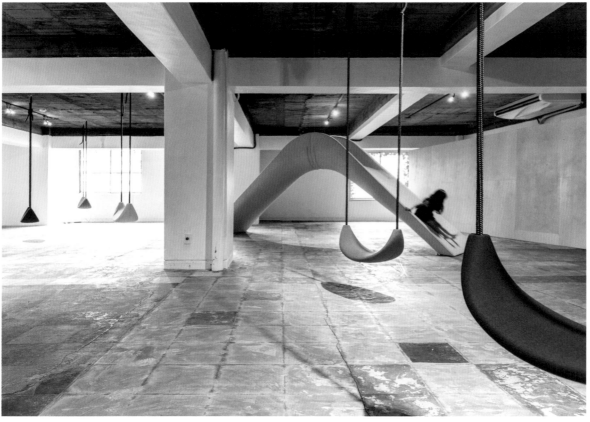

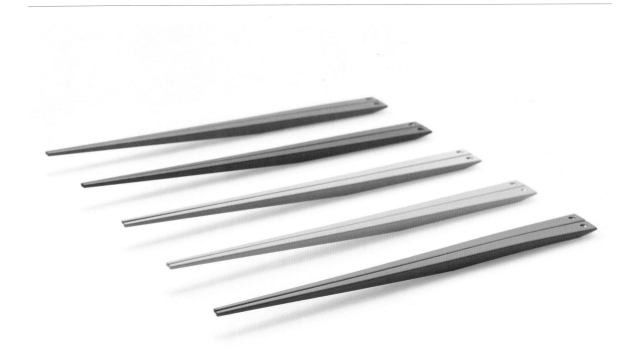

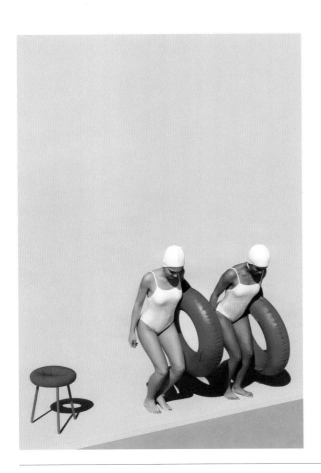

Facing page, top left
Massenat chair for Drucker
Image by Yosuke Owashi

Facing page, top right
Yamanami YC1 chair for
Takumi Kohgei
Image by Yosuke Owashi

Facing page, bottom
Playscape interactive
exhibition

This page, top
Uki Hashi chopsticks for h
concept
Image by Yosuke Owashi

This page, bottom
Donut stool for Diabla

Hitoshi Makino

When I was a kid, I used to read art and design books in the public library, and I'd do a lot of sketches at home. I enjoyed painting and building scale models, and I feel I was already looking at a career as a designer or architect. My parents didn't know much about art and design, but they were very supportive.

I studied industrial design at Salesian Polytechnic in Tokyo when I finished junior high school — I wanted to start learning about art and design to get to work as soon as possible. I was there for five years, and it was really useful for me. I think studying design at school or university is quite important, but we still have to find our own way through experiences in the field.

After being an in-house designer at a Japanese office furniture company, I moved to Milan in 2005. I worked with Lissoni Associati as a senior designer doing furniture design for Italian brands, interior design for hotels, shops, restaurants and villas, and various property projects. I had a great experience there, and learnt a lot of important ideas about interior design and furniture design from Piero Lissoni.

The main challenge for me now is to build a stable income and deal with labour costs. I'm based in Tokyo, but I often travel to Milan and other parts of Europe for meetings and to check prototypes. The financial and time costs are high, but I learn about different countries and cultures on every trip. It's very useful for finding unique ideas and solutions. When

I collaborate with European brands, I find that they respect designers' original plans, communicate well and create amazing solutions to realize new products, though sometimes we need to spend a lot of time together at the beginning of the project.

My studio specializes in furniture design, interior design and interior art objects. I'd like people to see my work as an alternative solution between traditional and modern lifestyles, and as having a unique style influenced by different cultures.

I use materials such as solid wood, plywood, iron, aluminium, glass and ceramics. I always make new discoveries and have had great experiences exploring the possibilities of materials with highly skilled craftspeople, and creating something beautiful together. A dream would be composing a private space, including all the furniture, objects and art.

We all have our own history and culture, and I believe we unknowingly design based on that. I respect the great works of our predecessors, and I believe that respect for the past, regions and cultures can lead to new creations. Japanese artists and designers I count as inspirations include Tadao Ando, Takashi Sugimoto of Super Potato, Kenzō Tange, Shiro Kuramata, Noriyoshi Ohrai and Isamu Noguchi. I think our unique wooden construction technology that persists for hundreds of years is a representative design, with unique spatial compositions and small objects born from our concept of lifestyle and interior space.

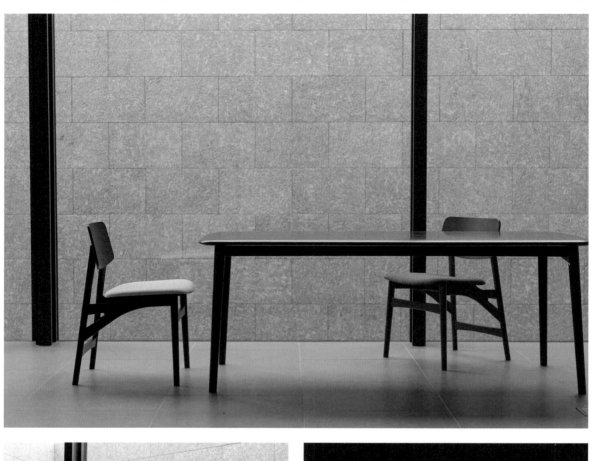

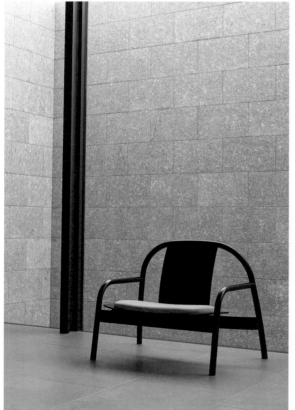

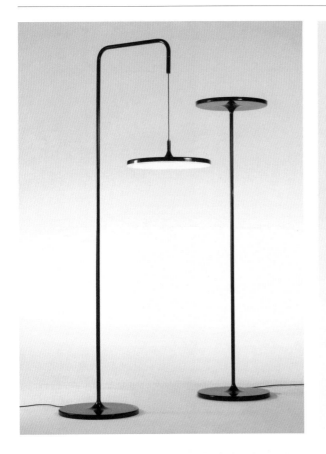

Facing page, top
RECO dining chair and table
for USCITA
Image by Yusuke Kawagoe

Facing page, bottom left
ARC chair for USCITA
Image by Yusuke Kawagoe

Facing page, bottom right
WA chandelier
Image by Yusuke Kawagoe

This page, top
YO-YO lamps for Roche
Bobois

This page, bottom
RECO bar chair and table for
USCITA

Naoya Matsuo

I wanted to be a designer from when I was around 15 years old, and my parents supported my choice. I went to an art university and a welding school in Tokyo as well as a woodworking school in London.

I think my choices were appropriate for what I wanted to do. There were no Japanese schools specializing in furniture design and making, and I needed to learn about design, welding and woodwork separately. I think what I learnt in each school was really useful.

Before I started my studio, I was an assistant in a design studio in London. I learnt a lot there, not only about creation but about how to work as an independent designer-maker.

At the moment, the main challenge is to get more desirable projects. Also, manufacturing costs are high in Japan, and it's difficult to find suppliers that can take a small order quantity. Normally, I design products spontaneously, not to order, and I

make the prototypes myself. The prototyping is more important than drawing for me, and I enjoy it more.

I generally work with wood, metal and plastic, and use commonly known techniques. I consider structures, assembly and how to make the objects precisely and cost-efficiently more than I consider appearances. This process is the most enjoyable part for me. I want people to understand that design is not a privilege, it's just a part of production. In future, I hope to design complete furniture series with chairs, sofas, tables, lights and so on.

I don't want to express my character or nationality in my designs, but I do want my works to be distinctive and show my taste. Similarly, keeping to traditions is not that important for me in my work, though I think in general it's really important. I'm not inspired by any person in particular, but by old, anonymous craftspeople. Looking at a more modern time, I think the *zaisu* floor chair is representative of Japanese design.

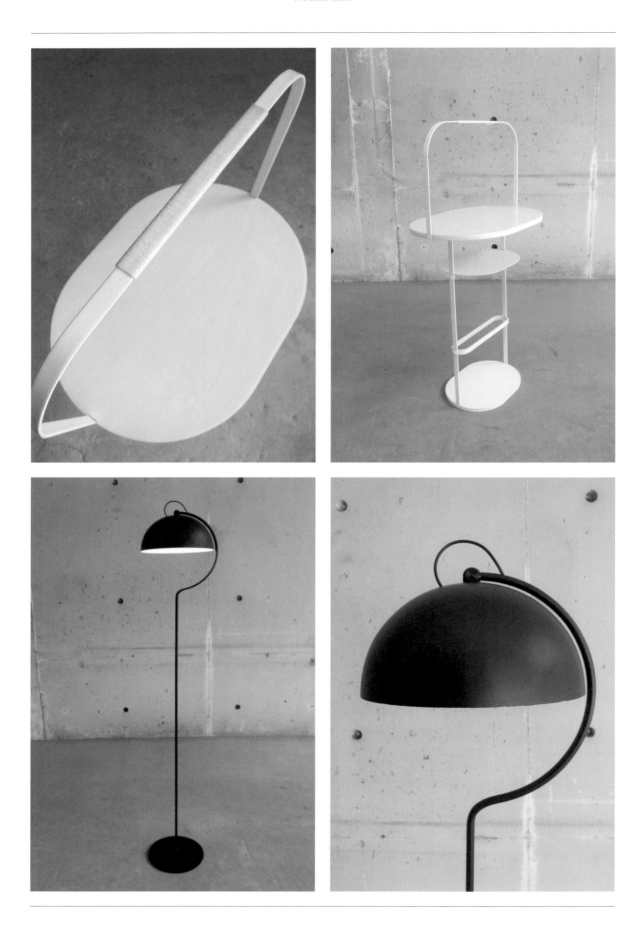

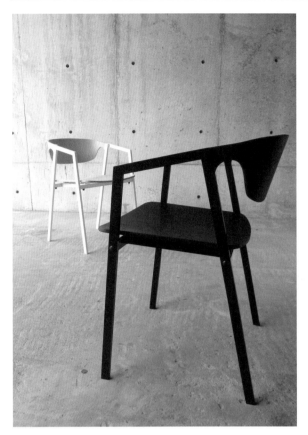

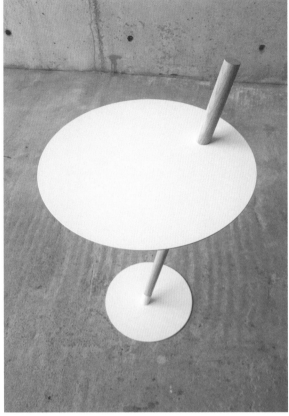

Facing page, top
PCNC side table

Facing page, bottom
Half Globe floor lamp

This page, top left
S.A.C. stacking armchair for
Woud

This page, top right
Tube & Rod side table

This page, bottom
Us6 umbrella stand

Jun Murakoshi

I decided to be a product designer when I was 16 years old and found that it was actually a job. Until then, I'd thought I'd be an architect. My family was happy with my decision.

I studied at Chiba University near Tokyo and the Royal College of Art in London. Many tutorials with the professors and tutors at the RCA made me think about who I was and how I wanted to be as a designer. I learnt professional skills and mindsets from classmates who already had working experience before coming to the RCA. These formed the basis of my ideas of 'design' and 'designer'. After university, I started out by doing some product designs for Takram.

For me, the challenges have been having enough time to design and getting my own workshop or large space in Tokyo. The advantages of being here are the increase in the number of foreigners coming in, and the number of still-unknown things and places in Japan. The government also helps — I've worked with small companies that ran projects with government funding.

Our studio designs products, art installations and visions of the future. I don't have specific design inspirations — I'm inspired by everyone and everything related to design, craft, art and literature. I've learnt ikebana and bonsai, for example. I also don't focus on any specific materials or techniques — I aim to start fresh every time. Any kind of project makes me excited. A dream project would simply be a project that I hadn't imagined until then.

I've collaborated with overseas brands. including MoMA, which saw some of my works at exhibitions in London and Milan and produced them as MoMA products.

I don't intentionally express my personality and nationality in my designs. If you feel them from my works, it's because I'm honest with myself when I'm designing. Expressing tradition depends on the product and project — I sometimes pay respect to tradition and sometimes am critical of an existing state and tradition. Overall, I hope people experiencing my work get an alternative perspective without really trying to think about it.

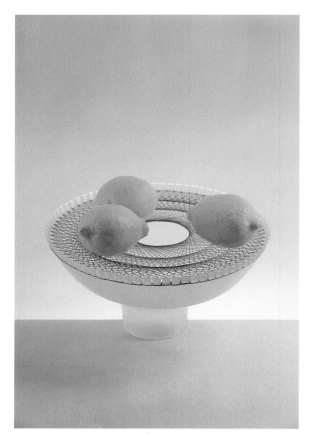

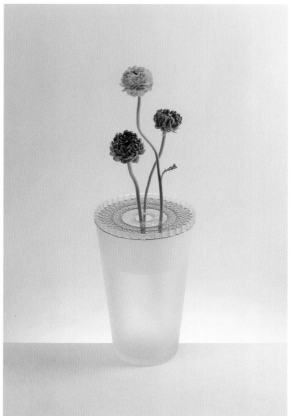

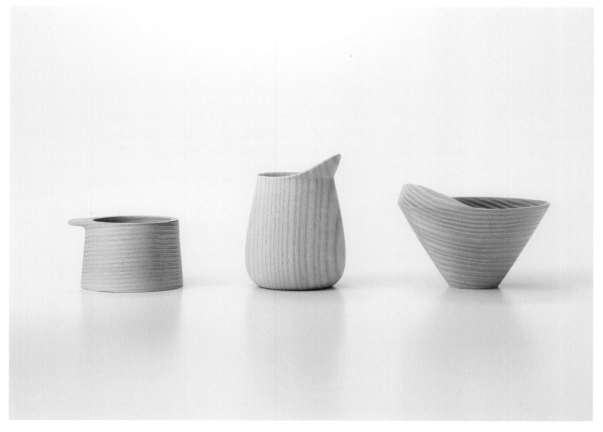

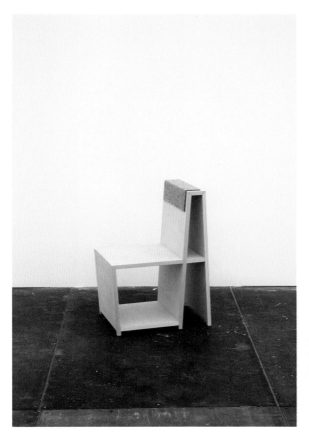

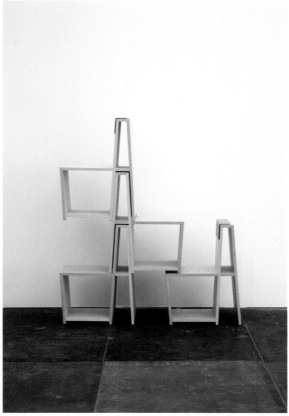

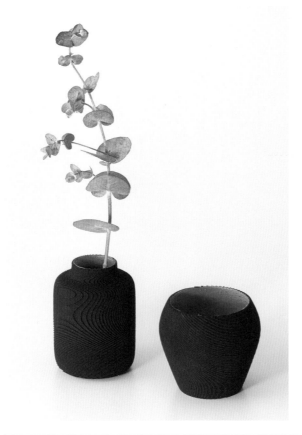

Facing page, top left
Bloom bowl
Image by Kota Sugawara

Facing page, top right
Bloom vase
Image by Kota Sugawara

Facing page, bottom
Appendix tableware

This page, top
Shelving chairs

This page, bottom
SO pots
Image by Yusuke Tatsumi

Junpei & Iori Tamaki

We didn't both start out wanting to be designers. For Junpei it began during high school, but Iori didn't study design — her interest started when we were married. Junpei studied design at Tama Art University before working in a design company. Iori majored in foreign languages and literatures at National Taiwan University, then went to Japan and graduated from the Graduate School of System Design and Management at Keio University before learning art direction at an advertising agency.

Junpei learnt how to build and sustain a passion for designing, which is crucial for a designer, and still draws on what his professors taught him. For Iori, the opportunities to communicate with English speakers as well as people from European brands have been useful.

We focus on designing for overseas furniture brands such as Cappellini, Living Divani, Ligne Roset and MUNK collective. In Japan, we also do product design for companies like Panasonic, and we design residential homes, stores and exhibition booths in Japan and Taiwan.

Our business is currently quite good, with collaborations with great clients and brands, but we do have targets we hope to achieve in the near future. One is to showcase several pieces of furniture from multiple brands at a design fair. Though we've been collaborating with a few furniture brands for some years now, we've yet to show with a few of them at the same fair. We think that's important for our future.

As we're based in both Japan and Taiwan, we find each country has its own challenges and advantages. For furniture designs, we don't have many collaborations with Japanese manufacturers — our work in Japan is mainly on spatial design, so the lack of collaborative opportunities is a challenge for us.

In Taiwan, we only do spatial design for residential homes and commercial stores, not furniture design. But there are many business opportunities available, as most Taiwanese tend to engage designers rather than contractors for their new homes and stores. This is a major advantage compared with Japan.

The opportunity to collaborate with those international brands came about at Salone Satellite in Milan. It seems there are only two options for Asian designers to work with brands like these: either seize the opportunity at Salone Satellite or be mentored by top designers who have worked with multiple brands. Without any mentorship, we decided to both launch our own brand and attend Salone Satellite at the same time to showcase our designs. We were fortunate that directors from various international brands came to visit our booth, which allowed us to secure collaborations with Cappellini, Living Divani and MUNK Collective. The awards we won in Japan for these collaborations also helped get us an opportunity to present to Ligne Roset. So, the success we had at Salone Satellite really helped create many business opportunities.

We enjoy using different materials to create different shapes and styles that come with new functions and appeal. Hopefully, people feel that our designs provide comfort and happiness. It would be great if we could consolidate our designs and hold solo exhibitions in different countries around the world, but we need to come up with more designs before we can do that.

For us, it's not mandatory to express our personalities or nationalities in our designs — it depends on the object. It's the same with traditions. When designing something for a certain region, some clients may actually request for local traditions to be excluded from the design.

As for Japanese inspirations, Shiro Kuramata continues to be one, and there are also many representative Japanese design objects. From past decades, the standout would have to be the Butterfly stool by Sori Yanagi, and more recently the Hiroshima armchair by Naoto Fukasawa.

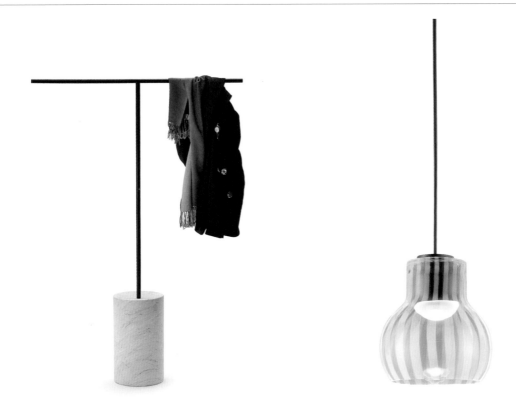

Facing page, top left
Tonbo coat stand for Living Divani

Facing page, top right
Milky Glass pendant for Panasonic and Hirota Glass

Facing page, bottom
Flicker cabinet for MUNK collective

This page, top
Rivulet chair for Living Divani

This page, bottom
Flower shelf for Cappellini

Shizuka Tatsuno

I decided I wanted to become a designer when I was 14, and my family was supportive. I studied at Kingston University in London, majoring in product and furniture design. As a foreign student, it was exciting to see the differences in cultures and design ideas. The workshops were very enriching, and the hands-on experience of creating products in the studio is still helpful in my work today.

For me, as most of my time is spent on client projects, the main challenge is that I'm unable to find time for my own creations. And even though I'd like to take on some overseas projects, I don't have the chance due to my current load of local projects. As my studio develops, I hope to be able to better control my schedule and expenses, and find better balance in my work.

Particularly in Japan, I think the challenges are high labour and manufacturing costs compared to other countries. But the advantages are the robust environment for creating different types of products, including handicrafts, and that most factories are able to deliver high-quality products on time. Government support is available too — I've received subsidies for regional work related to traditional handicrafts.

My studio mainly works in product design and graphic design affiliated to the products. Our strength is in product planning and branding. I want people who experience our design to understand the appeal of those design objects, including the materials, technology, history and production background. I enjoy capitalizing on the potential of our chosen materials and technologies to create attractive designs. It's the dream of every creator to have their creations adored by someone.

I'd also love to work with foreign manufacturers and to design a spectacular installation somewhere. I've worked with textile designer Rika Kawato to design the Kumihana range of table accessories for Royal Copenhagen, and I want to continue to do those types of collaborations.

To me, design is about a product made with the right materials and at the right place. Japanese confectionery is an object that I think represents our design culture. As for expressing my own personality and nationality, they can be integrated in suitable projects, but I exclude them if they're not needed. Similarly, most of our projects are related to regional traditions, but some aren't, so we don't work to traditions in those. For those that are related to tradition, though, I think it's important to have a good understanding of these aspects and integrate their merits. I think the Japanese person who has inspired me the most would be Sen no Rikyū.

Previous page
Image by Hisao Hashinoki

Facing page, top left
Hydrangea water vessel for
Korai and HULS
Image by Masaki Ogawa

Facing page, top right
Ren mobile for Korai and
HULS
Image by Masaki Ogawa

Facing page, bottom left
Tamari plates for Korai and
HULS
Image by Masaki Ogawa

Facing page, bottom right
Ryu Kyu Iro glass jewellery
Image by LALAFilms

This page, top
Tea set and Kasane bamboo
basket for Korai and HULS
Image by Masaki Ogawa

This page, bottom
hoki_hera shoe horn for Leif.
designpark
Image by Shin Inaba

Gen Suzuki

I've loved to draw and create things since I was young, but I only started working towards being a designer when I was around 16 years old. My mother, who teaches the art of colours at a university, was supportive from the start but my father, a researcher in fisheries, objected. Maybe he thought I was going to be an artist. He told me he could introduce me to his signboard-making friends if I ever had problems with my work.

I studied industrial design at the Kanazawa College of Art. It's a school that emphasizes an old-fashioned hands-on approach of designing in the workshop. After that, I worked for a while before going overseas to study product design at the Royal College of Art in London.

The basic principles of design that I learnt in my first degree were practical and very useful in my work, and the time spent at RCA was very special — I was able to connect with my deepest inner thoughts through my creations. Even though it wasn't the kind of learning that I could apply right away, the experience and knowledge that I gained over those years have been major influences on my designs today.

I worked part-time at Sam Hecht's Industrial Facility and at Barber & Osgerby while I was studying at the RCA, then at IDEO's studios in London and Boston after graduation. I've always wanted a mentor, but was unable to find a chance to understudy a particular person. Though when it comes to Japanese designers, I do consider Sōetsu Yanagi and Issey Miyake inspirations.

As a designer, I find it a challenge to spend enough time focusing on one particular design, but I think there are advantages to being based in Japan. It's a country with a long-standing culture of respect for craftspeople, and there are many highly skilled craftspeople who will always deliver their best work with a high aesthetic quality. I think it's an advantage for designers based here to work alongside these professionals.

Our studio designs items like homeware, furniture and appliances for local, regional and international customers. We also work with people from different industries and countries, from local factories to major corporations and from start-ups to renowned brands. I've spent half of my design career abroad, and now about half of my clients are from overseas.

I'm glad if our customers are comfortable with using our beautifully made gadgets and tools every day. For me, projects that capture the essence of simplicity, such as a beautiful chair created with an artisan and a few others in a small workshop, are like a dream.

Even though every material has its own features and elegance, we don't regularly use a specific material in our designs. It's fun to brainstorm and learn new ways to leverage and integrate different elements during the design phase.

I don't try to express my personality in every design, as I'd rather find the most natural style for my target design subjects. But my design habits do come out even if I try to exclude certain aspects. I think integrating the right amount of personality into a design makes it turn out well. Similarly, even though locality and traditions are important to me, I don't express them intentionally in every design. I do think it would be marvellous if they could be integrated consistently to deliver the best outcome; I also feel that activities related to traditional arts must be preserved and passed on to future generations.

I think if I had to choose a design to represent Japan, it may be shoji. Light that enters a room through the paper creates a flat, calm space without any contrast between light and shade. I think it's very Japanese.

Facing page
Oblique vases for E&Y

This page, top left
HT-B223 toothbrush for
Omron

This page, top right
Chocolate peanut serving
ware for 21_21 Design Sight
exhibition

This page, bottom
Table bell for Timbre

Shunya Hattori & Hiroki Nasu, Bouillon

We both decided to become designers during our university days, and our families were supportive of our decisions. We studied at the Nagoya University of Arts, and learnt about communication skills that are necessary for designers.

We learnt about architectural design and furniture making through hands-on experience when working in local design companies, after which we started Bouillon. So, we only started learning about the technical aspects while working in the industry, but we feel we've been able to catch up. Major challenges for us include developing skills and capabilities that attract the attention and recognition of major companies and factories, as well as communicating in English.

We focus on product and furniture design, and interior design for retail spaces. Hopefully, people can experience a new awareness of materials through our work. We have a deep interest in different materials, as each one has its own unique features.

In the future, we'd like to design more high-quality gadgets and furniture that become part of peoples' lives, and appeal to the masses instead of a fixed target audience. We're currently working towards exhibiting at events like international trade fairs.

Even though we don't pay much attention to things like nationality, we think our designs have a natural and Japanese style. Tradition is very important to us.

Inspirational Japanese designers to us would be Kenya Hara, since we think MUJI is very representative of Japanese design, Naoto Fukasawa and Kenzō Tange.

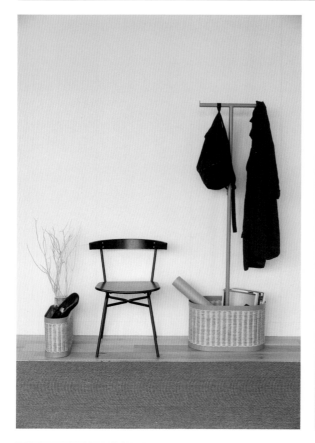

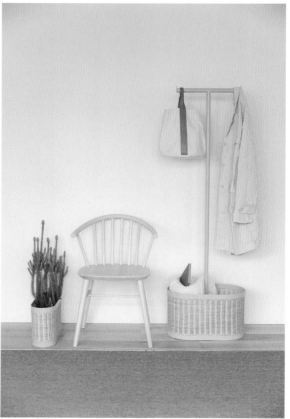

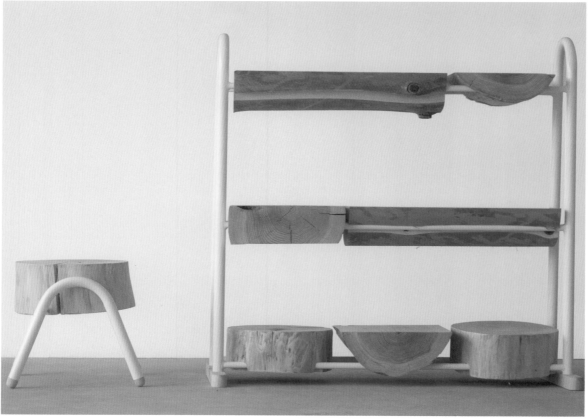

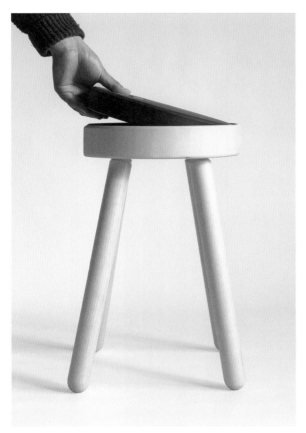

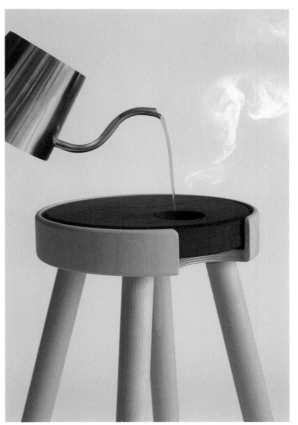

Facing page, top
Garniture collection

Facing page, bottom
Extra stool and shelf

This page, top
Warm stool

This page, bottom
Baton chair

Sanghyeok Lee

When I was younger, I wanted to be a bus driver. I didn't like the unkind bus drivers in my hometown at all. Although I chose to be a designer-artist, I like to think the way I make a difference to people is the same.

The moment I decided to go abroad to Europe was my moment of truth. It seemed like all the books I'd read before were there. And I still don't know yet whether my chosen career was the right one. You don't really know until you do it. I studied at Design Academy Eindhoven, and learnt how to solve problems myself. I think that was the main point of my education. Before I entered the school, conceptual Dutch design was really hot in the design field. I was kind of curious about what it was, and that's what I was expecting to learn. But what I actually learnt was how to start and finish a project myself, to finish what you've started. That's still something I have to get through on every project.

I interned at Piet Hein Eek. It was similar to what I did at school, but on a bigger scale and in the context of clients, markets and business. A few projects I worked on are still on the market, so I'm proud of that. Those experiences weren't really helpful for starting my own studio, because the business was already established. But the processes I went through have been truly inspiring.

Settling down was the biggest challenge for me. I started my own studio in a shared office with a few other designer-artists. It was a great start, but to do things properly I definitely need my own quiet place, my own racks of tools and materials, and so on. To get that takes patience, which is another big challenge. I think running my own studio means continually facing the 'biggest challenge'.

My inspiration is based on lived experiences and the architectural sources of the given surroundings, creating a scene for a dialogue between intangible body and rational practice. I conduct research on connecting materials, find harmony in forms, create relationships between function and surroundings, and appreciate the atmosphere of spaces — these are the values of my design-art approach.

I hope people imagine or experience what I've imagined through my working process. For example, if you step inside a building by a great architect, you're guided by that architect's imagination. You can fully experience what they want you to. I want people to imagine or experience something like that — I'd call myself a domestic architect. My dream project would be to create a space full of my own projects. Space and objects are always related to my way of thinking. My ideal space and my projects, whether failures or successes, would create a dialogue with each other.

I work with various ideas and concepts, so my choice of materials depends on the project. Expressing my own personality or nationality doesn't matter at all to me. Preserving tradition depends on the project, but it's not my main goal. I think traditions are also evolving or at least being changed by us. Keeping traditions isn't the question of the 21st century — it's more like how to adapt or share them.

Graphic designers in Korea are inspiring to me. The quality and amount of work I'd say is already at an international level. I like the idea of quality with speed. That inspires me a lot. I'm also a fan of the afterimage series by Choi Byung Hoon. He has an established concept and portfolio, and I appreciate the work he's put in. It's not so much about country or cultural context — it's just very strong and contemporary.

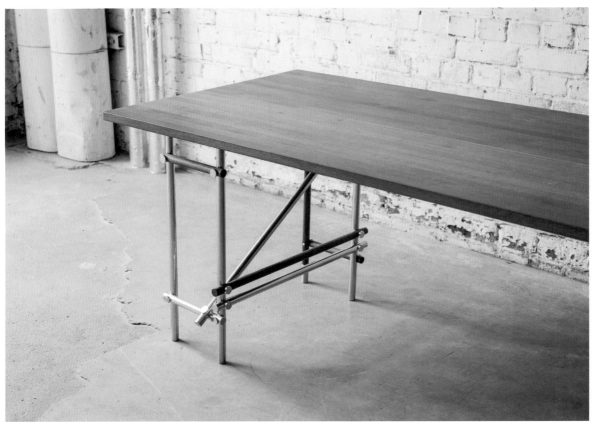

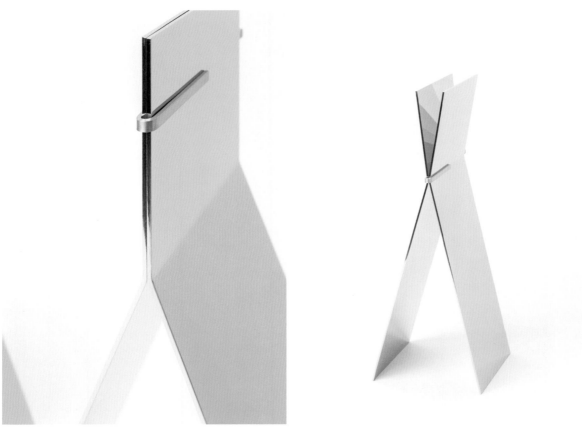

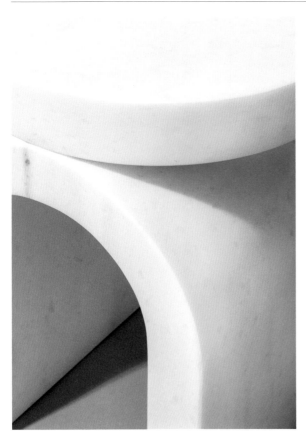

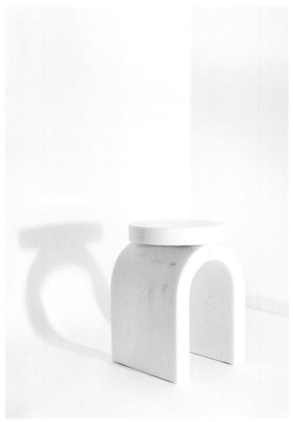

Previous page
Image by Dale Grant

Facing page, top
Useful dining table
Image by Ana Santl

Facing page, bottom
I'll Be Your Mirror
Images by Dahahm Choi

This page
Domestic Architecture
Images by Dahahm Choi

Ryosuke Fukusada

I was pretty good at drawing and creating things when I was young, so I wanted to study product design at university and be a designer. My family helped me make the decision.

I studied at the Kanazawa College of Art and then Domus Academy in Milan. What I learnt at KCA is relevant to my current job, particularly for design reviews based on the manual creation of physical models. At Domus Academy, I did an interior design course to study spatial design. That experience has really helped me with spatial visualization for designing furniture and lighting.

I was mentored by Patricia Urquiola before I started my studio. Her studio had various projects involving furniture, lighting, toiletries, tableware and so on for famous Italian manufacturers. I led projects in Japan, and went on business trips to Japan with her. These experiences have become an integral part of my work — the methods of creating shapes and selecting colours, for example, are different from what I learnt in Japan.

We're currently working on a couple of projects in Europe, and I feel that travelling distance, time and cost, as well as the lack of frequent communication, are some of the challenges. Even though communication is done mainly through email and phone, I think it's necessary to set up a base in Europe to have more direct conversations and expand the business. Another challenge of working in Japan is meeting the requirement of creating products based on strict quality management policies of clients and the market. Even though there are times when designers feel that some specifications are beyond what's necessary, they still need to invest long hours to meet these requirements. There are also times when certain design aspects like appearance and structure have to be compromised for quality standards.

But there are advantages. Apart from furniture and lighting, there are many companies in Japan that manufacture industrial products such as electrical appliances on a large scale. As many design companies are also engaged by these manufacturers to handle their product designs, major projects with good budgets are available.

In Japan, our studio designs products like furniture, kitchen appliances, stationery and sunglasses. We also design installations and exhibition spaces. Overseas, we have some ongoing design projects. I've collaborated with Italy's Bonaldo since I started my studio. We meet several times each year despite the long distance between us. Alberto Bonaldo is very responsive and has a clear vision for the furniture business.

Under his supervision, we've been able to commercialize several product designs into furniture. In 2017, I collaborated with Italian lighting firm Axolight, and in 2018, I started collaborating with Denmark's PLEASE WAIT TO BE SEATED.

Our process is to create physical models to check the structure of our designs. I prefer and enjoy the process of creating things manually using materials such as paper, boxes and foam, or making prototypes using wood that we cut on our own, rather than using computer simulations.

I hope users can appreciate the value and appeal of our works, and that the works can enrich their lives in one way or another. We also strive to provide new global values and cultural aspects that can transcend national borders.

As for a dream project, I still work with a Portuguese former colleague, Rui Pereira, from Patricia Urquiola's company. We're discussing the possibility of holding an event in 2043 that bridges designs from both Japan and Portugal to commemorate when the Portuguese first visited Japan in 1543. I'd also like to be involved in a cross-design project between Japan and Italy in a similar way.

My stance is that the expression of personality and nationality is not necessary, as our utmost priority is to provide designs that appeal to clients and these elements should appear naturally. However, some overseas clients do expect us to include such things in our designs. In these cases, I create designs with my iteration of Japanese style.

I think that tradition is an important aspect, and projects won't work without attention paid to it. Traditions are linked with the client's technology, past experience and the surrounding environment. I really treasure them, as they can facilitate creation and project operations. If I could choose a culturally Japanese design object, I think the low chair designed by Taisaku Chou for Tendo Mokko reflects our culture of sitting on the floor. This habit persists even in the presence of Western furniture, as Japanese still feel close to the tatami. The low seat chair stands out from other similar products, with this iconic habit also reflected in the design. The fact that the same product continues to sell today since its launch in 1960 best captures the cultural aspect.

As for influential Japanese designers, Sori Yanagi once came to my university to give a lecture. His ideologies were very popular throughout the university, and I learnt about the manual design method for the first time. I still live by his ideologies today.

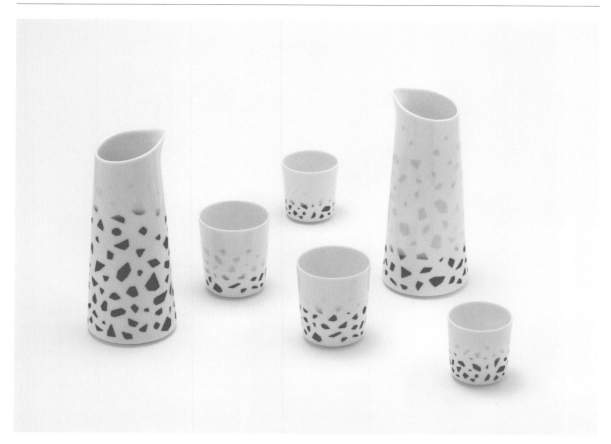

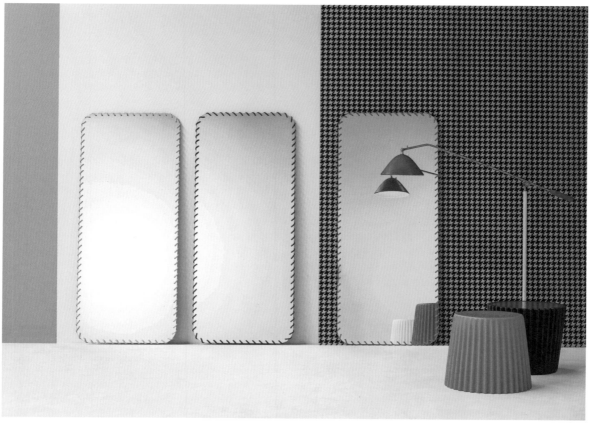

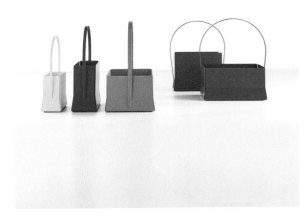

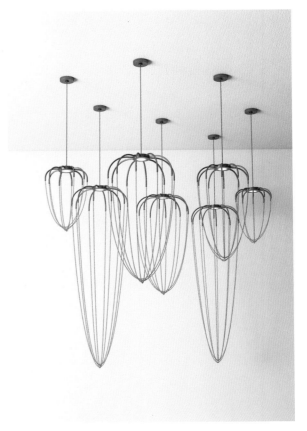

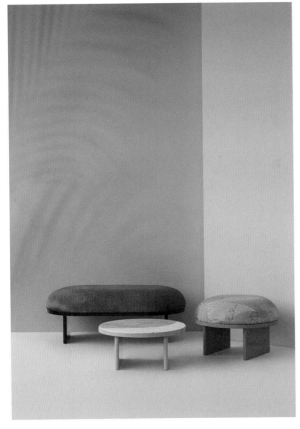

Facing page, top
Ukiiro porcelain ware

Facing page, bottom
Spiral mirror for Bonaldo

This page, top left
Magazine Bag series for
Bonaldo

This page, top right
Alysoid pendants for
Axolight

This page, bottom
Anza collection with Rui
Pereira for PLEASE WAIT to
be SEATED

Shigeki Yamamoto

I studied interior design at the Osaka Sogo College of Design. When I worked on my graduation project, I became interested in metal as a material and became fascinated not only by design but also by creating the furniture myself. After that, I began my career as a furniture designer who crafts their furniture by hand. My family started to support me after I did my first exhibition — they realized that I was serious about what I was doing.

I started to work as an assistant to a contemporary artist after graduating university because I wanted to learn how to create objects. He works with metal, so I learnt alongside him. After that, I became interested in other materials and other countries. I'd been fascinated by Dutch design since I travelled in Holland as a student, so I searched for exchange programmes in Europe and found one between Japan and Germany. Through that, I trained as a carpenter in Germany and started working at a studio in Berlin that works with scrap wood. They do all parts of the production process in their studio, and I wanted to work with them because I really liked their philosophy.

For me, the main challenge of being independent is to stay healthy. When I can't work, neither can the studio. On the other hand, I think the advantage of being based in Europe is that the market for contemporary design here and in the US is bigger than in Japan, so there are more opportunities.

I do all my design, production and promotion from my studio. The concept of my work is memory, and the forms of my furniture are based on my own memories. I hope my pieces evoke good memories in the people who see them. My favourite materials are wood and metal because I can work them easily by myself, whereas glass, for example, would be difficult. For me, it's very important to be able to work by myself. A dream would be to create huge objects in architecture and sculpture.

I believe my personality should be expressed in my work. Nationality isn't necessary, but people do often tell me that my work has a kind of Japanese sensibility. Even so, at the moment tradition is not important for me. Japanese tradition means to keep traditional techniques and designs exactly the same as they were a long time ago. Those traditions haven't changed at all, and don't have to change, but I work based on the idea that things have to change because of changing times. Japanese architecture and objects made of local materials have all been inspirations for me in some way, because they contain and represent the essence of Japan, like a thatched roof and mud wall.

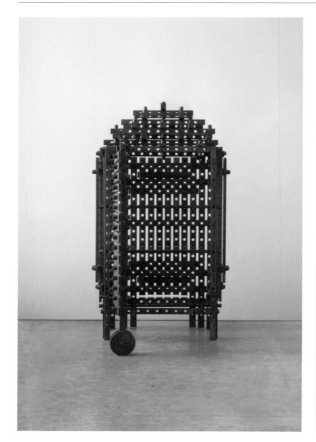

Facing page, top
Play cabinet

Facing page, bottom
Play cupboard

This page
Chalk Cactus room divider

Xrimi Li

I majored in product design at the China Academy of Art, then did postgraduate study in furniture design at Italy's Politecnico di Milano. Furniture design is a very inclusive discipline, with good potential for future development. It's different from product design, which is restrictive, and incorporates fields like fashion, art and culture.

My study has been useful directly and indirectly. The first lesson at the CAA required sharpening a hammer using only files and with a tiny error tolerance, which took a month, honing my skills and stiffening my resolve. At the Politecnico, we practised negotiation skills, and I learnt semiotics, and to examine how things work and how they subtly relate to each other. These are extremely beneficial not only in design but also as a way of thinking.

I had three jobs before establishing my studio. The first was with Andrea Branzi, a founder of the Memphis Group. He developed his own theory on the relationship between design, art and nature. His studio is also his home, and I'd have lunch there and chat with him to get a first-hand look at a master's life and work. He's very passionate, and still creates new pieces. He's my lifelong role model. My second experience was with Luca Trazzi. He learnt from Aldo Rossi, who later became his business partner. When Rossi passed away, Luca took over many of his unfinished projects. The X1 coffee machine he designed for Illy became a classic — an example of how to use colour and curves effectively — and many people still buy it.

My third experience was working as chief product designer for six years at Neri&Hu. I gained a great deal of experience, mainly through furniture design projects for top European brands, and that laid a good foundation for establishing my own studio. I agree with the 10,000-hour rule: your understanding, skills and experience will be much greater after 10,000 hours of work.

For me, the challenges are survival and the fulfilment of my dreams. Independent design is an emerging industry in China. Enterprises willing to pay for independent designers are starting to appear, but independent designers still lack choice and freedom in the sense of having a broad range of clients to choose from. It'll be some years before the market fully embraces fresh design ideas. In the meantime, we need to be patient and innovative at the same time.

A business challenge is controlling product quality. Our furniture brand URBANCRAFT works with about ten factories, each with strengths and weaknesses. Not one can make our products perfectly because of our diverse range of materials. And hiring people with experience in international standards of quality control isn't easy. But there are advantages. The power and desire to purchase designed products are strong, with people born in the 1980s and 1990s now comprising the major consumer group, wanting good design. And more and more, you can see European designers coming to work in China.

Our work is divided into two areas. One is Ximi Li Design Studio, designing furniture and lamps as well as doing some spatial work. The other is URBANCRAFT, which is stocked across China and Hong Kong.

I think a designer is a messenger, using multiple methods to communicate. For example, a chair can send cultural, artistic and creative messages. However, each recipient may understand these messages differently, with a varying degree of feeling or different feelings altogether. It's interesting that people interpret my work differently. If they happen to understand what I tried to express, that's great.

The materials I choose are natural, like metal, wood and stone. They've long existed, giving a sense of timelessness. I won't rule out using other materials though, because each has unique features and feelings in regard to appearance and usability. A dream would be to design a small building that allows me to express my ideas freely. Architectural design requires broader thinking, and that transition is fascinating to me.

Expressing personality happens naturally because design is the external expression of thought. Many people say they can see the same characteristics in me and in my design works. But the design style I'm currently working in is just temporary — I'd like to be more cutting-edge. As for expressing nationality, I think Chinese designers carry a heavy burden because of our ancestors' production of excellent designs hundreds of years ago. Our generation is in a hurry to express ourselves and seek our roots, but we're not yet capable of doing so. The gulf in cultural continuity hasn't been closed, so Chinese designers are seeking answers and their means of expression.

My design idol is IM Pei. He was a true master. His standard of design, his mind and temperament, as well his sense of national identity, are admirable. He employed simple geometric shapes to create architecturally and culturally impressive work. That requires a sense of harmony and the realization of absolute talent. His buildings give you a wonderful feeling.

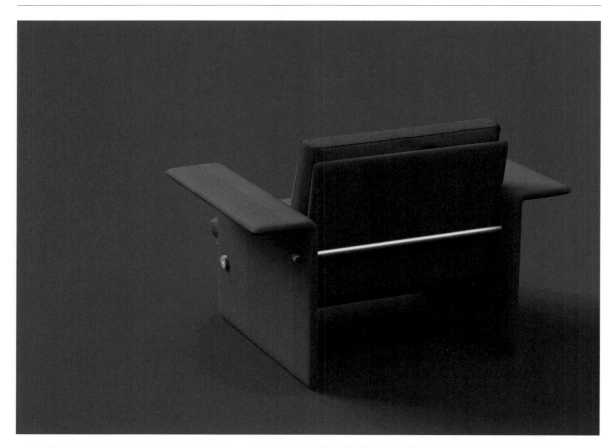

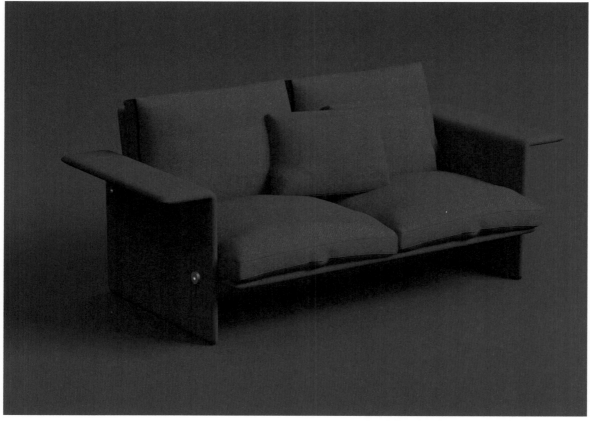

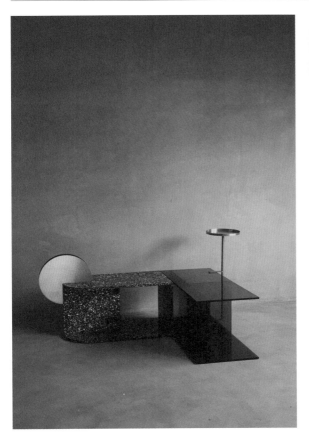

Facing page
Tang sofas

This page, top left
Glass and terrazzo tables
from the BY3 collection

This page, top right
Detail of the terrazzo table
from the BY3 collection

This page, bottom
Clothes rack from the Yuan
collection

Zhipeng Tan, Mán-mán Design

When I was working on my final-year project at university, I visited a copper factory by chance and saw the copper casting process. Hot, molten copper was poured into a mould and given a shape. This visual image had a very strong impact on me, and that was the beginning of my design journey.

My family was very supportive of my decision. From a young age, I've always been a relatively assertive person, and I like to share my thoughts with them. So, when I told them about the work I loved, they were very happy for me.

I studied at the China Academy of Art. I think what I learnt was very useful. We acquired the design mindset in a systematic way, and I'm very passionate about hands-on creation. All of this has had a big influence on my career.

Rather than work for anyone else, I established my own studio after graduating from university and started creating my own designs. I find it very enjoyable — it makes me happy. And I haven't faced any major operational challenges yet. Perhaps I'm lucky. But there are other hurdles. China is developing rapidly, and the best global brands have an active presence here. As a new brand, we're facing several challenges, like how to compete with international brands and how to maintain high quality and continuous innovation. One advantage is that China has the largest consumer market in Asia — and in the world, for that matter. We have high expectations for the market and for our brand. There is some government support available — I haven't used any, but my studio partner Daishi Luo received support from the China National Arts Fund in 2017. The fund is administered by the Ministry of Culture to support young designers and artists.

Daishi and I opened Mán-mán Design in 2015. Our strength lies in discovering material properties. We use material-creation thinking to explore the boundaries between design and art, and the relationship between materials, nature and humans. In recent years, we did a series of explorations mainly based on copper. I specialize in lost-wax casting, while Daishi focuses on copper colouring art research. We experiment with the shapes and colours of copper from a physical and chemical perspective. Our works are created both independently and as a team, using integrated design, and we explore various possibilities of material through continuous experimentation and application.

Our works have been exhibited in various leading exhibitions, art galleries and institutions all over the world, such as Design Miami/ Basel, Collective Design, Salon Art + Design and Design Shanghai. We were recognized by the China National Arts Fund in 2017, and our works have been collected by several art galleries and individual collectors. I've also held exhibitions with 1stdibs and Kips Bay Decorator Show House.

There's an old saying in China about learning from nature. Mother Nature is my main source of inspiration. I'm awed by nature and its beautiful creatures, all of which continue to inspire me. My wish is for people to experience the aliveness of my creations, and not to see them as standard houseware.

If I could do any project, I'd like to do a set of scenic sculptures. Not the same old thing that's been done before, but truly interactive sculptures that form a bridge between humans and nature. In our rapidly developing society, technology allows us to keep moving forward, but we should never forget that all the beautiful animals and plants on Earth are our companions.

As for expressing my personality and nationality, I focus more on whether my thoughts and feelings can be expressed through my work. Nationality has little to do with design. A good piece of design should be able to resonate with people and provoke discussion. Similarly, tradition is not important to me, because I use whatever techniques and craft methods are needed to complete each piece of work, which are not necessarily related to tradition. But I hope traditional crafts can adapt to contemporary development in different ways, and achieve greater vitality. This is one thing I'm willing to work hard for.

As for an inspirational person, I'd say Daishi. She's not only my business partner, she's also my life partner. From her, I learn the meaning that creation gives to life: we choose this not only as our work but also as our way of life. We always discuss projects together, and our discussions always spark interesting ideas.

And when it comes to a design that symbolizes China, I'm yet to find one. I believe a country or culture is not defined or set. Rather, it's inclusive and allows us to express different ideas within it. We are an integral part of our culture, but maybe the part we play is only a fleeting moment.

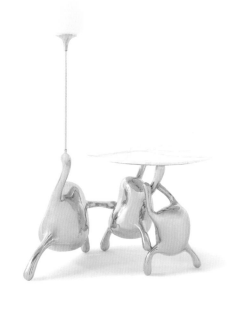

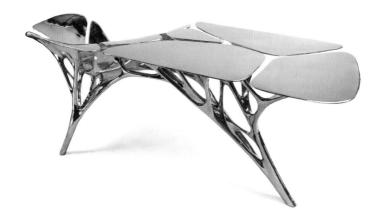

Facing page, top
Melting table

Facing page, bottom left
Walking vase designed with
Daishi Luo

Facing page, bottom right
TanTan side table with lamp

This page, top
33 Step bar chair

This page, bottom
Lotus telephone table

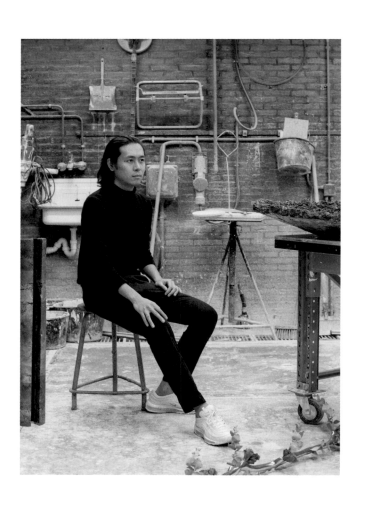

Hongjie Yang

When I was young, my family travelled frequently. Encountering different cultures and people, I was always attracted by new and exotic things, and they fostered my curiosity for objects, so design really spoke to me when I found out about it. Obviously, back then my understanding of the field was superficial, and so was my parents', but they supported my decision to pursue it as a career.

I did my schooling in China before moving to the US to study design at Columbus College of Art & Design, then I interned with Karim Rashid in New York City and saw the life and work of a designer up close. To develop my own practice, I eventually headed to the Netherlands for a master's in contextual design at Design Academy Eindhoven.

While studying in the US equipped me with design skills, it was in the Netherlands that I developed my own methods and approaches to design. School became a place for me to experiment and explore. It was a quest to define myself as I discovered my likes and dislikes, as well as what inspires me. It's a process that may never be complete. But it's important to me that I know what I stand for in my work. The design culture in the Netherlands has been particularly important on this journey of self-discovery. While design is a personal pursuit, the Dutch encourage and admire artists who express their personalities — even the radical ones.

Running an independent practice was new to me, and I had to learn everything from scratch. At first, I had many fantasies about being an independent designer. However, I've come to realize that in order to keep going I need to know more than just design. Of course, hard work is essential too. I still have a lot to learn.

My touchstones are to learn, think, design and communicate. Every day, I research a range of topics and collect all sorts of information. Although not everything makes sense at first, it provides new perspectives, insights and inspirations for my designs. The studio is also very focused on production, and

I'm involved in every single aspect, including coordinating and collaborating with other parties. Finally, when my works are ready, I seek out the best means to share them with the world.

My designs communicate through the common language of beauty, and express the multiplicity of perspectives that exist in the world. That could mean idealistic, pure or challenging. I don't limit myself in terms of exploring different materials or methods of crafting. I'm most happy when people admire the aesthetic of my works while also reflecting on them and asking questions. To me, the relationship between humanity and nature across time is the most important subject to explore, as it's constantly changing with the evolution of culture, technology and climate. My practice seeks to discover the relevant and urgent contexts in this relationship, not only to understand our past but also to build an ideal future. It's why I'm deeply interested in both fashion and architecture, as they're powerful tools for exploring humanity.

To me, design is a form of communication. The key to mutually intelligible communication is strict logical deduction while remaining personal. Personality is an important part of one's work, especially in the crowded field today. While I'm considered a Dutch designer in Europe, and categorized as a Chinese designer in China, I don't think of my design in terms of nationality. In any case, cultures and design philosophies are increasingly blended together in our globalized world. Even Dutch design has been influenced by other cultures in recent years. What I do think is important is that designers must reflect on what has come before them. The creation of new things involves a balancing act between traditions of the past and provocative suggestions for the future.

I learnt a lot from my tutors, particularly Maarten Baas and Formafantasma, who are very open towards design yet also rigorous. In terms of a design that reflects my cultural background, I'd say root-carving furniture reflects the Chinese aesthetic in following the laws of nature and the harmony between people and the world.

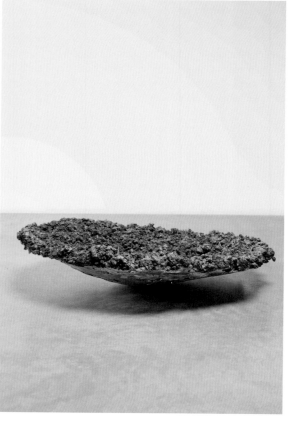

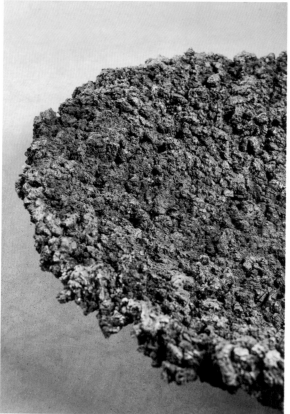

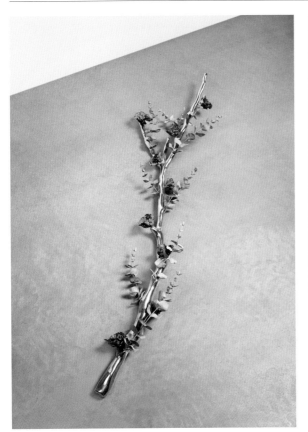

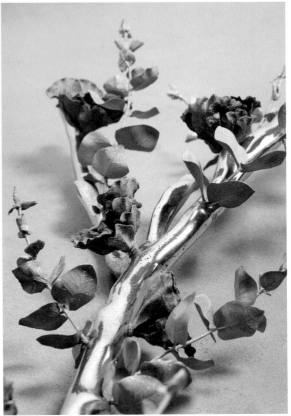

Facing page, top
Vessel from the Radical
Fossils series

Facing page, bottom
Bowl from the Radical Fossils
series

This page
Twig from the Metallic
Transformation series

Mario Tsai

I started out in 2011, designing furniture at a factory in Beijing. My family didn't know much about the design industry, but they agreed that I made the right choice. I studied furniture design and manufacturing at Beijing Forestry University, but there were many skills I had to learn on the job. My degree was in wood science and engineering, not art, so what I learnt about manufacturing, production processes and materials, for example, was very helpful.

I worked there for two years, then my younger brother and I opened a store in Hangzhou, selling handmade crafts from India and Nepal. Shortly after, I became an independent designer. I think the main challenge was not having sufficient capital. Organizing exhibitions and creating products is expensive. The situation is improving, but we'll be investing more. And although China has a huge design industry, designers and manufacturers approach design from very different perspectives, which is the source of much conflict in the market. But designers who work with corporations' needs can do well.

We're a research-oriented studio whose core function is to explore the potential attributes of materials and new production methods while adhering to sustainable design principles. We're not limited to product design — we work on furniture, industrial products, art installations and interiors. We also consult on brand strategy and art direction. So far, we've provided design and branding consultation for customers in China, Italy, Denmark and Norway.

We've connected with different brands through Greenhouse, a young designers' platform provided by the Stockholm Furniture & Light Fair. After exhibiting for three years, we gained the opportunity to work with ferm LIVING, Northern and Woud. Collaborating with them is a very smooth process, and has given us a good start in entering the European market.

I want my work to give people a sense of surprise, and for them to find my creations easy to understand, giving them a feeling of warmth. This is the kind of gentle minimalism I advocate. For me, material and technique are not deliberately chosen — they arise naturally as part of the creative process. With this approach, designers can form their own design language throughout their careers. I don't want to be limited by fixed ways of thinking or labels. My goal is to continually reach beyond my comfort zone to become a better designer.

I hope one day I can harness the power of design to mitigate pollution and smog. If we move factories to other countries, it merely passes on the problem. When we're faced with the problem on our home turf, we can work to resolve it by redesigning machines or manufacturing processes. This would truly be a remarkable thing to achieve.

I don't think it's necessary to express personality and nationality in my designs. I think trying to incorporate Chinese backgrounds in design is a false proposition, and I don't think a 'Chinese style' exists. In our cosmopolitan environment, I question the merit of deliberately protecting national identity and the so-called 'originality' of Chinese culture. The word 'protect' implies the concept is small and weak and needs protecting, and I don't think we can say we design in a 'Chinese style'. We live in China, and when we consider our daily environment, our design approach and the people we interact with, it's clear that we're already doing Chinese design. We're not creating a specific kind of style. Design is a spontaneous expression, not a deliberate act of predetermined creation. If we're aiming to preserve craft and cultural continuity, then keeping a sense of tradition in my design is important. But if certain elements don't fit with the project, we should abandon them rather than give them undue significance. So, our designs don't deliberately showcase Chinese culture, but some do incorporate it in an objective and rational way.

China's design industry is still relatively young, but there are many other designers who have influenced me in a big way, such as Konstantin Grcic, nendo and Formafantasma. When I first became a designer, Grcic was my favourite. He sees the whole industry from an industrial designer's point of view. Much of my own design language has been influenced by him. My second phase of inspiration came from nendo, when I was learning about studio and team operations. It wasn't their designs that influenced me, but their whole marketing and design approach. My third phase came from Formafantasma. Their approach is to integrate the materials perspective with the perspectives of culture and the current consciousness. This creates a more artistic result, similar to the exaggerated approach of fashion designers. I think people tend to focus too much on commercial design these days, and end up neglecting the true essence of design.

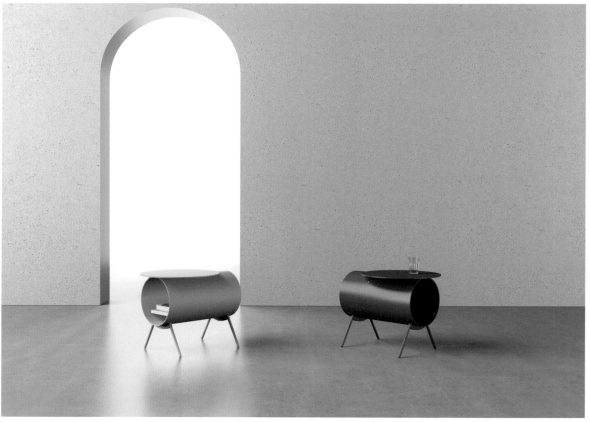

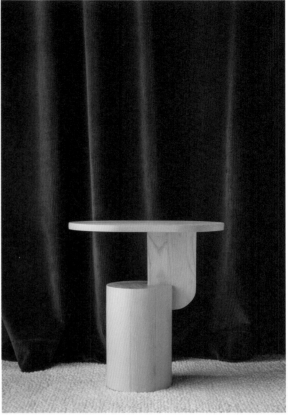

Facing page, top left
Lift floor lamp from the Lift lighting series for Mx object

Facing page, top right
Hold pendant for Mumoon (above); Candle from the Component series for Mx object (below)

Facing page, bottom
Pig table for Mx object

This page, top left
Flying Shelves designed with ferm LIVING

This page, top right
Insert side table designed with ferm LIVING

This page, bottom
Grid bench
Image by Chen Hua

Gunjan Gupta, Studio Wrap

I think I knew at age 12 that I wanted to be in product and interior design. My mother was very house-proud and would entertain a lot, and I enjoyed helping her arrange things in the house. My family has always been very supportive of my choice.

I did a master's degree in furniture design at Central Saint Martins. It was project-based, and my research topic was the lack of contemporary furniture design from India in contrast to its rich heritage of decorative arts over the past 300 years. It was a two-year journey that revealed many unknown facts about the state of craft in India and empowered me with a vision for the future.

I worked with interior designer Varsha Desai on luxury homes in Mumbai, including the home of Mr Mukesh Ambani, and got an insight into the world of bespoke furniture and customized interiors, where uniqueness was valued most and spaces were designed as statements.

Striking the balance between head and heart is the hardest sometimes for us, especially in the context of our commercial work. Also, design is centred in the West, and being in India can be quite isolating in that way. The image of India as a producer of cheap and cheerful handicrafts creates a bias as well. There is some state support — for example, an exhibition of Indian craft that I'm curating at the Grand Palais in Paris is being supported by the government.

Our studio undertakes a variety of projects in the space of interior design, customized furniture and product design. We have two brands: Gunjan Gupta Collectible Design and Ikkis, a new brand of functional and affordable products that we launched at MAISON&OBJET in January 2019. I've also collaborated with overseas brands, including Swarovski for their Wedding Project and Droog for the EXD Biennale in Amsterdam. Both experiences were amazing, as they helped me to think out of the box in a global context and put my work in the context of my favourite designers. They pushed me to think about India's cultural potential internationally, and made me push the issue of quality much harder. Our Bicycle Thrones emerged from the workshop that we did with Droog in Amsterdam.

I'd characterize my work as being about sharing the paradoxes of India in a playful manner. It's not about nostalgia but about the future of India. It's about beauty, but not the conventional vision of beauty that one associates with India. It's about contrasts and a play between old and new, and between street chic and royal decadence in the same breath. I don't have a standard materials palette, but some do figure a lot in my work, like stone, brass, copper, jute and raw wood.

For me, it's important to express my personality and nationality in my designs, and to keep traditions alive. I think a dream project would be to build a contemporary Indian craft and design museum in India. For a quintessentially Indian design object, I'd choose the lota water pot, which represents India at its best. As for inspirations, I love the work of architect BV Doshi, and have had the pleasure of spending time with him in Ahmedabad.

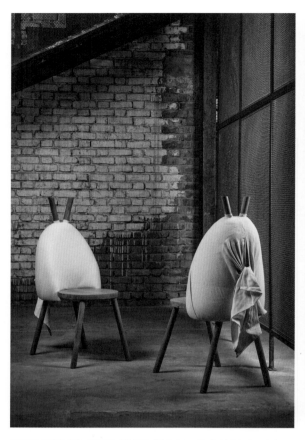

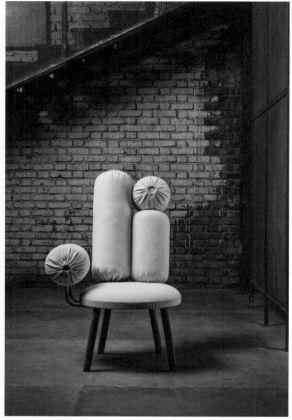

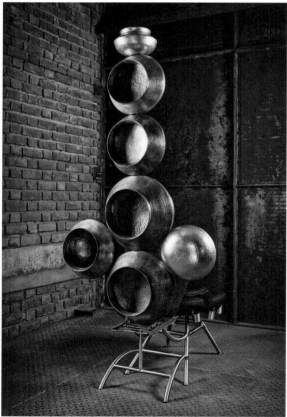

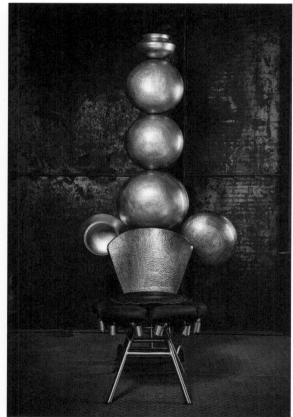

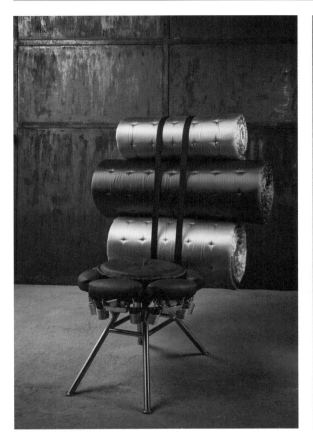

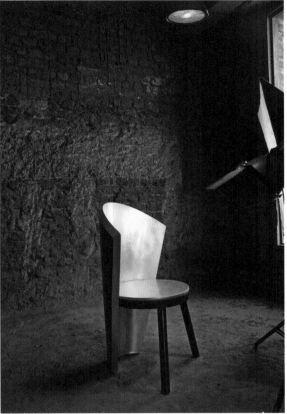

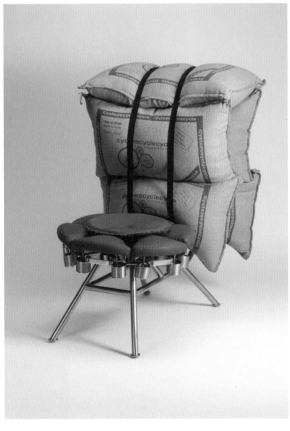

Facing page, top left
Potli chair

Facing page, top right
Masand chair

Facing page, bottom
Bartan Walla Bicycle Throne

This page, top left
Gadda Walla Bicycle Throne

This page, top right
Dining Throne

This page, bottom
Bori Throne

Nikhil Paul, Paul Matter

I'm told I was a curious kid — curious about how things worked. I'd dismantle small objects that I found around the house or in my toolkits and reassemble them. I guess it was then that I got my first indication. It was a natural way forward and I'm glad it worked out this way.

Initially, it was hard for my doctor parents. This wasn't the career path they would've chosen for their son — back in the late 1990s every second kid was either an engineer or a doctor. But eventually, they did go out of their way to support my choices.

I studied design, graduating in product design in India and doing a master's in business design in Milan. School was a great experience for me. In India, I learnt the basics of design deeply rooted in the country's rich handicraft heritage. It helped me understand and appreciate skills that are an integral part of our making process even today. School in Milan was an explosion of exposure to various cultures and the Made in Italy model, which has inspired me to build a studio that may be local but is global in its approach. I like collaborating with foreign designers and brands because it allows the exchange of wisdom, of the design process and of the making process. This is the main driving factor in the way we choose and approach each collaborative project. Then it doesn't matter where it is in the world. Each collaboration is so special, and the learnings are always reflected in future projects. A dream would be to collaborate with some of my design heroes.

I've had the opportunity to work in various fields ranging from the design of small objects such as jewellery and watches to systems and space design, from craft scale to industrial scale, from drawing to photography. As designers we have the privilege to juggle genres, and I certainly enjoy that a lot.

I think I'm a bit of control freak — I have to inspect every little detail, and we do pay great attention to detail. It can't go out of the studio unless it's absolutely perfect. In running the studio and business, I've come to realize that every single iteration is the very best that one can do at that time. Tango, our first light collection, has evolved so much — but little by little — in its hardware from the time of its launch two years back.

Our work is about timeless design and longevity, and I want people to experience that timelessness when they interact with it. I want these pieces to be passed on from one generation to another.

I feel Asia, in general, is the place to be. It's dynamic in many ways, and is where the action is. New Delhi, with all its challenges, is my choice by default as it's my hometown. The Indian government is at a very early stage when it comes to sensitivity to design or making design-conscious decisions, though this is changing slowly.

As for material, at the moment we're exploring light. We're enjoying how versatile it is. One cannot contain it and yet we can play with it. I also enjoy the geekery behind it.

I don't necessarily try to express my personality or nationality overtly in my designs. They're hidden qualities, and I enjoy that a lot. But I'm definitely interested in fitting with local traditions and keeping them alive. Being able to do that is a privilege, and I intend to steer the studio more and more in that direction in future.

When it comes to influences, I spent many summers in Chandigarh, the small state designed and inhabited by Le Corbusier. There's a stamp of Corbusier in every corner, and that plays an important role in the way I approach design. I'm also hugely inspired by certain century-old objects designed by Indian artisans. There's so much attention to detail, form and finish. Almost every object is ceremonial. If I had to choose an object that represents Indian design, I'd say the lota water vessel.

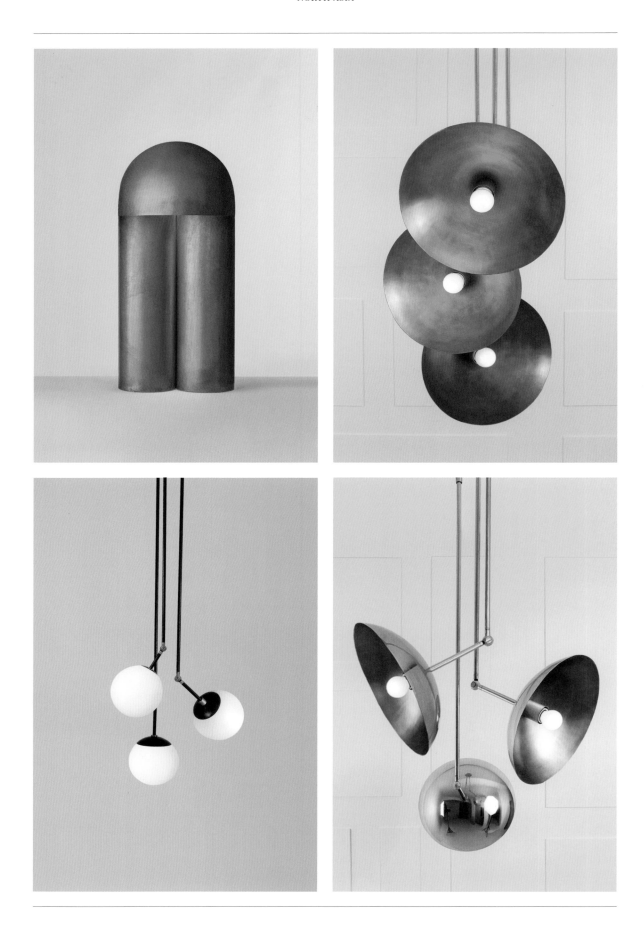

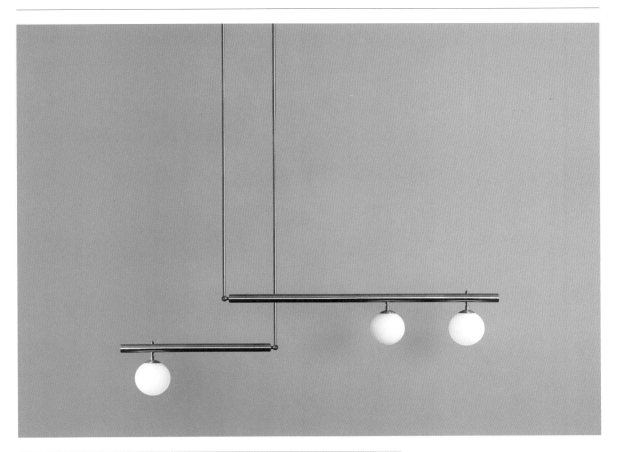

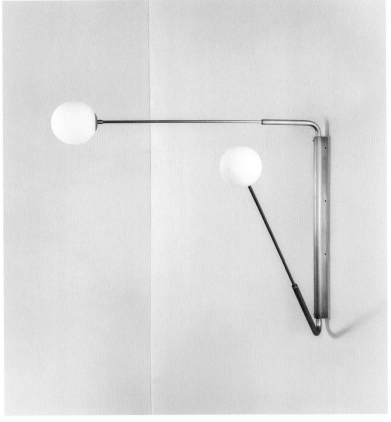

Facing page, top left
Monolith table lamp in brass

Facing page, top right and
bottom
Pendants from the Tango
series

This page, top
Satellite 2 + 1 pendant

This page, bottom
Flutter Two wall sconce

Yi Liao & Yanko, ystudio

We came to design differently. Yi majored in mathematics at university because his family hoped he'd become a teacher, but after graduation and a year of thinking, he changed to design. Yanko was initially just into design and creating in a broad sense. As he majored in industrial design at university, he grew more knowledgeable and passionate about material, manufacture and detail of products.

After Yi's bachelor's degree in mathematics, he received a master's in industrial design from National Cheng Kung University. Yanko graduated in industrial design from Shih Chien University. With Yi's mathematics background, he can analyse company and brand issues logically, and think outside of the box. Much of Yanko's schooling involved actual making, with fast-paced processes, which helped to develop his planning ability, flexibility and resilience.

We met when we were colleagues in another company, both working as industrial designers. We also had to work closely with the marketing and sales department, which helped us understand different aspects of how brand positioning works. To transform from industrial designers into company operators, the main challenge was to learn about building a brand. From managing and marketing to financing, everything was a new beginning and a big challenge.

There aren't many examples of brand building for us to follow from Taiwan, so we were kind of groping in the dark a lot. At the same time, Taiwan is a culturally plural society. We don't have too much of a cultural burden, so the flexibility in design and brand building is huge, and there are plenty of good manufacturers in Taiwan, so we can do product development at a low cost. We also participated in Fresh Taiwan operated by the Taiwan Design Center, which meant we could attend international fairs and exhibitions at a lower cost. And we've used the Ministry of Culture's subsidy programme. Both gave us great support.

Our main operation is the brand ystudio, under the concept 'the weight of words'. Besides product development, we organize activities and exhibitions related to writing in order to promote its value and power. We hope through our work people can remember the beauty and strength of writing, and recognize ystudio as a brand that shares in that.

Given that the concept is about weight, we think the best materials to present that are brass and copper. They're a bit heavy, and you'll naturally slow down when you're writing, which creates a sense of thoughtfulness. Brass also changes colour through time and usage, which means a relationship between human and object is gradually formed.

We'll keep focusing on stationery in the next few years, and keep sharing 'the weight of words'. We really hope to develop a fountain-pen nib that's completely designed and manufactured by Taiwanese, but we've found it more difficult than we imagined.

In 2018, we collaborated with Rakugei in Japan, a traditional foil art workshop, to develop the YAKIHAKU pen. It was a very good experience: the Japanese craftspeople were great to work with and the product was loved by customers. It gave us a lot of confidence, so we decided to collaborate with three Japanese craftspeople and brands this year. We're very excited to work with these craft techniques, which are more than a hundred years old.

As Taiwan's modern history is quite short, we don't have a fixed culture. Everything we do now is shaping this culture, which makes things very exciting. We hope to not just use our local culture, but to become one of its symbols. Local tradition is important to us, but it's not what we're focusing on at the moment. We do our best to pass on our concepts to customers through design, products and activities, to gradually influence people around us and make them think about the beauty of writing.

There's no particular Taiwanese designer we count as an inspiration, but over the years since starting our business, we've visited and consulted countless senior peers and friends who selflessly shared their thoughts and experiences. They made huge efforts to make a better business environment that's essential to ystudio. Those are the people we look up to.

It's hard to choose a representative Taiwanese design, as we don't have a fixed culture. For us, any design from Taiwan could represent Taiwan, which is why we feel special and lucky to have founded our business here.

Facing page, top
Classic desk fountain pen

Facing page, bottom left
Portable fountain pen in resin

Facing page, bottom right
Brassing fountain pen

This page, top left
Classic rollerball pen (above), Classic tape dispenser (below)

This page, top right
Classic tape dispenser

This page, bottom
Classic bookmark set

Kelly Lin, Ketty Shih & Alex Yeh, KIMU Design

We came to design at different times. Ketty was inspired by a design history course in senior high school. For Kelly it was at university, and she decided to continue with it after graduation, after considering psychology and biotechnology. Ketty's family has always been very supportive of her decisions, but Kelly's was against it initially before coming around later.

Ketty studied product design at the National Yunlin University of Science and Technology, then worked for a year before doing a master's degree in product and spatial design at Aalto University in Finland. Kelly studied industrial design at Chang Gung University, where KIMU's other co-founder Alex also went. For us, not all courses are useful in the workplace, but the learning process is very important. Even if at first you don't use everything you studied, you can still apply that knowledge in other ways in future.

Both of us worked for other studios before starting KIMU. Before Ketty went to Finland, she worked in a design company doing product and branding design. One of her biggest lessons was that it's very important to have good colleagues at work to help you along. Kelly developed products for a gift company, and worked at a company providing design services. The management in both companies was very good, and supported Kelly in exhibiting her graduation work in Japan. That trip became the inspiration for her to develop her own brand.

One challenge is that we have to handle all aspects of the business, not just design, like accounting, warehouse management and customer communications. This means we have less time to spend on design, so we need to optimize our efficiency at work. But being based in Taiwan has benefits. Compared to other regions in Asia, it's relatively young and quite open-minded — we're not too weighed down by tradition. Also, it still has a lot of factories that offer technological resources young designers can experiment and create with, and the resources are easy to access.

A governmental fund helped us establish our studio. The government also provides subsidies for us to participate in overseas exhibitions and projects. These are very beneficial for small brands that wish to enter international markets.

KIMU aims to promote 'The New Old Life' concept in design, which is inspired by old items, utensils and traditional habits. We redesign and reproduce these traditions, giving them a redefined place in our modern lives, so they can go on and on forever. We want KIMU's products to ignite different inspirations and ideas about life. When people bring our products home, their attitude towards life might change — for example, they might start appreciating the changing seasons or pay more attention to their home lives. We even hope that others will be introduced to or understand our products as the work of Taiwanese designers.

When it comes to materials and techniques, we often draw on our fascination with ancient items and local traditions. When our society moves forward, we must also look back to the past. That way, our local culture can continuously evolve, and that's a value worth upholding. One dream project would be to design a temple.

When it comes to putting our personality or nationality into every design, it's not a must. It depends on what message we want to communicate. KIMU aims to show the lifestyle of Taiwan and Asia, so it's important that we present products of international quality with local features. It is very important to keep traditions alive though, and it's a goal we always strive for.

As for a Taiwanese designer who inspires us, the work of Yenwen Tseng is beautifully simple and functional. That's what we love. For a product that represents Taiwan, when we created The New Old Light we aimed to skilfully combine Eastern and Western styles, just as we feel Taiwan does.

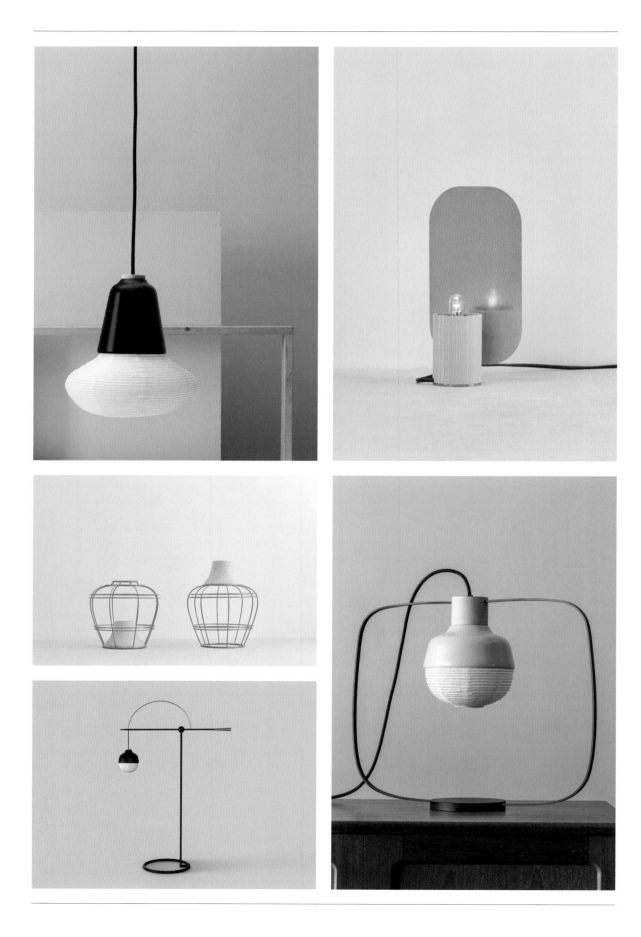

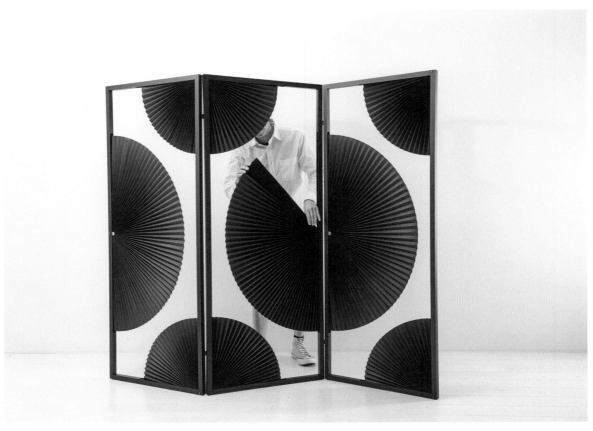

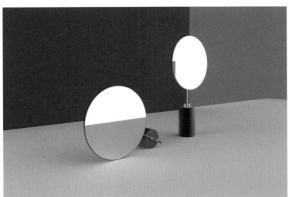

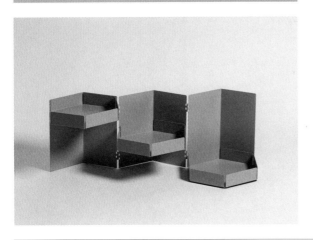

Facing page, top left
The New Old Light pendant

Facing page, top right
Screen Light 2.0 table lamp

Facing page, bottom left
The New Old Vase (above), Landscape floor lamp (below)

Facing page, bottom right
The New Old Table Light

This page, top
The New Old Divider

This page, middle
Pose table mirrors

This page, bottom
Column container from the Reveal series

Ray Teng Pai, Singular Concept

When I was 18, I realized I was more passionate about creating than doing research, so I switched from biological science to industrial design. I knew then that was the field I wanted to work in, and my parents were very supportive as always.

I did all my studies in Taiwan, and I think everything I studied was invaluable, from design methodologies to design history and the practical handicraft classes. Those learnings defined my ability in and knowledge of product design. However, we should never stop learning and must always stay curious. That's what my two most enlightening university teachers taught me.

Before starting my own studio, I worked at fuseproject's New York branch as a product designer and then at Pilotfish's Taiwan branch as a project manager. Running my own studio, I have to handle all aspects of the business. At first, I didn't really know how to operate and manage a company, and being the only person in charge there wasn't much time to learn, so I just had to feel my way through amidst a lot of uncertainty. I had to learn about financial reporting, project planning, trade principles, marketing and so on. The biggest challenge is that there are so many rules to follow!

Although my company is based in Taipei, not all our product sales, working partners and design customers are in Taiwan. Taiwan's market isn't big enough, so international expansion is a necessary step. However, the advantage of starting a business in Taiwan is that there are many manufacturing and processing factories, both large and small, and being local it's easier for us to make product samples or small production runs here than in other countries. I'm glad I live here so I can enjoy this unique advantage.

I was also lucky enough to go to New York as part of a cultural and creative industries training programme organized by the Ministry of Culture, and after starting the studio, I was selected to participate in several overseas exhibitions organized by the ministries of economic affairs and culture. That really helped me to break into international markets.

We do product design and public artwork, and we have educational partnerships with design schools. I hope people can draw design inspiration from my work and enrich their imaginations, leading to fresh ways of thinking about life or about creating. My work can be interpreted in many ways — I don't want it to be defined in a way that rules out all other possibilities.

I like things that can be taken apart then reconstructed, as the result can be completely unexpected — I find Lego fascinating for that reason. I'm actually achieving my dream step by step through my creations, and I hope that my designs can be produced on a larger scale, spreading their artistic value further afield.

I started working with LVMH group's art auction gallery in France in 2017. I wanted to transform my Junction desk organizer into a larger and more luxurious artwork for the gallery. After a year of back and forth communication, my work was sold at auction. In the process, I earned myself another title: artist. Working with French people is different from working with Chinese people: the pace of our communication was elegantly languorous.

I don't intentionally pour my own characteristics or patriotic thoughts into my design, but my style has always been consistent. People who know me recognize my new work because it has the same distinctive look. My style has built up naturally over time, not intentionally. I find the Bouroullec brothers and Barber & Osgerby inspirational, as their work is simple and elegant yet so varied.

I think it's wonderful that a tradition can be kept alive through a piece of design, but it doesn't have to be the core concept of the work. My design inspirations often come from some small observation or a story. For example, the tube bending technique I use when making my Linear task lamp from a car chassis is inspired by old stories of manufacturing and export trading told to me by a factory owner I know. As for the Junction desk organizer, it's actually based on exposed conduits I noticed when passing an old train station and abandoned factory. Design inspirations like these come from the environment I live in, so the link to traditional culture is indirect.

I think chopsticks are a representational design object for Taiwan. In the West, people like to break down big challenges into small tasks in order to work through them, while in the East, people like to solve complex problems with simple methods. Chopsticks are an iconic example of the Eastern way of thinking. We can eat all sorts of food with just two simple wooden sticks.

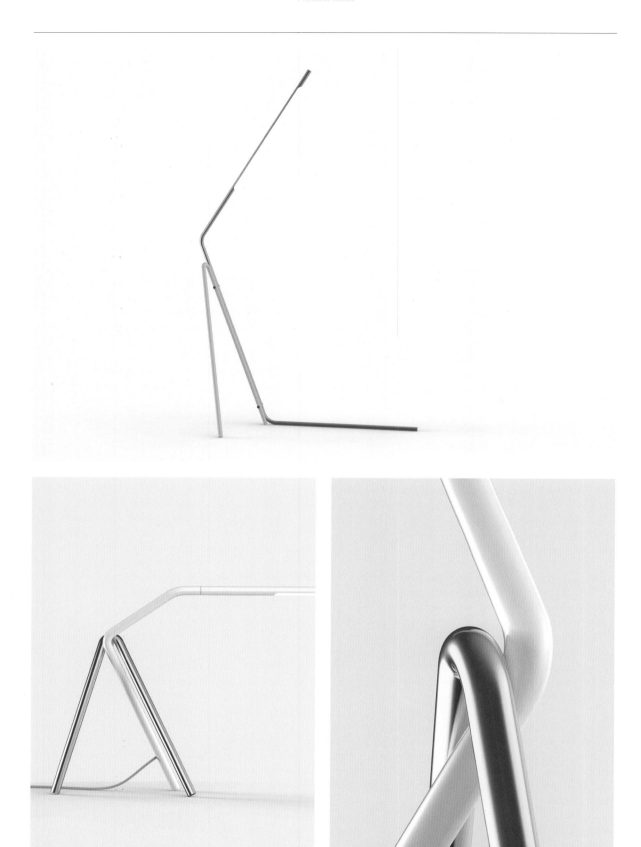

Facing page, top
Linear floor lamp

Facing page, bottom
Linear task lamp

This page, top and middle
Junction desk ware

This page, bottom
Prism P00 jewellery

Shikai Tseng, Studio Shikai

I was born into a printing industry family, and I believed I was going to be a graphic designer. However, since none of my family or friends worked as designers, and visual communication design or graphic design was called 'commercial design' at the time, which is very close to 'product design' in Mandarin, somehow I misunderstood and ended up choosing product design as my major! I've been a product designer since then, and I've never felt it was a mistake.

I studied at Ming Chuan University for my bachelor's degree, then at the National Taiwan University of Science and Technology for my first master's degree. I also received a government scholarship to study a second master's at the Royal College of Art in London.

Because I took a gap year for military service, I experienced two very different periods of the RCA: the last year of Ron Arad and the second year of Tord Boontje being the head of the course. The education I'd had before the RCA was basically skills training, more about 'what' and 'how' but less about 'why', so my first year really changed me and led me to find my own motivation and my own perspective, no matter what format I created in the end. My second year was a very different experience, focused on creating products rather than just a piece of design-art. I needed to think about the material and manufacturing process, and sometimes business and cost, but still keep it exciting. I struggled with the different approach, but I feel it was worth it.

I started my own studio right afterwards, as I was commissioned for a project. But if I could go back, I'd definitely plan to work in another designer's studio for at least a year and learn as much as possible from them. In the beginning, I was by myself and able to just focus on design and execution. However, I now have more colleagues, so I'm doing more administration and management. Changing from a designer to a director has been a big challenge.

Taiwan has a relatively complex history and many ethnic groups, which has led Taiwanese people to have very different self-identities and cultural recognition. For designers, it's a challenge but also an opportunity, as there's no final definition of Taiwanese culture — designers have more space to develop it, which is already happening. The Ministry of Culture also has programmes that help creative professionals to start and develop their careers and businesses, and the Taiwan Design Center helps new designers by connecting them with manufacturers and brands. The TDC and Industrial Development Bureau also provide support to encourage manufacturers and brands to use design resources. These have really benefited my studio.

I remember my tutor Daniel Charney told us in our first week at RCA, 'You're not here to become another Ron Arad!' Since then, I've spent years finding my own path, and now through material and culture research I'm telling my own stories and perspectives. We love to learn all the stories and details of materials, products and clients, then develop new concepts out of them. We also curate and produce exhibits for fairs, often working with designers in different fields to develop concepts and designs together.

We like our designs to link the past to the current era and to let it exist in people's lives in a poetic, beautiful way. If people can understand the stories and meanings behind our designs, it's the highest compliment for us. For me, a dream would be building my own house, studio and workshop from scratch, and doing design until I'm 80 years old.

Through my project Bamboo Forest, I've been able to work with some foreign brands, like Mint Shop and Gallery FUMI in London, and Rossana Orlandi in Milan. I also have a lighting design called Ripple that was a collaboration with another Taiwanese designer and has been licensed to Lobmeyr in Vienna. Products from the home accessories brand I started with my friend Hanhsi Chen, Beyond Object, have been sold around the world.

I believe all creations come from the background, culture and habits of the creators, or issues that the creators care about. It's a life journey of finding and redefining ourselves. I also believe fitting in with traditions is important, but we can't keep them alive forever. The world is constantly changing, and people aren't going to need the same tradition one day if we don't update it. I know it's a tricky balance, but it's necessary to discuss and act on it.

There isn't much research on past Taiwanese designers, so we have very limited knowledge of what they achieved. However, Rock Wang is still the designer I admire most. He merges traditional Taiwanese craft with design in new ways, and creates remarkable pieces to extremely high standards. For a representative object, I'd choose young designer Pili Wu's Plastic Classic chair, which merges the iconic Ming-style round chair with the ordinary plastic stool often seen at street food stands. It presents how Chinese culture has transformed and evolved with local culture, and creates a new kind of character.

Facing page, top
Ripple lamp for Lobmeyr

Facing page, bottom
Stationery collection for
Beyond Object

This page, top left
Mirror for Bronze China
project

This page, top right
Hand Drip Coffee Set for
JIA Inc

This page, bottom
Object for TALISMAN —
Contemporary Symbolic
Objects exhibition by IN
Residence, Milan 2017

Meng Hsun Wu, Lab M.Wu

The year before I started university, I found out there was a department called Industrial Design, so I went for it, though my family would've preferred me to choose computer engineering. I went to National Cheng Kung University here, and then to Design Academy Eindhoven in the Netherlands.

The working environment is changing rapidly nowadays. It depends what specific subject you choose, but there's always a gap between school and work. It was like living in a bubble while I was studying. It gave me basic knowledge and skills, but it's your own responsibility to find what you really want to become good at.

I worked at two companies before I opened my own studio. One was a stationery-design studio, where I worked with talented people and learnt how communication is done in a business. It was there I also had the first assignment that I didn't like, which was to draw 50 different staplers without any context. Now I think I should've started with the context instead of the shape they asked for. The second company was a metal products manufacturer. It was interesting to work right next to the machines that produced what I was looking at on my computer.

There are plenty of things I need to do as a self-employed designer, like finding a workspace, buying equipment, networking, marketing and sometimes taking care of my self-esteem — basically the things school didn't emphasize. And working in a foreign country — I'm now based in the Netherlands — presents some challenges, though I've had government support and I've found that people in Europe are also more open to art and design compared to people in Asia.

I have broad interests in several topics. My works are mostly related to material experiments and are sometimes conceptual.

If I had a dream project, I'd already be working on it — I have too little time for all the things I want to do.

Through my work, I want people to experience things that they don't expect to happen. Affordance is an important element in design that makes the product more intuitive to use. I think it's not just intuition, but also how we're trained to take a certain action for a certain purpose. When an unexpected result comes about, the user starts to think and explore what's going on.

I like all sorts of materials, but I do have preferences when it comes to certain products, which is difficult to explain. I prefer to make the shape neat and precise because I find it satisfying to see the components fit together perfectly.

Most of my works express my personality through their shape, material or concept. It seems to me that nationality can sometimes help people to understand a designer's work, but to only express nationality seems like a restriction. However, it's important that a design fits into a local tradition from a marketing perspective. And I appreciate designers who try to keep traditions alive, but that's not the most important element in design for me, as globalization is progressing and I'm interested in how traditions will change.

There are many designers in Taiwan whose work I find attractive. If I had to choose one, I'd say Pili Wu's work has really caught my eye. His works have a delicate balance between different cultures, with great execution. As for one that represents Taiwanese design culturally, for me that's Yii Design. It's a project that connects craftspeople and designers. Their creations are all based on crafts that have been mostly replaced by industrialized production, and they show the aesthetics of these traditional crafts while still being modern.

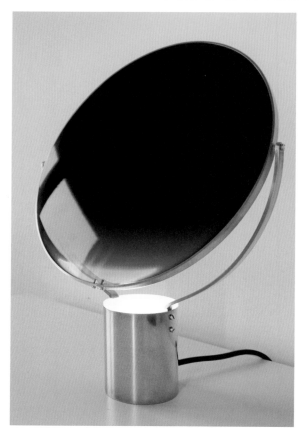

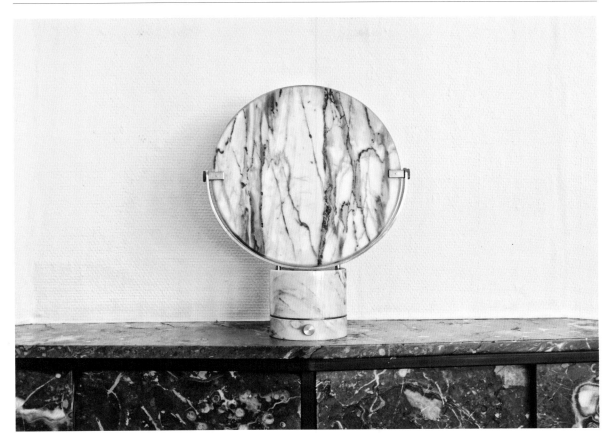

Facing page, top left
OI lamp in brass

Facing page, top right
Labour Currency artwork

Facing page, bottom
CMY Choir interactive
installation

This page
OI lamp in marble
Top image by Form&Seek

Pili Wu

I've had my studio since I was studying at graduate school, when I got a scholarship from the Taiwanese government that helped me to set up. My family has been supportive as well. I studied at Shih Chien University. It helped a lot, so now I try to share my experiences with students at my school.

I didn't work for someone else before I opened the studio. So far, I've found the main challenges to be finances and meeting deadlines. But the advantages of Taiwan's design culture are that designers have a lot of creative freedom, and that we preserve Chinese traditions while learning from other cultures as well.

The studio tells local stories through integrated design approaches, and we want people who experience our designs to know the stories behind our work. Rather than particular materials or techniques, we love to collect details and stories from our daily lives in Taiwan.

A dream would be to create a mass-produced furniture brand to present our life in Asia. So far, I've collaborated with some foreign brands, like creating the Tsé series for Lyngby Porcelain. I was happy people loved my work when I showed it in Milan.

I think design reflects culture and background, so it's interesting to see different points of view from different cultures. And I do believe fitting in with local traditions is important. I'd say a representative object from Taiwan would be our red plastic stools. If there was one designer I could name as an inspiration, it would be Gijs Bakker, who established Droog.

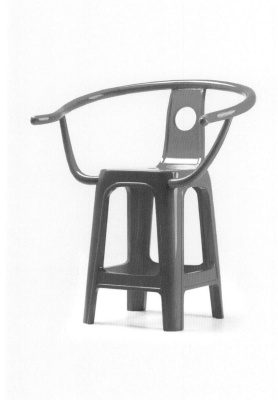

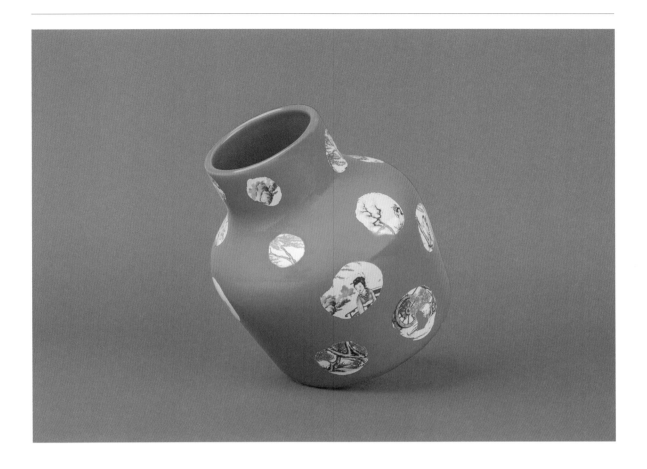

Facing page, top
Tsé porcelain tableware for
Lyngby Porcelain and HAN
Gallery

Facing page, bottom left
Plastic Classic chair

Facing page, bottom right
4 Seasons for JIA Inc

This page
UTP — Second Layer vase

Kenyon Yeh

I majored in computer engineering until I found industrial design by accident, when I saw students carrying interesting design objects around the university campus. So, I moved to industrial design and have practised since then. My family are open-minded people — they support what I like and what I do, which I really appreciate.

I received my bachelor's degree in industrial design in Taiwan and my master's degree majoring in furniture and spatial design from Kingston University London. I've found that working in design and studying at school are two different areas: at school my practice was about hand-modelling, concept development, computer skills and how to express my design concepts. While I still implement that basic design knowledge in my working environment, I've found there are more experiences that only can be obtained when we have to think more deeply about making a design feasible, availability for people, new materials, new techniques, learning from factories and communicating with clients. School and work are like combining hardware and software, and they also need to be upgraded from time to time.

Before I set up my design studio, I did a three-month internship with London-based designer Simon Hasan. I learnt so much from him about how to run an independent design studio, in areas like what designers need to overcome and pay attention to.

I think the biggest challenge is interpreting a concept and turning it into a real product that's functional and accepted by people. Also, as I'm based in Taichung, it's a challenge to keep close relationships with companies in the West; I can't just get in a car and visit them, so long-term communication and keeping in touch with them is important. But the advantage of being in Taiwan is that we can have a close relationship with factories that have rich experience in processing and producing objects using different techniques and materials. The Taiwanese Ministry of Culture also assists us through its mission to support creative industries. They have an open call every year, and designers have the opportunity to be selected for a subsidy to go towards exhibiting or product development.

Our studio focuses on working with international brands and clients on different types of products that fit into a common design language shared between the brand and the studio. Sometimes we also do small-scale interior projects. A dream project would be designing a house.

We aim for our pieces to be original, minimal and easy to match with any environment. We may use familiar techniques but create a completely different result or possibility in form and function.

Some of the brands we work with provide no design brief. That's a challenge for us, as we need to study the brand story, products and market position, which leads us to the new items they need to add to their collections and also what will be accepted in the market. This kind of process takes up to two years or more.

It's important to have a design that express the designer's or studio's personality — it's kind of a reminder to people of our studio's style. Fitting in with traditions depends on the project: up to now, most of our projects have been done with modern techniques, but we're open to using local traditional techniques in future.

To me, all designers who put dedication and focus into what they believe in are my inspiration to keep doing what we're doing.

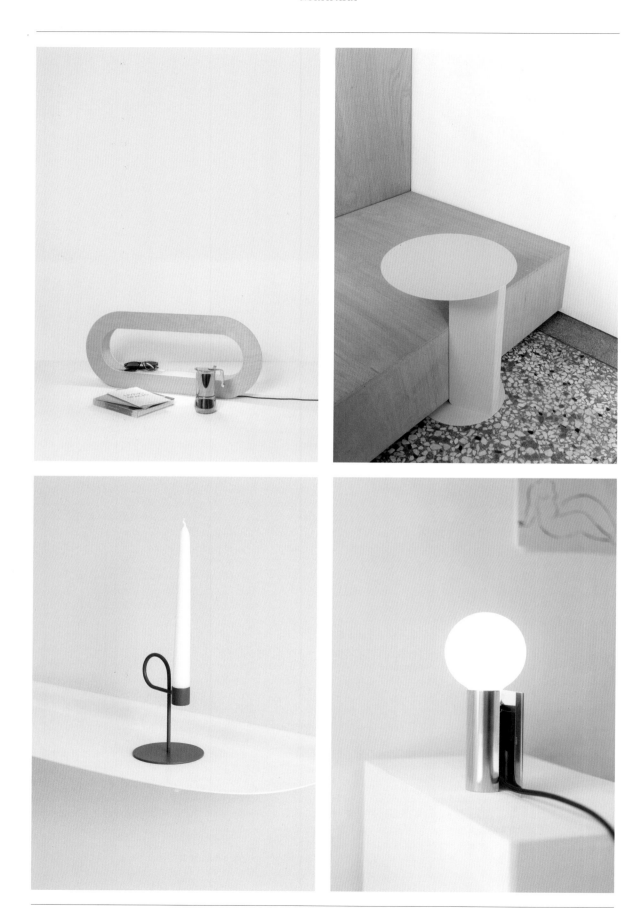

Facing page, top left
Cave desk lamp for META
Design

Facing page, top right
Kipa side table for Esaila

Facing page, bottom left
Loop candleholder for Hiro

Facing page, bottom right
Maku table lamp for Esaila

This page, top left
Rove side table for Dims.

This page, top right
Pushpin stool for Esaila

This page, bottom
Yeh wall table for MENU

Furong Chen, WUU

A few years ago, I participated in an exhibition called Metaphysics. We drove a van more than 10,000 kilometres across China looking for local creators. We shot a documentary throughout the journey, and created an exhibit in Shanghai of all the creators we encountered. One was disabled, and he developed mechanical prosthetics. Another was making a walking mechanical elephant for his 60th birthday, and another was living in the mountains and sculpting just for fun. I thought they were all good designers and living very natural lives. I love design too — I want to devote myself fully to design, and regard it as my lifelong career.

I studied integrated design at the Shanghai Institute of Visual Arts. It was a very experimental course dedicated to exploring the boundaries between design and art. I think it's been useful. What's cultivated in school is a way of doing things and thinking.

WUU was founded in 2014. We develop contemporary furniture, lighting and accessories while continuing to participate in art and design projects. Throughout the design process we research material and update basic items, driven by a sense of timeless beauty. I've also collaborated outside China, with Maison Dada on the Looking for Dorian mirror.

We're imposing challenges on ourselves with materials and process. Our requirements are very high, so we make an effort to work very closely with factories — I find it exciting. In China, we can cooperate with factories directly, constantly working to understand and deepen process technology.

I hope that after a decade or two, people will still appreciate our design style and its details. When people look at the finer details of our products, I hope they'll see and appreciate the strict requirements we put on our craft.

In the past, I liked to use cement as a creative material. I experimented with it a lot, eventually creating designs out of 0.7-millimetre-thick pieces that were developed for resilience. In recent years, my interest in metallic materials has grown significantly. I find it fascinating to see how metallic textures change in different states — from seemingly cold and distant to rustic and familiar.

I've wanted to try sculpting for a while now. Design is a comprehensive, integrated skill, and sculpture is closely aligned with the act of creation, so I'd like to use that medium to express my perceptions. I'd also like to take part in public art projects.

I didn't think my nationality was very important to my work at first, but slowly I realized my preferred approach to design was one of caution and control. The final outcome of each of my designs, whether rational or emotional, always exhibits a sense of control. I believe I must have developed this way of thinking by living in an Eastern country like China.

As for tradition, some designs serve no other purpose than to be beautiful, and that's great. Others are able to weave in local traditions and crafts, and drive the development of local industries — I think this is a very good thing. It's very important to me.

Chinese design is still emerging, so there aren't many designers I follow yet. However, there is one Chinese artist, representational abstract artist Ding Yi, who I greatly admire. He's also my teacher. His values and creations have always influenced my understanding of design, sculpture and painting. Looking abroad, there are several artists and designers I like: artists Donald Judd, Isamu Noguchi and David Hockney, and designers Konstantin Grcic and Ronan and Erwan Bouroullec.

For a design that represents China, perhaps it's traditional Chinese toys. They're all full of wisdom — from nine linked rings to Lu Ban locks, diabolos, dice, chess and mah-jong.

Facing page, top
Axis table

Facing page, bottom left
Rings trays

Facing page, bottom right
Stargazer table lamp

This page, top
Quark pendants

This page, bottom
Logic table

Yun Fann Chang, Tipus Hafay & Shane Liu, Kamaro'an

Two of our co-founders Shane and Yun studied together at school, choosing industrial design because of their love of geometry in architecture. They were inspired by the idea that our work would be entwined with daily life and might appear in people's homes. Afterward, they completed undergraduate and postgraduate degrees at the National Taiwan University of Science and Technology, majoring in industrial design.

After graduation, most of their classmates went to work for ASUS or Pegatron, and some started their own businesses. Yun participated in many projects related to craft and design as a postgraduate student — in fact, Kamaro'an was the topic of her doctoral dissertation. While still at school, Shane worked with Dutch bicycle brand VanMoof to create a raincoat. The experience gave him the opportunity to meet a lot of people in Taiwan's textile industry, which has proven very useful in producing our woven series.

Our third co-founder Tipus is an indigenous Taiwanese who specializes in environmental planning, and recently returned to her hometown to pursue cultural work and learn traditional crafts. We started Kamaro'an straight after graduation, and the process was quite bumpy! If we'd worked for someone else first, we might have gained a lot of useful experience, but we might also have been more fearful.

We sell most of our products in overseas markets, and it took a while to learn how to handle foreign trade. The hardest part was probably generating exposure in the early stages. Even if your brand concept is great and your work is brilliantly designed, you can't sell your products if no one knows who you are. Luckily, information flows quickly in Taiwan and people are always willing to lend a hand and introduce us around.

Although some industries here are moving abroad, the island still has a lot of traditional small and medium-sized factories. So, whether we're working with the metal, leather or textile industry, we can always work with highly skilled masters to develop new products. And when we participate in overseas exhibitions, we can apply for an allowance from the Ministry of Culture to help cover fees.

Kamaro'an partners with experienced craftspeople who act as product development consultants. We work with young indigenous girls to create umbrella sedge and other woven products, as well as seeking out and overseeing projects. Our name is taken from the Pangcah indigenous language, and means 'a place to live'. Each of our products is handmade in our studio by skilled indigenous weavers, welcoming young people back to their hometowns. The Pangcah pick rattan on the mountain and collect wood by the sea to make items out of, creating a self-subsistent life in which people rotate roles and support each other.

The young craftspeople are not only learning about life through their work, they're also learning indigenous history through the crafting records. We hope people will learn from Kamaro'an's products and appreciate the inspiration behind them, drawn from nature and from traditional life.

Our aim isn't really to create new design stories. We're upholding traditional techniques and crafting products and everyday household items, but we incorporate industrial design methods into the crafting process.

The materials we work with and the weaving are imbued with culture. From inspiration to creation and end use, crafting is a way of life and the outline of life. The umbrella sedge mat we sleep on during summer and the driftwood chairs both blend with the environment so well that you don't even notice them, as if they were part of nature. And when people sing the praises of the solid, organic driftwood chairs, the makers can intuitively reply, 'It's our indigenous chair.'

We hope to expand into architecture, expressing life across space. We've also just launched a special edition gift for Issey Miyake — a traditional vase made using indigenous umbrella sedge.

For us, expressing our culture is the most important aspect of our work. We want to design products inspired by traditional concepts that will blend in, so people will focus on the craft rather than the look. Designing products is like being a translator, translating age-old culture and handicrafts into the language of modern life. Preserving tradition is our top priority. Taiwan's design field has shifted from focusing on electronic products to having more design studios focusing on daily life and culture. Studios are collaborating to move forward and inspire each other. We think the Sapud Kacaw chair made of driftwood is a classic piece of Taiwanese furniture. The natural, organic curves and the local materials showcase how the Pangcah live as one with nature.

We look up to Japanese designer Sori Yanagi, who combined the spirit of handicrafts with mass production. He produced simple and universal designs to let people around the world experience the beauty of Japanese culture in a subtle way.

Facing page
Riyar pendant, Cidal lamp
and Faho' storage pieces,
all from the Umbrella Sedge
series

This page, top left
Sapud chair from the
Driftwood series, with Cidal
pendants

This page, top right
Traditional Lid bag from the
Woven series

This page, bottom
Woven Triangle bags from
the Woven series

Zeng Peng, BUZAO

I've been certain about design as my dream career since I was young, though I wanted to be a fashion designer at first, not a product designer. When I was picking my university major, I wasn't really familiar with the smaller sub-sectors within the design industry. Fashion design was on my mind until 2013, when I attended an exhibition during a work trip to Shanghai and saw the incredible designs by independent fashion designers. It brought me a sense of comfort knowing that there were excellent fashion designers in China already, so I finally made up my mind to focus on product design. I've realized I simply love creating things.

I studied at Guangzhou University. What I learnt wasn't enough for a professional career, but it wasn't useless either. It was just too generalized for coherent application and deduction. I think knowledge builds over time, like a sand pile slowly growing in size and covering a blank area. The more you know, the greater the effect.

Several years before I started BUZAO, I worked on product design and experimental projects with BENTU. I joined when I was a student, so this was where I developed my tastes and honed my thoughts. BENTU is a humanistic brand that transforms ideas about the industry's environment into products. Working there inspired me to break through the status quo, to work unrestrained by the past and to strive for what I believe in, even when current conditions aren't favourable.

From being a simple product designer to the director of an entire brand, the greatest change was that I couldn't view things from a purely aesthetic angle — not even designs. The main challenge is choosing between what the market likes and what I like, and to balance my judgement without losing touch with trends. But China at the moment is hungry for design-driven development, which means designers enjoy many opportunities and platforms to express themselves. And China's enormous manufacturing industry is an advantage for product designers. The government also offers subsidies for participating in overseas exhibitions.

I launched BUZAO in 2017, and I regard it as an experimental brand. BUZAO aims to break the divide between products and art, and introduce the uncertainty of artistic creation into product design. We don't create definitions. We admit that all matter already exists, and nothing new can be created. We extract a substance's innate qualities and break down these features to grasp its essence. Through design, we build a bond with people, and this takes the form of a lamp, furniture piece or decorative object. Instead of creating a product, we're producing a poetic reaction.

We source volcanic rock, marble and industrial materials, such as glass and stainless steel, and we're going to start with cast aluminium too. We don't see material as traditional, natural or artificial — the only relevant category is 'existence'. The features of a material aren't our concern — what we seek is the artistic element of uncertainty and irregularity that matches the eventual design. I hope when people see our work, they'll stop and stare, maybe zone out a little, and create a snapshot of that moment in their memory, instead of only seeing a functional product in front of them.

For me, the material is what really matters. My choice depends on intuition and preference, both through unconscious decisions made by filtering visual experiences and through known forms of design experienced over the years. These are semi-rational designs, and combine product attributes with artistic elements. The artistic process is an expression of cognisance, and the design process is a display of your understanding of the world. Art is incredible for being undefinable, while design requires definition and recognition. BUZAO was born as an attempt to balance art and design.

I think expressing personality is essential; nationality and local tradition aren't, though I do think some of our designs express Chinese cultural elements. The F table corresponds to the dual-layered Taoist concept of *wuwei*, or inaction. The first layer is to follow the laws of nature, which applies to humanity and the environment. The second is to follow the laws of humanity, which should be the same as the laws of nature. So Taoists believe in assisting natural development and not working against it. The F table brings volcanic rock back to its origin, juxtaposed with artificial material. At first glance, the rock and its fractures remind people of the flow of lava and the process of condensation. Natural materials lose their normal appearance after industrial processing, and we wanted to keep the manufacturing process visible while concealing the result. The volcanic rock is crafted both artificially and naturally, showing contrasting aesthetics together.

Our glass Null collection uses China's most common industrial material to reflect Laozi's philosophy that existence and non-existence are not dilemmas, but instead are contrasting elements where one's end is the other's beginning — like yin and yang, movement and non-movement — to show that existence comes from non-existence. The composite glass geometrically highlights depth and surface, and visually comprises positive and negative space. It's visible then it's not, it exists and then it doesn't. From being to not being, Null is an evanescence of space — a visual abyss.

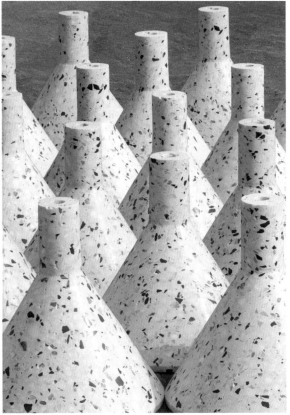

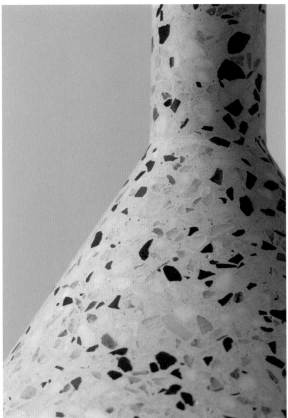

Facing page, top
Bench and table from the
Hot collection

Facing page, bottom left
Coffee table from the Null
collection

Facing page, bottom right
Side table from the Null
collection

This page, top left
Gong table and Piece
pendant from BENTU's
terrazzo collection

This page, top right
Jin pendants from BENTU's
terrazzo collection

This page, bottom
Jin pendant from BENTU's
terrazzo collection

Dennis Cheung, Studio RYTE

Everything began after I read a book about semiotics by Roland Barthes when I was 16. Although it was confusing, the one per cent I grasped was enough to spark my curiosity in design, from architecture to interiors, furniture to branding. I was fascinated by how powerful it can be to convey ideas, represent culture or make a statement with any medium.

I'd say that I'm still studying. I studied architecture at the University of Hong Kong and then did a master's at MIT. I completed another management master's on a part-time basis and I'm studying online at the moment. It never ends.

MIT promotes innovation and cross-disciplinary collaboration at all levels, and cultivates a strong entrepreneurial spirit. That was what fostered the hands-on working style in our studio, one of intensive fabrication and iteration-based design.

Working for others was beneficial for me. I learnt about cross-scale design and detailing with Kengo Kuma in Tokyo and Beijing, competition strategies at c+s Associati in Italy, the design architect's perspective for an architectural project at CL3 in Hong Kong, and the administration architect's flow and procedures at RLP, also in Hong Kong.

I've found that putting a dollar sign to the things you find valuable, when your client doesn't, is a big challenge in pushing a project in the direction your team wants to go. And in Asia, the stage for architecture, interior and furniture design has long been set by Japanese designers. Throughout the years, they've established the bar for quality and craft. In recent years, Taiwan has started to promote original designs, Korea has overtaken Japan on pop and mass culture dissemination and Thailand is also building momentum in public design. What about Hong Kong? It's not so much about design here — it's always been about finance, efficiency and economy.

I always find our studio's work difficult to summarize. We transform from time to time, and our objects always go well with the given space. We do architecture, interiors and a lot of furniture design. We create through the simplest instruments of design: material, colour and proportion. We work with simple geometries and are fond of repetition of lines. The complexity of structure or fabrication is usually subtly hidden.

As for materials, we don't really limit ourselves. We enjoy the process of working with different materials. But we've consistently used wood because of its carbon content as well as the subtle warmth it brings. Lately we've been trying out different species of wood.

We always dream of meeting the Vitra-to-be in China, if there is one. Back in the 1950s, Vitra worked very closely with Charles and Ray Eames on the design and development of furniture and products that had a profound influence on the industry. There was tremendous advancement in materials, technology and engineering. And materials were always challenging for them. But because of their efforts with the manufacturer, they successfully produced collections using plywood, fibreglass and aluminium. We hope to see what further limits we can push in the current era, where China is the world's leading manufacturer.

Currently, we're working with a small German lab near Stuttgart on composite material that replaces carbon fibre with plant fibre, which makes it organic and biodegradable. We're creating furniture together. And since they're a partner of Mercedes-Benz and Porsche, it's the perfect place to work with this kind of material.

I don't focus on expressing personality or nationality at all. We believe that design should focus on function, form and technology, be it an embedded technology or the technology used for fabrication. But Chinese history has a lot to take inspiration from. Sometimes it's a good anchor for us to design from. As for tradition, if the project context prompts us towards preservation or revival, we usually follow that. But we always make a small twist to give a new interpretation of the subject.

When I think of local design influences, if the boundary extends beyond Hong Kong to greater China perhaps I'd say Neri&Hu. The way they work across scales, having control of spatial representation as well as furniture articulation is very much our direction. As for an iconic local object, handmade bamboo steamers for dim sum are a fantastic representation. They're synonymous with Hong Kong's culinary culture, made with low-cost materials yet naturally able to balance moisture and temperature. Their curvature comes from the bending of the material to form an enclosure, and their beauty from their functions and the properties of the material. Looking at a larger scale, one finds the shape and content echo the way Chinese people sit and eat around a table. Looking at a closer scale, one sees the versatile and sustainable qualities of the material.

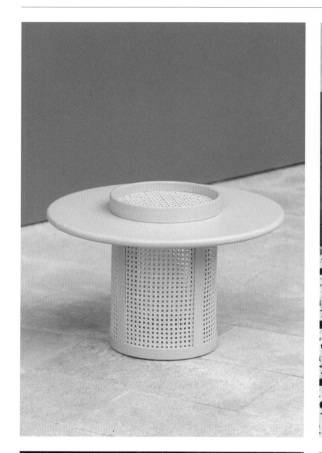

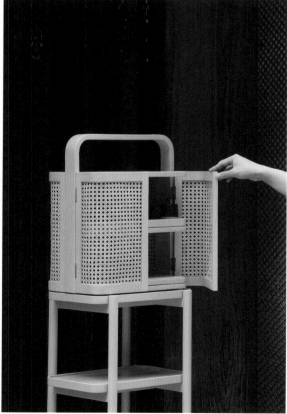

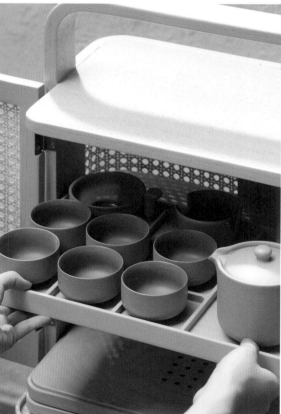

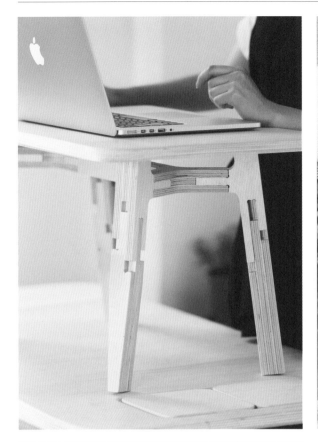

Facing page, top
Rattan table

Facing page, bottom
Cabinet T

This page, top
ButterPly bench

This page, bottom
Triplex stool

Jervis Chua, Build Republic

I've always enjoyed tinkering with things, and when I was deciding what major to take at university, I discovered industrial design. That's when I knew it would be my chosen career path. My parents weren't supportive in the beginning, but they became supportive over time once they realized I was really passionate about design.

I studied at Domus Academy in Milan. It's been very useful — it gave me the confidence and the proper mindset to have conversations with C-level executives. But I also worked for other people before going out on my own. I started out as a visual merchandising and packaging designer for jewellery, and I worked for Jozeph Forakis in Milan for many years. It's where I was properly taught the importance of design mastery and meticulous attention to detail. I then founded my studio to help start-ups build their brands with design, and I've also worked with international conglomerates. That's a really good test for both design skills and persuasion. It's fulfilling, frustrating, exciting, stressful, fun and challenging, all at the same time.

There are other challenges as an independent designer as well. Doing accounting is one, as is dealing with high operating costs in Hong Kong. Also, speed is at the forefront of business culture here, but it comes at the cost of poor product desirability.

We strive to instil the discipline of attention to detail in the work that we do.

We believe in 'honest materials' as a mantra — these always bring out the best in a design. We love working with natural materials such as wood and glass, and combining them with industrial materials.

A dream project would be a high-tech desk lamp that could be infinitely upgraded so it never goes obsolete, and with an aesthetic as timeless as most of Achille Castiglioni's work.

I don't try to express personality in my designs — I think a piece should always express the context of what I'm designing for. We're not aspiring artists. However, personality will always play a role in all our work — after all, anything we do is really just a culmination of all our years of life experience. Fitting a tradition is more important — this is what makes a product more human and meaningful.

In terms of design influences and designs that express Hong Kong, Michael Young has been an influence on me: he once said, 'The more you live the better you design'. And Bookniture by Mike Mak is almost like a commentary on how ridiculously small Hong Kong flats are.

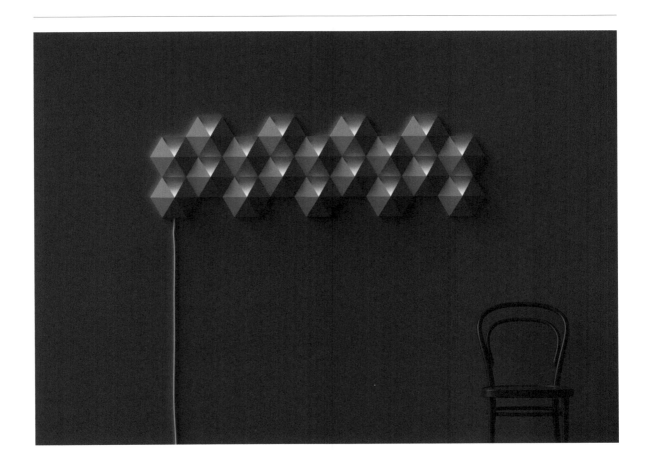

Facing page, top
Ambi Climate IoT air-
conditioning device

Facing page, bottom
Lam bench

This page
AmbiHive ambient wall
lighting, designed with nbt.
STUDIO

Manchuen Hui

When I was little, I lived close to nature. I started using natural materials to make my own toys, like slingshots, so my interest in product design began from my childhood. My family supported me to follow the path I chose.

I studied at Hong Kong Polytechnic, then did product design at Aston University in Birmingham. I think it was useful, and the problem-solving skills I learnt are particularly essential. After 15 years in the design industry, I've worked on product design, installations and interior design projects. Every project had new challenges, but a big challenge motivates me to look for an alternative.

I worked at Michael Young's studio as an industrial designer for six years, and I had opportunities to work with many international brands and different materials. My design philosophy was gradually formed during that time. I'd say Michael is my biggest design influence.

I think Hong Kong's background in manufacturing and finance provides rich soil for designers to make their designs real. My studio works in design, project management, marketing and e-commerce, and when people experience our designs, I hope they get a sense of sleek and timeless design.

As for materials, I like working with leather because it's natural, durable and versatile. I can create a range of different objects from leather. And given that my studio makes accessories for classic Minis, my dream project is to design a Mini Cooper.

I feel it's important to express personality and nationality in my designs, as well as to work with local traditions. I think keeping traditions alive is my social responsibility. Similarly, I think furniture represents folk culture. A piece that I think expresses Hong Kong is my Dong stool, which was inspired by the classic dai pai dong food-stall stools. The stool won an award from the Hong Kong Designers Association and is now part of the Hong Kong Heritage Museum's permanent collection.

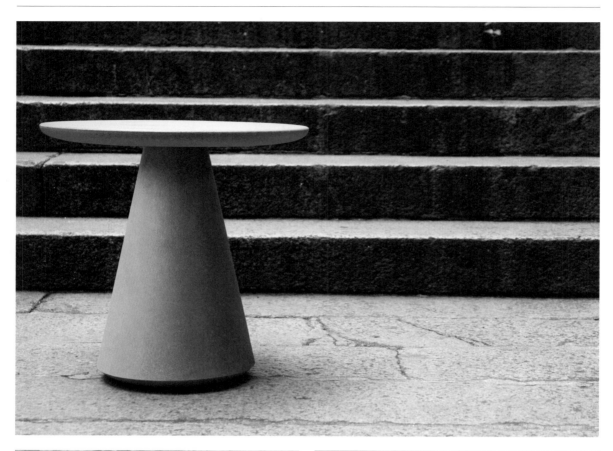

Facing page, top
Niente side table

Facing page, bottom
Dong stool

This page, top left
Leather lifestyle accessories
(above); leather cable
organizers (below)

This page, top right
MiniGear gear knob

This page, bottom
LiteHouz voice assistant

Wilson Lee, STUDIO ADJECTIVE

I remember I was in browsing in a library as a teenager. I picked up the book *An Organic Architecture: The Architecture of Democracy* by Frank Lloyd Wright and read it cover to cover. I was deeply inspired by the philosophy and by what architecture is about besides making a building, and I decided my path was to study architecture and make people's lives better through design.

I ended up studying architecture at HKU SPACE, which specializes in professional and continuing education, where my tutors were great influences. My business partner Emily Ho, who is our marketing director, got her bachelor's degree in Australia. So we're not just design professionals — we have a strong marketing and communications background.

What I learnt most from school wasn't about knowledge, but about understanding myself and learning different ways of thinking. And about how to fight for something I believe in by learning to tell a convincing story. Before I graduated, I was lucky enough to work for Gary Chang and his studio EDGE Design Institute. Gary is very strong with concepts and transforming compact spaces into magical places. I learnt a lot from him about the importance of design concepts and storytelling, and the appreciation of small spaces. I'd say he's my main design influence.

There are challenges in what we do. Both Emily and I think it's an art to transform our design thinking in different ways to create, for example, market value and brand identity for different types of clients. We hope to develop a solid image for our studio, which is very challenging but important. With Emily's marketing background, she manages this part well. I've found that working in an ultra-dense, fast and market-driven city has given me a good sense of flexibility and an understanding of the importance of making a project that's sustainable in the market, but the biggest challenges are the tight deadlines and sometimes the difficulty of convincing people about the value of design against the value of money. The market needs more education on the value of design.

We focus on architectural and interior design, and within that on creating storytelling concepts with no fixed categories. We always hope people can read the concept and intention behind the appearance of our projects. So far, we've worked across hospitality, residential, co-working spaces and even clinics.

We recently collaborated with Japanese furniture company Ishinomaki Laboratory to design our first piece of furniture. We developed a design for a stool. We met the founders at an event, and we were deeply inspired by their brand concept of creating honest, simple but good designs for community building. Our team studied the brand and created a design with mock-ups, then we flew to Japan to present it. They accepted the design and we worked closely to finish it. It was an amazing experience for all of us.

We hope people who experience our works will feel that they're blended well into the context and community, and are nice enough to want to experience again. Our designs are usually very direct and simple, but we also focus on details. We enjoy it when people keep exploring different subtle details in our space every time they pay us a visit.

I like honest materials, and materials that project a unique sensibility. When we've understood a site's context, we think of the atmosphere we want to create and start selecting the materials. I personally like rough, earthy materials — they give a kind of warmth to our projects in contrast with the city we live in.

As for a dream project, we're looking for a chance to design a space for kids. We believe the sense of exploration is extremely important for children, and there are some very good examples of kindergartens in the Nordic countries and Japan. We believe good design can enhance children's development and provide a happy environment for them to learn in. Emily also really wants to have a lifestyle project in Australia.

My design is a reflection of what I believe in and the outcome of challenges I want to take on, and it becomes an expression of myself very naturally. But I'm more concerned about whether it's obvious in some way that my work is created by a Hong Kong designer. Hong Kong is still debating and discussing what 'Hong Kong style' is. The design community here was very inspired by Western philosophies and perhaps recently the sense of simplicity in Japanese and Scandinavian style. But I believe Hong Kong is a unique city, and one that has a very strong character in terms of flexibility and efficiency. We just need to keep exploring, and transform these elements into our own design language and let the world understand.

I feel it's definitely important to keep traditions alive. We've worked with local craftspeople on projects and on furniture design. We understand that to help the tradition carry on, we need to inject new design ideas and collaborate using their skills to create something new. Otherwise, traditions will end up in a museum and never be part of the culture again.

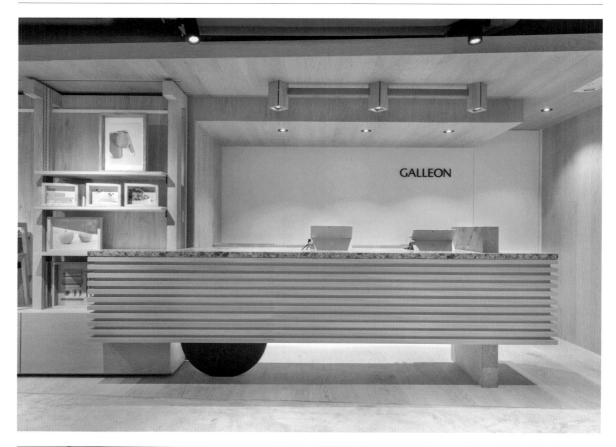

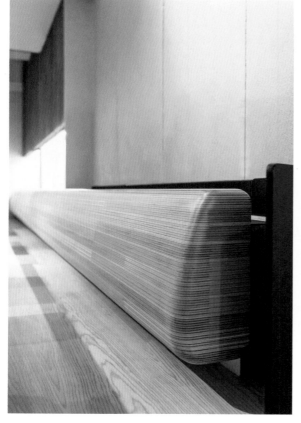

Facing page, top
Service counter at concept store Galleon, Hong Kong

Facing page, bottom left
Bench at Urban Coffee Roaster at Galleon

Facing page, bottom right
Display shelf at Galleon

This page, top
Tripodal stool for Ishinomaki Laboratory

This page, bottom
Custom-designed cabinet for a residential project in Hong Kong

Michael Leung, MIRO

I've known I wanted to be a designer since I was at school. I didn't know what design was, but I remember I wanted a style of jeans but couldn't find something like it. I asked if it was possible to make it, then I was told there was something called fashion design. That was probably the first time I heard the word 'design', and I thought I'd become a fashion designer when I grew up. But I chose product design for my bachelor's at Hong Kong Polytechnic. After that I went to Design Academy Eindhoven for my master's in conceptual design.

It was more thinking and attitude that I learnt at school, so it's still applicable and useful to my practice, especially when my projects vary across disciplines — it's the thinking that allows me to work in such a way. I also worked in a design consultancy before going to Eindhoven. The experience was good, as I got to work on projects that were more industrial rather than ones that were more about branding.

I think the main challenge as a designer is to focus on designing and get everything else done too, while in Hong Kong, the spaces and understanding of design are challenges. But the government does provide some support. I actually went to the Netherlands without enough savings to complete the course, so I searched for funding and applied for the Young Design Talent Award supported by the Hong Kong Design Centre — luckily I got it.

My studio both designs and curates. We start with research and development of a concept, then we find a suitable medium for the execution. What I hope people experience from it depends on the project. If it's object-based, then it could be the ritual or the stories behind it, like a tradition or a local production method that still exists. If it's an exhibition, then we hope the concept can be enhanced through the experience. We hope they can be inspired a little.

We've collaborated with brands as well as museums, like the Vitra Design Museum and the v&a. We've been lucky, I think — they understood and appreciated what we do, and the collaborations were great.

As for materials and techniques, I work a lot with sheet metal, like galvanized steel or brass, mainly because of the production aspects. Galvanized steel objects can be made locally in small workshops and one-person factories. For me it all started with a maker working in a workshop in an alley in between two buildings. He was around 60 years old, and making products there by himself. I was just observing at first, then after understanding a bit about his techniques I asked him to make some small objects. We later worked with different workshops and small factories, depending on the scale of the project and the techniques involved.

I'd love to design a space, the experience and everything around it, but it's more about who I get to collaborate with that makes it a dream project or not.

I never prioritize my personality or nationality in my work, but they can't be avoided since they're part of me. What is essential is different for each project. And there are the basics as well, like how the design process and outcome relates to the environment, for example. As for traditions, I think they and local industries and culture are all important. Some traditional skills and crafts are preserved in micro-factories in Hong Kong, which I've been working with in my projects. I recently started a research project with a team to document and collaborate with micro-factories in my area.

As for Hong Kong design inspirations, I actually couldn't find much information about them when I was younger, but the more I learn the more I appreciate what they do. There are iconic designs here too. I actually just learnt some skills for bamboo working, so I'd say a bamboo steamer is a good example. They work well, make food taste better, are sustainable and are beautifully made.

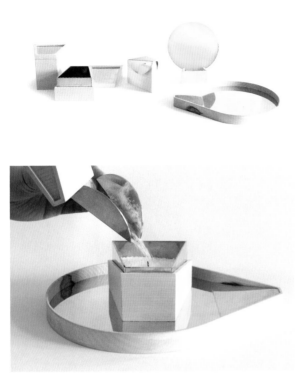

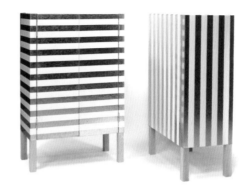

Facing page
Transform series
commissioned by the
Government of Hong Kong
for the exhibition City Dress
Up: Seats.Together

This page, top left
Content series of candle
objects

This page, top right
Silver cabinet for industry+

This page, bottom left
Silver desktop series

Vincent Lim & Elaine Lu, Lim + Lu

We were both raised in creative families, and developed an interest in the creative field at a young age. Vincent's father is Hong Kong architect William Lim, and Elaine's parents are both artists. Our families have always been very supportive of us pursuing our passion.

We studied architecture at Cornell University, so we've always been used to the architectural way of thinking macro to micro. We think from the city scale to neighbourhoods, then buildings to units, rooms to furniture to tabletop products. After venturing into interiors and product design, we started to think from details. But having an architectural background pushes us to rationalize our designs.

Before starting Lim + Lu, we both worked in New York. Vincent worked as an architectural designer at Kohn Pedersen Fox and Elaine worked at Robert A.M. Stern Architects and in store design for Tiffany & Co. Our work experiences helped establish our knowledge of the industry as well as our design process.

The biggest challenge is handling every aspect of a project and the business by ourselves. It's also beneficial to our work, as we're very much involved in every detail of a design. And there are advantages to being in Hong Kong. We've completed quite a few projects due to the fast-paced environment and quick turnaround time in Hong Kong and China. The abundance of resources and techniques here allowed us to hit the ground running as soon as we moved here.

We see Lim + Lu as a multidisciplinary studio working across interiors, furniture and products. Our holistic approach allows us to explore design in a multitude of scales, in search of creating synergy between objects and spaces. Our inspiration is drawn from the vignettes of everyday life, looking to transform the mundane to ignite an emotional connection.

We approach design from practicality and aesthetics. There shouldn't be one without the other. In terms of practicality, flexibility is the main feature. In today's society, nothing should be static, be it a restaurant, a bedroom, a sofa or a candleholder. Design must complement and at the same time challenge the way people live. As for aesthetics, we often use colours and bold lines to provoke an emotional response. Design is made for people — it should trigger the senses. It's about the balancing of different materials, textures and colours in a space or product to create harmony and excitement. We like to balance heaviness and lightness, masculinity and femininity.

A dream project would allow us to design from the macro scale to the micro scale. For instance, a stand-alone restaurant where we design everything from the architecture and interior to the furniture that it houses to the tableware and crockery. Every element within that ecosystem would work perfectly with the others and create true synergy at all scales. A museum would be a dream project as well.

We've collaborated with Tai Ping Carpets from Hong Kong as well as New Works and Lucie Kaas from Denmark. We enjoy developing products with other brands, as their knowledge of techniques, production and business further elevates our design concepts. When we began brainstorming a design with Tai Ping, we first learnt the different techniques of rug fabrication, which we incorporated and which resulted in a more exciting product.

It's essential to express our personalities, but not necessarily our nationality. As the world is getting smaller, styles and cultures are starting to cross-pollinate. In a world full of talented designers, the only way to distinguish yourself is to translate your personality into the design. As designers, we're given that opportunity in the hopes of forging an emotional connection with the end user. Looking through our work, a common thread is playfulness and whimsy.

Our nationality does express itself sometimes. Due to our East-meets-West education and lifestyle, a blend of cultures tends to manifest naturally. And we do think it's important to design with the context in mind, which often runs parallel with local styles and traditions. We often employ nostalgic Hong Kong tropes if they're relevant and appropriate. However, we think it's important not to just take the elements at face value. They should act as a reference point to an earlier period, while not losing their design identity. If we had to pick a design that exemplified Hong Kong it would be the lazy Susan, as it best represents Hong Kong and the importance of sharing food in Chinese culture.

Since we design furniture and products, working with craftspeople to preserve their traditions but also help them develop new methods is important to us — this means they're able to adapt to change. For our Split and Totem vases, we travelled to Jingdezhen, China, to thoroughly understand the properties of porcelain. We wanted to design something that challenged the conventional method of how vases are made. We arrived at a design that we feel is unconventional and rather special.

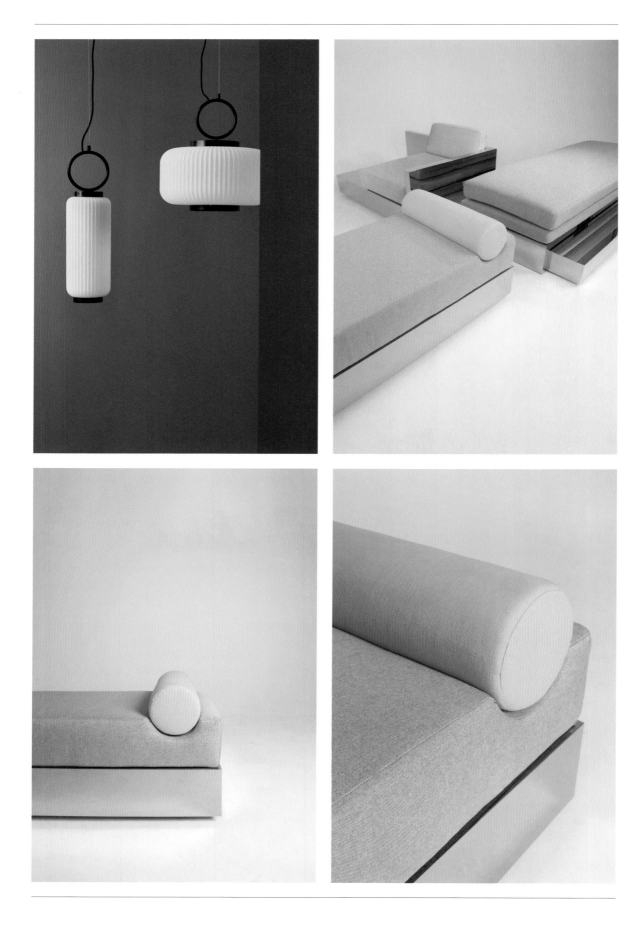

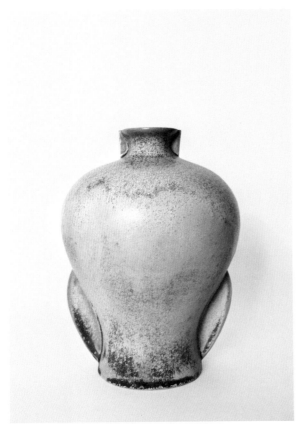

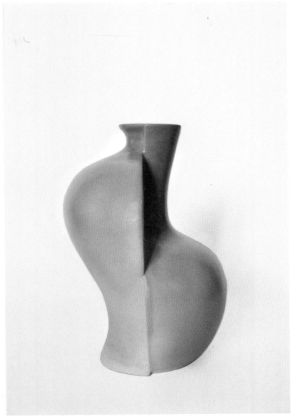

Facing page, top left
Moonbeam pendants for
Lucie Kaas

Facing page, top right
The Mass series includes a
reconfigurable sofa, a daybed
and a pull-out bed

Facing page, bottom
Mass series daybed

This page, top
Split vase

This page, bottom
Reform I carpet for Tai Ping

Patricia Lip & Yun Ting Lin, Studio Lim

We knew we wanted to start a design brand after our master's degrees. Having seen many artistic objects and design pieces by talented designers, we were curious about how our choice of materials could apply to everyday products.

Patricia studied in the US before doing a bachelor's degree at the Duncan of Jordanstone College of Art and Design in Scotland and an exchange programme at Konstfack in Sweden, then a master's at the Royal College of Art in London. Yun Tin did a bachelor's degree at the National Taiwan University of Science and Technology, then a master's degree at the RCA, where we met and found we had the same goal of bringing new aesthetics to sustainable design.

Critical thinking is essential to develop an idea. At the RCA, we were encouraged to explore the possibilities of material from how it's formed to what it could be. This wasn't built on an intuitive approach but through experiments — the artistic result was a form based on discussion, failure and non-stop hands-on sample making. Our studies led us to focus on materials through experimentation and to follow what we found through our hands.

Both of us worked for other people before we launched our own brand. Patricia worked for a distributor of furniture and lifestyle brands to understand how to drive profitability and develop and sustain relationships with customers. Yun Ting worked at a firm designing consumer electronics like smartphones and laptops.

Sustaining business growth while focusing on creativity is one of our biggest challenges. We also find it challenging, but necessary as a start-up with limited resources, to create value over the long term. It's been tough to launch a design business across Hong Kong and Taiwan, but there are advantages. While Taiwan is rich in materials and manufacturing, Hong Kong is a finance and trade hub. Between both, we think we're standing in a place of opportunity for design and business as well. We've also received support from the Taiwanese government, such as opportunities to exhibit in international trade fairs and funding for design projects.

Our product range is a result of craft, technology and modern manufacturing. Made of flax fibre and finished with lacquer, our Fibrewood Objects and Time Lapse collections demonstrate what we think is an innovative approach to materials, with an emphasis on aesthetic appeal through research and experimentation. We plan to continue to manipulate plant fibre to further develop new products for sustainable living. We also participate in design projects where we can employ our skills and design perspectives.

We're dedicated to plant fibre because of its uniqueness and sustainability. Despite the complicated production process, the nature of the material plus wood shavings collected from carpenters in Taiwan and old newspapers always bring about unexpected results. The intrinsic features, such as the patterns that resemble brush strokes and the characters and words revealed from the newspapers, give character to each piece. We aspire to one day create an interior space from walls to furniture; each pattern would be created by different types of plant fibre or upcycled materials.

We're always inspired by natural elements. We collaborated with the Toyama Prefecture General Design Center to design a chopsticks holder. As the goal was to create a product with a Japanese technique, we wanted to reflect some sort of Japanese authenticity in the design, so the landscape of Toyama was part of our consideration.

Expressing our personalities in our designs isn't essential, but it's intrinsic. We believe every designer is an individual with different knowledge and experiences, and their work always communicates how they think. Sometimes this isn't deliberate — it's revealed through the look and style associated with a piece.

We don't think design should be defined by its national origin unless nationality is key to the design. Design can help preserve culture and keep authentic skills alive, but we think designs created within the idea of tradition don't necessarily work. In the modern world, design thinking allows us to preserve tradition in a new form. As for our inspirations, design is still a new industry in Asia, so our inspirations don't always come from our own countries but from around the world.

An iconic Hong Kong design would be the rooster bowl: a bowl with a hand-painted rooster between a rather rough painting of bok choy and chrysanthemum. In the 1950s, this cheap, durable bowl was commonly used in dai pai dongs — stalls that provide inexpensive cooked food — and eventually at home. The bowl has witnessed the societal and economic change of Hong Kong, and has become a traditional part of the local food culture. For Taiwan, there's the Plastic Classic by Pili Wu. It represents part of Taiwan's immigrant culture, as well as exhibiting the influence of cheap and mass-produced plastic goods on our daily lives.

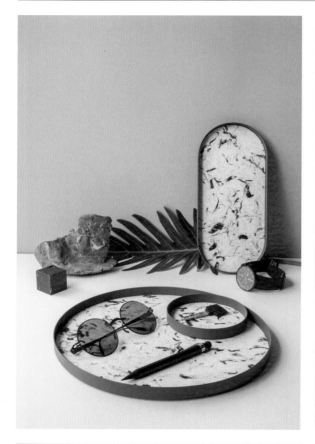

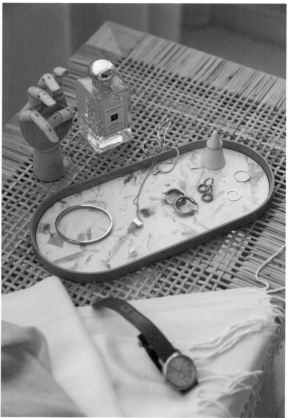

Facing page, top left
Round Tray 280 from
the Fibrewood Objects
collection

Facing page, top right
Long Tray 280 from
the Fibrewood Objects
collection

Facing page, bottom left
Round Tray 120 from the
Time Lapse collection

Facing page, bottom right
Coasters from the Fibrewood
Objects collection

This page, top
Fibrewood Objects dessert
plates

This page, bottom
FLIP 110 tabletop or wall
mirror

Raft Wong, Rcube Design Studio

I've loved design and drawing since I was in secondary school. I feel very excited that design inspiration is everywhere — it keeps me thinking about creating things or solving problems.

I studied product design at Hong Kong Polytechnic. I've found what I learnt to be useful but not enough by itself, especially in the design field. I think it's more important to keep your eyes open for new trends, new technology or enhanced tools — you can't stop learning and observing every single day. You have to enjoy being a lifelong learner. Sense and talent are also very important — good designers can reflect their personalities in their designs.

I've been an industrial product designer for over 15 years, several of which were spent with other companies before Rcube. I've focused on consumer electronics and telecommunication products, and worked for brands including RCA, GE, Alcatel and Siemens. I've also worked with designers from countries such as the US and France.

I think the greatest challenge is creating our own brand and letting everybody know about it. As a start-up, we may find that buyers don't trust us or want to buy from us. Building a brand is definitely a process, but that ongoing effort results in establishing long-term relationships with your customers. A recognizable and loved brand is one of the most valuable assets a company can own, but it's also the most difficult to achieve.

The second challenge would be financing. I don't think there's enough government support for the creative industries, though we've had some support in export marketing. It's difficult to see the advantages of being a Hong Kong designer. We're facing the rise of Taiwanese and Korean design, backed by government support. And people in those countries love and are proud of their local design products. In addition, the European and US markets perceive Hong Kong as just a part of China, and they feel that we produce copycat designs. We've participated in some international design awards to get recognition and prove the quality of Hong Kong design.

We launched in 2012 as a multidisciplinary design studio, with the key principle of design from geometry. We believe that good design can enhance the quality of life, and we specialize in creating innovative and practical home accessories and stationery. We think our products blend this innovation with simplicity.

We aim for minimalism, and most of our products are created with natural materials. They're not only eco-friendly but also durable. The raw materials range from brass to concrete. They evolve over time, and their character and beauty are elaborated in their surfaces through use. We hope users feel our products are simple but unique and fun.

As for dream projects, every new idea is my dream project and I put all my effort into it. When we get there, the dream is the next one. That means the best never happens. Pursuing new things is my dream — it's imagination-driven.

I do feel our products represent my personality, and it makes them unique. I strive to use eco-friendly, simple, pure, sensitive and tactile materials to achieve what I call 'simplicity and surprise, materiality and immateriality, from object to space'. But it's not important that they fit into a local tradition.

Facing page, top
INVISI portable and desk pen

Facing page, bottom left
EX!! cupholder

Facing page, bottom right
Ruler dock

This page, top
Ball tabletop mirror

This page, bottom
BalloonDock

South Asia

Farzin Adenwalla, Bombay Atelier

I've enjoyed the process of creating since childhood, so my career happened rather organically. I studied at Victoria University in Wellington, New Zealand. Design school was quite tough for the first couple of years — it was retraining my brain to see things differently. In terms of building a design process and being in a high-pressure environment, I feel that it's added value. However, working in the field is a completely different animal. I worked with Rahul Mehrotra's RMA Architects in Mumbai and a couple of other studios before I started Bombay Atelier. It was a great experience — I learnt how to be organized and work in a team.

As an independent designer, there are many challenges. I'd say the business aspect of it — marketing and sales — requires a completely different skill set. Furniture manufacturing is largely an unorganized sector in India, and while the relationship between craftsperson and designer is much closer than when working with large-scale manufacturers, it can be really difficult to streamline processes and production.

I describe Bombay Atelier as an experimental and culturally focused design studio. The goal is to tell a story through every object created, and to strengthen cultural and social narratives through design. I like to think of it as poetry through objects, and I hope people who experience my work can appreciate the art of storytelling through design. I also want to get people interested in the actual process of creation, rather than the final object. I'd love to collaborate with technology companies to bring together new ways of experiencing art and design.

I use metal in many of my designs — it has a cold nature attached to it, so I find it a worthy challenge to create something that can resonate with human emotions.

I consider myself an Indo-Persian New Zealander. It's difficult to me to be able to convey all these different values and aspects of myself into my work. However, I do believe that by the very nature of this diversity I'm developing my own language, and therefore there's an inbuilt personality in my work.

I wouldn't say there's a particular designer I'm inspired by. I get my inspiration through poetry, literature, science, sociology and psychology, and from artisans who work with local materials and carry on ancient traditions. I think instead of choosing an object from a country that symbolizes its design, I'd rather attach emotions and adjectives — so India is excitement and colour, Iran is nature and heritage, and New Zealand is calm minimalism.

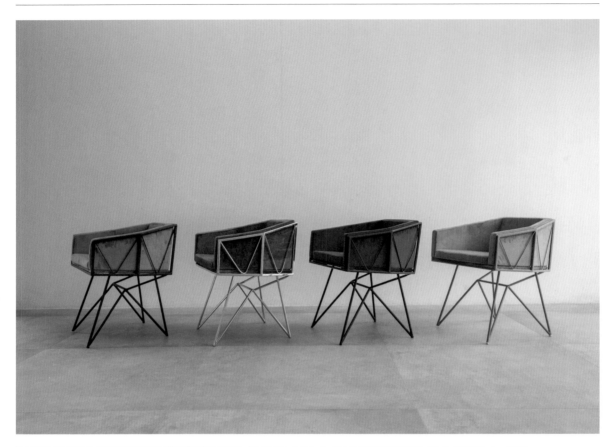

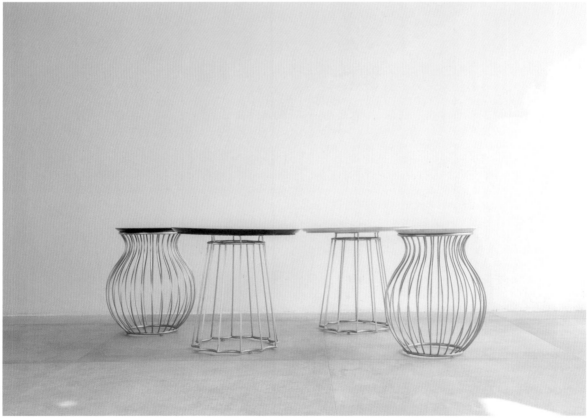

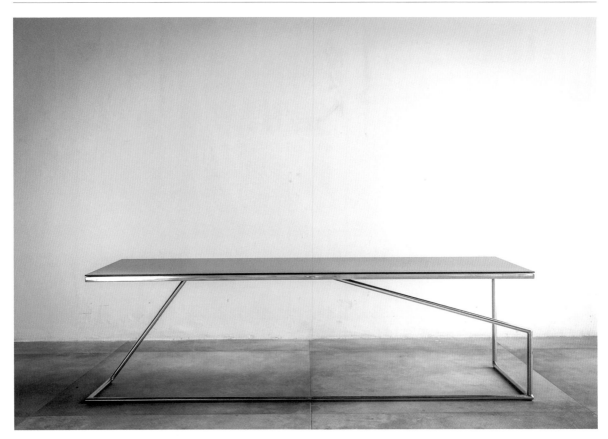

Facing page, top
Crow chairs

Facing page, bottom
Handi Man and Mister Chai
side tables

This page
Asana table

Ashiesh Shah

Exposure to art and design classes since I was young piqued my interest in design. Sheetal Gattani, a teacher and incredible artist, would persuade me to visit galleries with her during the summers. I remember being awestruck by the Jehangir Art Gallery, and later seeing lifestyle programmes on the homes of the rich and famous. Being a dreamer and with the support of my family, I commenced my journey in design.

I studied architecture at the Rachana Sansad Academy of Architecture in Mumbai and went on to Parsons for a master's in interior architecture. Parsons moulded me through a developed interest in the micro instead of the macro. I think it really moved something in me, changing my perception about design as a profession and its vast reach.

I then worked for renowned architect Nozer Wadia in Mumbai, a true pioneer of design thinking and development, who moulded my skills and helped me develop my strengths. He brought discipline into my work ethic and exposed me to unparalleled field learning.

Interior design and related practices have often been dismissed as inconsequential in India; working here has been packed with other challenges as well as advantages. When I came back from New York, I initially felt lost. There was no industry as such — even today I feel there's no formalized interior design industry. However, that gave me a beginner's advantage in a country developing at an unparalleled pace. There was a big market waiting to be explored. It was a matter of time before people started realizing the importance of living well, and I think I was there at the right time. We have the most interesting people in Mumbai, and I can't imagine a life anywhere else. Sadly, the infrastructure is at a point that we want to run away every other day. But that will evolve.

Our work is deeply rooted in minimalism, change and the overarching philosophy of *wabi-sabi*. Once I started exploring my interest in product design through my first piece, the Lingam bench, my understanding of the simple concept of geometry began to grow and I started seeing materials very differently. That's when I started building an identity of my own. I also realized that I'd been trying to force myself into a bracket and to give my work a language, but from then it started falling into place on its own. You can't force design — it's evolutionary. You evolve very spiritually when you start finding your own geometry and you keep going deeper. Eventually, it's a search to try and find a meaning in everything you do. Then when you're making something new, your first thought is 'Do we really need to create a new product? Aren't the iconic pieces already iconic?'

If I have the urge to make something for myself, I know there'll be a buyer somewhere. When you make something new, the first client should be you, who knows that millions of things exist in the world. That's how spaces develop a sense and senses develop a feeling that trails into an experience.

Recently, I've developed a passion for Indian crafts, ranging from a burnished clay art form from Meghalaya popularly called Longpi pottery to wooden toy crafts coloured in natural dyes known as Channapatna toys from Karnataka. Besides working with local artisans to achieve one-off pieces, I'm trying my hand at marble and resin. These are the kinds of challenges that keep me going.

My upcoming atelier has been my dream project that I'm very excited to actually see find form. We call it an atelier on the lines of old-school French ateliers: a thinking space where we invite people to have conversations on a much deeper level. What I really miss in India is design and art conversations; we hope to change that.

My designs express my personality by maintaining my visual aesthetic with a predominant passion for creating change. With nationality, I subconsciously employ traditional handicrafts or artworks, and I relate to Indian tribal art in my visual aesthetic. It's important to design spaces based on context. Local traditions come into play through those handicrafts, including our reconstructions with a modern perspective. We also encourage these artisans of dwindling craft forms to keep traditions alive by pushing boundaries in their design thinking. It's an association with long-term benefits.

An inspirational Indian designer would be BV Doshi, who continues to be one of the most celebrated urban planners of all time. Doshi instituted a shift in the way architecture is perceived through impeccable foresight and forethought. I recently acquired his conceptual sketch *Tower of Babylon*, which triggered an understanding of where I am in the current world through the parallels it draws with my own practice.

It's hard to choose a single piece to represent India, but in terms of geometry it would be the form of the lingam, which is unique to Indian geometry. The iconic shape often associated with Lord Shiva is a symbol of divine generative energy, and its form easily relates to arches and curved surfaces in architecture. I tend to design keeping in mind this form of calculated proportion, and have integrated this geometry into my furniture pieces.

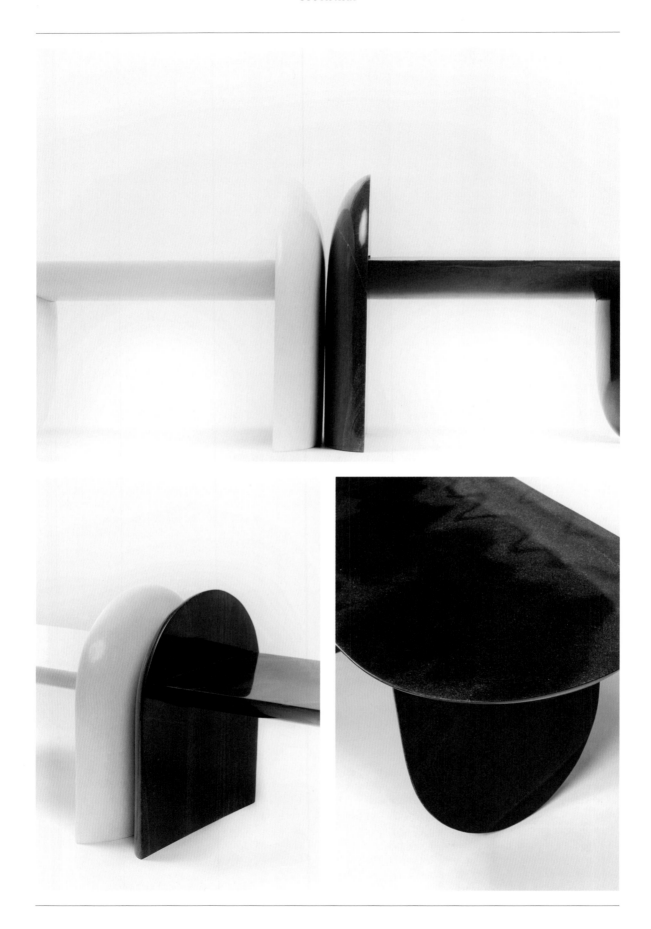

Facing page
Lingam bench

This page, top
Jaipur Blue Totem stools

This page, bottom
Many Moon stackable
tableware collection

Parth Sharma, Bombay Bungalow

My earliest fascination with design happened because of my love for cars, which made me want to become an automotive designer. But limited exposure and high competition in the field led me to pursue my bachelor's degree in product design instead, at Raffles Design Institute in Singapore. My parents were initially sceptical about the course, which was completely understandable — design as a professional career was unconventional in India at the time. But they took a leap of faith and supported me in my desire to pursue it. It made me feel indebted to them, and I wanted to excel and prove to them that they made the right choice for me.

In my course, I learnt many fundamental principles and foundations in design that I still use, but nothing compares to hands-on experience that provides real-world skills and insights you can't learn at school.

Apart from a short internship at Tata Motors in Pune, I was then employed with luxury furnishings designer Christopher Guy in Singapore for nearly ten years. Working directly with him gave me invaluable experience in furniture design and the industry as a whole, and a new appreciation for furniture designers from the 1920s to 1950s. He rewarded my perseverance with bigger roles and responsibilities over time, with large interiors projects in Sanya in China and for Harrods in London. I began as a junior designer but departed the company as a brand management and product design manager.

As I'm currently the sole proprietor of Bombay Bungalow, it's been a challenge juggling the creative and administrative parts of the business single-handedly while also competing with large furniture brands for a position in the market. While I was in Singapore, business set-up and government support for the creative industries was very strong, and it's been more difficult for me in India. But India's single biggest advantage is the variety of traditional handicraft skills available in different parts of the country, which Singapore just doesn't have.

I describe Bombay Bungalow's core philosophy as Indian modernism and minimalism. Every design is inspired by India in some form, be it traditional architecture or the fascinating quirks of everyday life, and reimagined into refined products. Until very recently, there were many Indian designs that were beautiful but too ethnic in taste for people around the world to purchase and match with other furniture pieces in their homes, and my designs aim to help bridge that gap. A dream project would be to acquire one of the many beautiful 1940s Art Deco buildings on South Mumbai's sea-facing Marine Drive, and completely refurbish it to a timeless aesthetic using Bombay Bungalow's design philosophy.

I love the realization and appreciation people have when they can relate my minimal designs with their subtle Indian connections. I hope it makes them view Indian designs in a different light, and enjoy the stories that come with each piece of furniture. Personally, I'm a fan of using a combination of materials, which is clearly visible in the Purda cabinet that uses marble, metal, acrylic and fabric. But recently, I've been experimenting with more sustainable materials.

I don't think it's essential to express my personality or nationality in my designs, but with globalization and generic design proliferating in everything we see, injecting my character into what I do helps to differentiate Bombay Bungalow from the rest and bring some creative variety into the global design scene.

I don't have a specific designer I'm inspired by, as I draw my inspirations from many different places — people, culture, technology, nature. Thankfully, in India there are many local design traditions still thriving in the domestic market. It would be exciting if I could help to adapt these traditions and create new designs with a more global aesthetic while maintaining cultural identity.

As for a design that represents India, I'm not sure if it's the best, but the most recognizable object would be the centuries-old traditional Indian woven bed called charpoy (meaning 'four-legged' or 'four-footed' in Hindi). Its simple construction and natural materials stand the test of time.

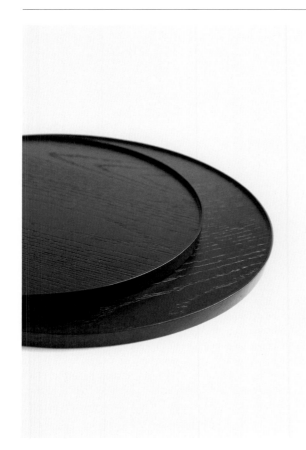

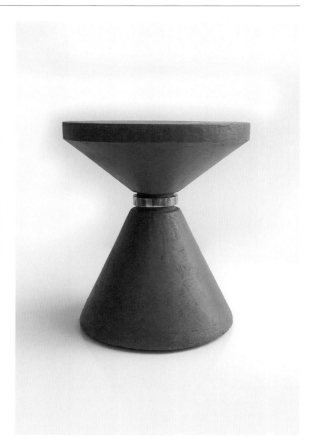

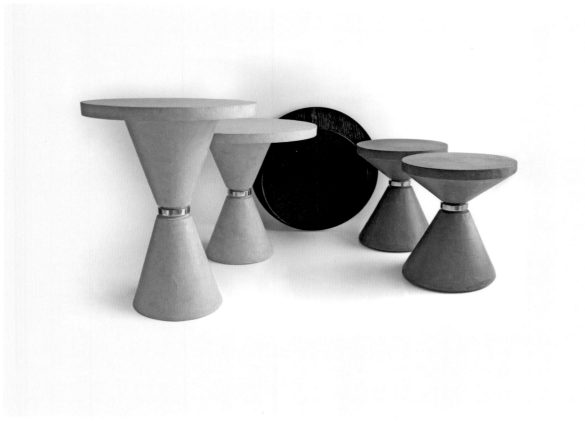

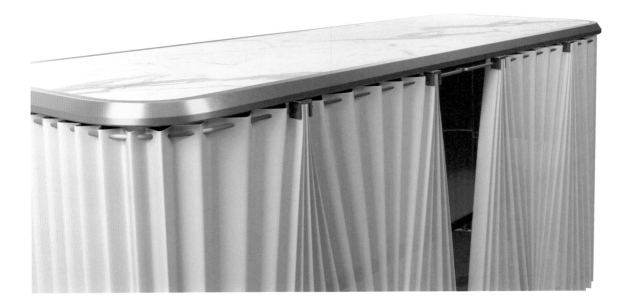

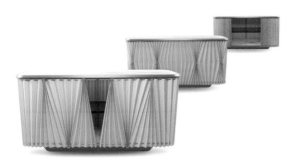

Facing page, top left
Chit Chaat trays

Facing page, top right
Chit Chaat stool

Facing page, bottom
Chit Chaat side tables and
stools

This page
Purda cabinet

Nikita Bhate, Sār Studio

I spent a lot of time sketching and painting when I was a kid, a gift my parents believed was God-given because nobody in the family could even draw a straight line! I realized my love for design when I was in college, which was also a result of the exposure I got because my father made us travel around the world. I studied a bachelor's in interior design in Pune, then a master's in European design and product design at IED Madrid, which was then headed by Jaime Hayon.

Education in India is slightly orthodox, and I feel I didn't get much exposure when it came to hands-on work. But during my master's I met a lot of important designers, visited workshops and exhibitions, and worked on projects that had a hands-on approach. I think this makes a huge difference when you actually start building things — it makes you independent.

I had great opportunities to work with other people before I started off on my own. After my master's, I was selected for the International Design Pool at Vista Alegre, which is a 200-year-old Portuguese porcelain and crystal company. There I met with david/nicolas, who introduced me to Fabrica Research Centre, where I was accepted for a one-year residency. This was one of the greatest experiences of my career — all the talented young people I met from around the world have become the pillars in founding Sār. Our design revolves around stories with a cultural exchange, concepts that make design an experience and not merely a product.

When I was starting out, the challenge was to find producers open to experimenting and prototyping. It's hard for them to change, which makes it really difficult to get exactly what you want. But the studio has grown bigger, and we're setting up our own workshop so we can explore all our ideas. I'm glad for the large population we have in India! The production costs are competitive, even paying above market rates, and I believe it brings a strength to the brand — to both make and sell products at an affordable price, to make good design accessible, which is our primary aim.

Sār Studio's main way of working is through collaborations. Design is about exchange and exploration of culture and know-how, which results in interesting concepts. The experience has been great — ideas flourish, conversations lead to surprising stories, and most importantly we grow together.

We want to build pieces that aren't categorized, but make living comfortable for people in the given context. We hope people experience the functionality we want to bring, like our UPGRADE system, which considers sustainability and our ever-changing environments. We want to make as per necessity and create less waste, so a single-seater can be 'upgraded' to a three-seater just by adding or subtracting parts. The client has to only purchase the additional part, we're able to recycle the unneeded part, and thus we optimize material usage for sustainability.

We don't have a single material or technique that we like to use, though we like to source locally for sustainability. Sometimes we keep seeing materials in the same context and that creates this specific impression in our heads, but it's amazing when we see the material in a different application.

I definitely have a dream project. I'm thinking of building a Sār Village — a place built on the idea of self-sufficiency and sustainability that harvests its own materials, hosts designers who use them, and has products built by families who can live and thrive in the same place, all with food, water, electricity and other resources harvested on-site. I hope to invite people from around the world to explore design in any direction, be it with products, architecture, food or anything that can have a creative process.

I don't believe in any style in particular, and I don't see any boundary that needs to be set in terms of nationality. I believe a product should have a character of its own, independent from trends — more relative to the context in which it needs to be made or lived. We do believe in keeping the forms 'essential', meaning a clean, simple language, but if a piece needs some exotic decoration, so be it. And while it's important for a product to fit with its local tradition, I feel that keeping a tradition alive need not be deliberate, but should be an ingrained part of the object — even a little hint is enough sometimes. It all depends on what the context is. Plus, there are many ways in which these traditions can be reinterpreted to suit the contemporary world and lifestyles. It's important to adapt so that people can relate to it much better, giving it scope to stay alive. I love some of our architects like BV Doshi and Bijoy Jain. I believe they've found a way of retaining what's Indian but reinterpreting it for a more modern life.

As for an object that represents Indian design, I love the Indian lunchbox. It sums up the culture in the best possible way — from the emotions of the family who prepares the food to the idea of carrying a homemade wholesome meal, to the functionality of its compartments and simplifying the act of eating without the need of additional plates, just a simple stainless steel object that is hygienic and long-lasting!

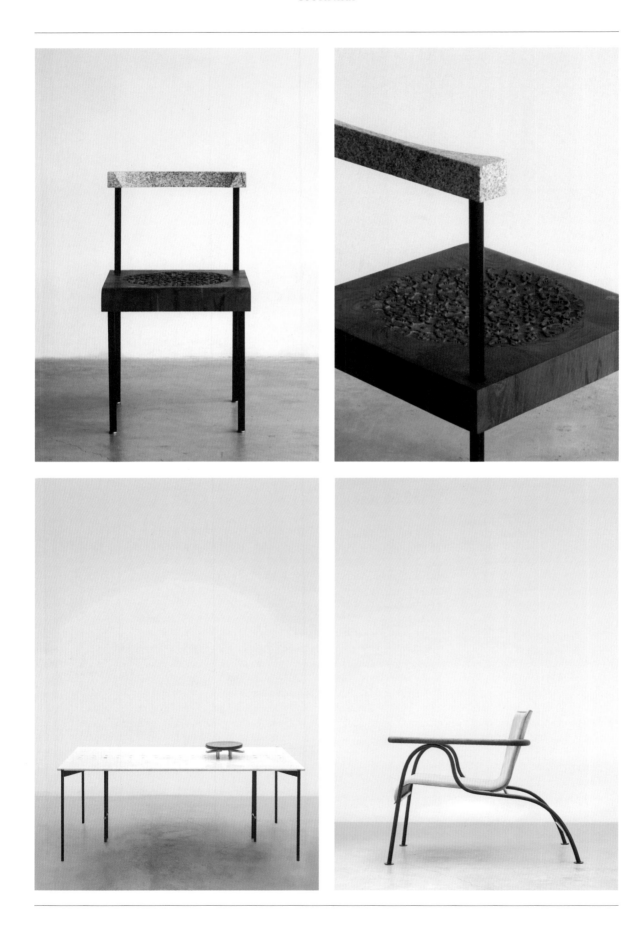

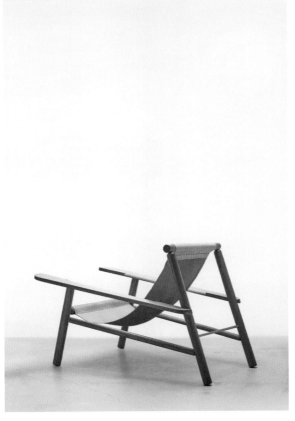

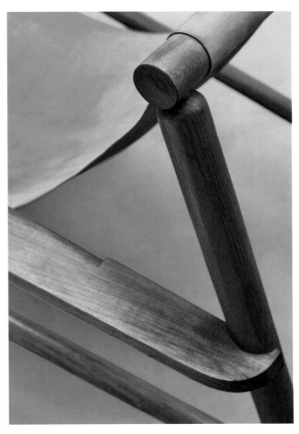

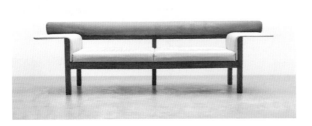

Previous page
Nikita Bhate (right) with
creative adviser Pascal Hien

Facing page, top
Sancha (Block) dining chair

Facing page, bottom left
Dasta (Handle) dining table

Facing page, bottom right
Tankan (Stroke) lounge chair

This page, top
Ayama (Extend) deck chair

This page, bottom
Barza (Balcony) sofa

All from the Reclaimed
Stories collection designed
with Pascal Hien

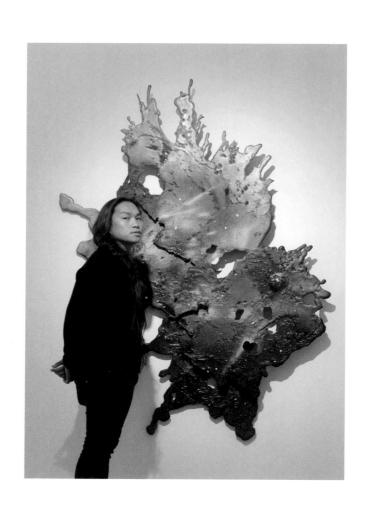

Jinggoy Buensuceso

When I was a kid, I was always very happily entertained by creating things with my hands. I'd manipulate existing objects and turn them into something else, and that remains true to this day. My family supported my dream to be an artist, and sent me to the University of the Philippines to study fine arts.

Whenever I get invited to give talks on art and design in universities and colleges, I always say that you only get 30 per cent of your learning from school and that the other 70 per cent is through experiences after that. The 30 per cent is key because that's the foundation for the 70 per cent.

Before I started my studio, I worked for TN Philippines as a product designer for almost two years, and I was mentored by Al Coronan during that period. It felt like it was my *masteral*, or doctorate, in material and technique, and it helped a lot to enhance my design work and art.

I find the biggest challenge is with people: managing and training my team to uphold standards and timelines, and to face new challenges in projects. Working in the Philippines is an advantage because we have a good supply and assortment of natural materials and skilled artisans who deliver quality work. The challenge is still in the lack of technology that could speed up production or help create more advanced forms and finishes. Our government has platforms for emerging talents in design and art, such as Manila FAME by CITEM, and it supports designers and companies to showcase their work in exhibitions abroad.

I have a highly skilled team, who I carefully selected to assist me in working on medium and large-scale sculptural installations.

We work with different kinds of metal, wood and cement. My studio workshop is set against the backdrop of lush greenery in Alfonso, Cavite, and I believe this helps everyone to be inspired and balance the challenges of our work.

I create linear and organic forms combined with Brutalist textures and techniques. My pieces are beyond form and function because they tell stories that engage the audience. A dream would be to be able to create a sculptural, architectural building that's iconic and will make a difference to this generation.

Metal is one of the most challenging materials for me. I like discovering different techniques and processes to create new forms and objects from it that support my artistic vision and design.

I've found in collaborating with foreign brands that you may receive preset guidelines but you have to add value to the process, showing your identity as an artist or designer. Identity is key for me, and anything I do and make is Filipino because I am Filipino. I don't limit myself to what traditionally looks Filipino, but I do have some works wherein I preserve and promote certain traditional designs, techniques and materials, such as when I worked with rattan and a century-old weaving technique from my hometown in Bataan.

My inspirations are mostly from art: Jun Yee — my mentor — Arturo Luz and Gus Albor. I don't think there's been a particular design piece that represents the Philippines, but there are iconic materials like rattan and Capiz shell. That iconic piece is yet to be made.

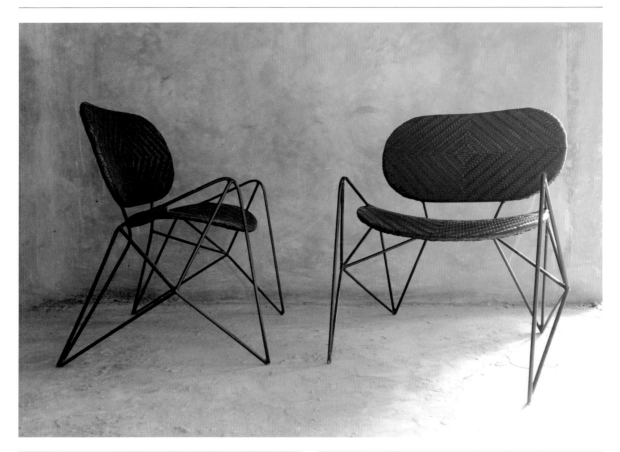

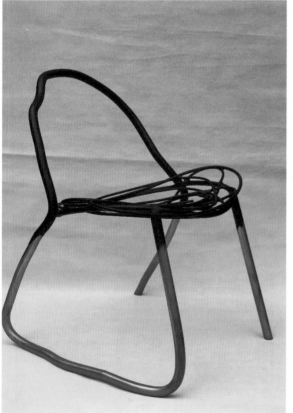

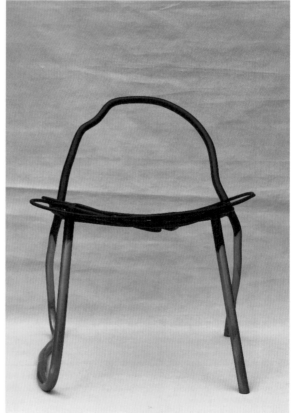

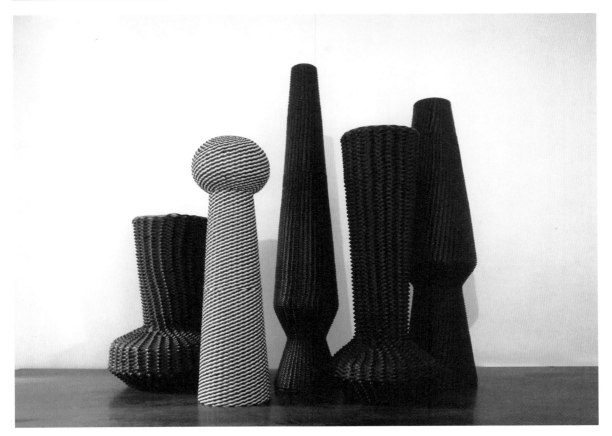

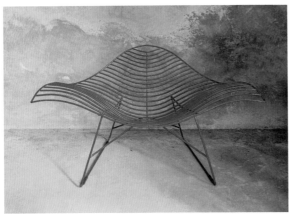

Facing page, top
**Spider chair for
HM+Buensuceso**
Image copyright Sam Manalo

Facing page, bottom
Half-baked chair

This page, top
Simpay sculptures
Image copyright Sam Manalo

This page, middle
Moth chair
Image copyright Sam Manalo

This page, bottom
Tirintas pendant

Rachelle Dagñalan, Rada Collab

Ever since I was a child, I've been fascinated with the arts. I made toy cars and villages with modelling clay, traced cartoons and imitated projects I watched on *Art Attack* and other shows. I knew in high school that I really wanted to pursue a career related to design or the arts. My parents were very supportive.

I grew up in a provincial area with limited access to design and art education. I developed an interest in industrial design when I read about it in a magazine, and later I had to choose between doing a marketing degree in my home province or pursuing design, for which I'd have to move to Manila. I eventually did a degree in industrial design at the University of Santo Tomas. My studies taught me tools that would be useful in the field, and how to go through the design process.

I first worked as an assistant designer to artist and design consultant Jinggoy Buensuceso when I was training at the Design Center of the Philippines. It was an introduction to the different crafts of the Philippines, and made me appreciate the craftspeople and how much potential there is in manufacturing locally. Travelling from one province to another to witness how local products are made and meet different manufacturers gave me the foundation to start my own studio.

Starting young, and with very limited capital, I learnt to take on different roles in managing a business. Coming from a family that isn't so entrepreneurial, I had to learn on my own, attending seminars, taking short courses and learning from friends and mentors. The best learnings came from failures and dealing with challenging clients. But I'd say that it's an advantage to have the abundance of natural resources available in the Philippines — being a creative, there's a lot to explore. The disadvantage probably would be the very limited job opportunities available to fresh graduates.

I also credit my beginnings to CITEM's Red Box programme, a training programme for young Philippine designers that provides a platform to collaborate with local manufacturers and showcase our works in local and international exhibitions, all under the mentorship of renowned local designers.

The studio is turning seven this year. As our portfolio has grown, I've started marketing the products I've designed for local makers and manufacturers under the brand Rada Collab. The studio specializes in product design, space design and packaging design, and we're developing and producing a home decor line in collaboration with local artisans and designers.

Through my work, I hope to help more people, especially Filipinos, appreciate the beauty of our locally made products. It's my vision to make well-designed Philippine products more accessible to everyone, and to spark interest in the new generations to continue learning and preserving our traditions by supporting our craft products.

Through the years, I've learnt to work with a variety of materials such as different fibres, textiles, marble, wood, paper, clay and metal. What I like the most with woven material is its flexibility in application. It can be moulded, dyed, come in different patterns and be made soft or hard. I want to develop more possibilities with it.

A dream project would be designing for top brands or collaborating with an international designer. I did once work with another designer on a livelihood project for an international footwear brand, creating new products out of their scrap and factory rejects. I learnt how strict the brand was with quality control — we could hardly tell what was wrong with some of the rejects. Just imagine the volume of factory waste in the manufacturing industry across the globe. It's our role as industrial designers to bring in more thoughtful design for mass production, and to minimize waste through designing more environmentally conscious products.

I think my designs should always show my personal style, but infused with the identity of the client or of the community. It should be something I personally like or would feel happy about. I also try to use local materials and engage craftspeople to keep their traditions alive, but not necessarily to fit a local tradition. For local products to continuously thrive, we must learn how to make local more global.

Two Philippine design icons who have really impacted me are Kenneth Cobonpue and Budji Layug. I've looked up to Kenneth Cobonpue since university. When he became our chairperson while I was teaching at a university, I learnt even more from him, especially about perfecting forms. Budji Layug has also inspired me to explore and go bolder in design to make statement pieces.

The first thing that pops into my mind when I think of Philippine design is the *bahay kubo* or nipa hut. I think it best represents our heritage and our culture of families being closely knit. Each *bahay kubo* is distinguished by the culture and the environment of its location.

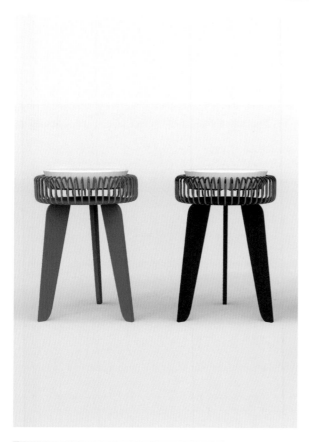

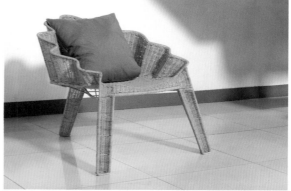

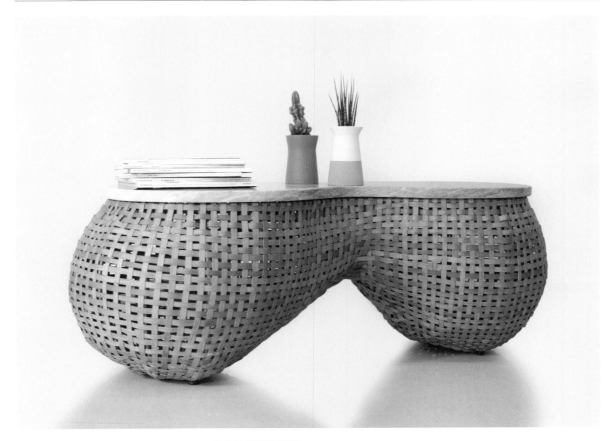

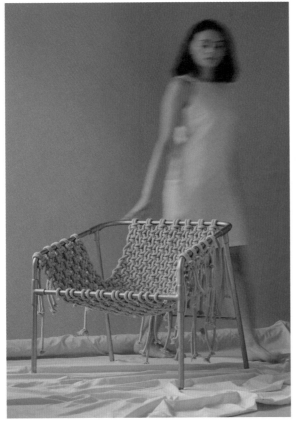

Facing page, top left
Musketeer stools

Facing page, top right
Tart chair

Facing page, bottom
Abaca baskets
*Left image copyright Frankie
& Friends General Store*

This page, top
Ola bench

This page, bottom
KnitKnock chair
*Image copyright Frankie &
Friends General Store*

Gabby Lichauco, openstudio

I knew I wanted to follow this path from the time I enrolled in art class at around seven years old. I've always enjoyed sketching, painting and creating DIY projects, whether for school or for myself. My family was very supportive, and encouraged me to find the right design programmes.

I did my bachelor's degree in industrial design at De La Salle-College of Saint Benilde, and then a master's in industrial design at Scuola Politecnica di Design in Milan. The subjects that focused on skills and research were the most useful for me. Overall, the applicability depends on the specific type of design practice you get into. From experience, I've grown to realize that it's time that will help develop you as a designer.

I worked at different creative practices before I decided which field I wanted to concentrate on. My first job was in a post-production and animation house, where I was surrounded by artists and I learnt to be more self-expressive. Then I worked for an architectural firm, where I learnt the fundamentals of interior design and architecture. Eventually these practices helped me decide the direction I wanted for my own studio.

The challenge for me is sustaining the studio with projects that are both challenging and financially rewarding. Sometimes it's one or the other. The advantages of working in your own country are the resources and the familiarity, but the challenge is expanding your project reach within the region and finding new networks through shows and exhibitions. However, there are government agencies with programmes that help young designers develop and connect with local export manufacturers. I haven't received funding, but my work has been showcased in the local CITEM show. They're the export arm of the Department of Trade and Industry, and their yearly trade fair promotes local exporters and designers.

My studio is a multidisciplinary design practice. We do everything from commercial and retail interior design to product development for manufacturers and brands. We've even done curatorial work for exhibitions. I hope that through my work, I can bring Philippine craft to the fore.

For me, exploring materials is like a food addiction — I can never have enough of it. Recently, I've been really into glass, exploring its many possibilities and working on it over and over again. A dream would be to design a zoo or aviary, or even be part of an aquarium park design project.

I find collaboration with foreign brands exciting not only because of the cultural exchange but also because I get exposed to their industry practices. When I learn more about their cultures, I have a better understanding of how to approach the projects. This also allows me to see things from a different perspective, which I then try to apply to local projects. One of my most memorable collaborations was working with industry+ to develop nendo's Tokyo Tribal Collection.

More than anything, personality is part of the foundation of my design process. Nationality is expressed by default through the materials readily at my disposal, but I don't think that overtly trying to reflect my cultural roots is an intentional part of my design process. I do always try to infuse local craft though — for example, the Philippines has a long tradition of hand weaving, the use of which I've explored in non-traditional ways.

Of Philippine designers, I admire architect Lor Calma. To me, he's a pioneer of contemporary design in the Philippines. He was also one of the first multidisciplinary designers here.

I know it sounds crazy, but if I had to choose one object to represent Philippine design, it would be the ubiquitous barrel man, a popular souvenir. It's a male figurine carved out of wood, partially hidden inside a round wooden barrel. When the barrel is taken off, the male figure inside is revealed, with a prominent phallic protrusion jumping out. It's a bit pornographic, but I think it singularly reflects Filipinos' creativity and humour. It's been a favourite gift for foreign friends and tourists as far back as I can remember, and to me it's one of the most underrated pieces of Philippine culture and art.

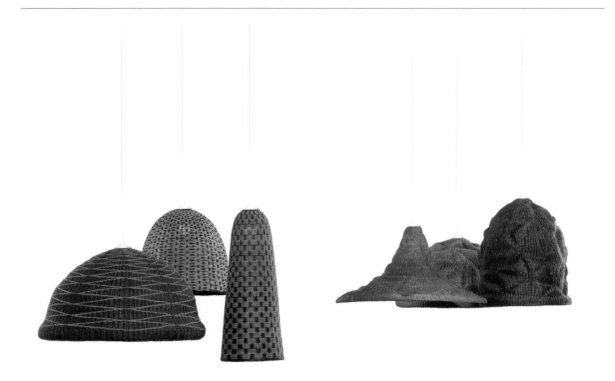

Facing page, top left
Candy (left) and Monolith
(right) pendants for
ZACARIAS 1925

Facing page, bottom left
Flute from the Pinch the
Bublinka collection for
Spektacularis

Facing page, bottom right
Winter Clear designed with
Jiri Pacinek for Spektacularis

This page
Spring stool for industry+

Lilianna Manahan

I think I always knew I wanted to do something in the arts, and it became more defined when I was picking a course for college. My parents were supportive, since I come from a family that enjoys the arts.

I did my foundation studies at Central Saint Martins, then my bachelor's degree in industrial design at the University of the Philippines. In my foundation studies, we were taught how to think and sketch in 3D, which meant a lot of quick sketches with paper maquettes, and how to draw from different sources to come up with design concepts. In my bachelor's, we were taught how to be resourceful, and model making was a huge part of our process. So, when I started working, my foundations were set and it really allowed me to be limitless in generating concepts. Drawing and making maquettes also helps in communicating with craftspeople.

I worked for Kenneth Cobonpue's design team for a year before starting my own studio. I saw how the business side of design worked, and there were always constructive critiques on each piece, which taught me to consider every factor in making a product.

The biggest challenge I face running my own studio is the business side. It doesn't come naturally to me! I also think a big challenge will be to keep pushing myself to continue with my ideas and be brave enough to see how people will respond. Another challenge is showing the local craftspeople that there's great value in their work, and continuing to push them to do new things. The Philippines has a lot of untapped craft talent. There's a lot to dig deep into in our culture because it's so diverse.

I've received some government support. I joined the Red Box programme organized by CITEM, which allows emerging designers to work with export manufacturers to produce a capsule collection and show it at Manila FAME. It was helpful because I was able to see how several companies worked and to work with different materials.

I usually start out by making quick sketches until I feel I've exhausted all options. Sometimes I do that on paper, sometimes with modelling clay or by manipulating paper. I then make a scale drawing, then a full-scale mock-up or drawing. I usually send out some parts to a subcontractor, then do the finishing and details myself. In the last year, I've tried to incorporate a particular craft I've been learning. Right now, I'm learning metalsmithing and traditional water gilding, so I do most of the water-gilded parts and small metalsmithed parts myself.

I hope people will find fun and delight in my work. I think everyone is given some sense of imagination and creativity, and I leave room for the viewer to expound on the image I jump-start them with. CS Lewis said that the role of the creative is to help illustrate the things others cannot imagine. Though most of my work may look fun at first glance, my hope is that it will help point people to certain realities that we sometimes cannot picture, but through an image could hopefully understand.

My choice of material has been narrowed down to mostly metals or anything with a metallic quality. Metal can be formed in so many ways, and I like how there are different options in working with it, whether through hammering, cutting, casting or bending. I also like how it can be finished in so many ways, so it leaves a lot of room for experimentation. However, I've also been able to work with glass-blowers from the Czech Republic. I learnt so much about glass as a material, which was really exciting. The glass-blowers are masters, so they knew how to execute my designs efficiently and beautifully.

I'd love to do the interiors and tableware for a restaurant, and make sure that everything helps heighten the experience of eating. I'd also really like to do a site-specific large-scale sculpture or installation.

I think my personality automatically comes out in my work, because I usually end up making something that expresses something personal. I hope that when my whole body of work is put together, there's one quality that ties everything together so one can see that it was all made by one person. I do try to incorporate tradition — I want to showcase craft and techniques that are slowly fading. I've noticed that I'm drawn to labour-intensive work. I want to bring back the art of working with your hands.

The Snotty Vase by Marcel Wanders is what got me interested in product design. But locally, I saw that Kenneth Cobonpue's work could appeal locally and internationally. I saw it even more when I worked for him and witnessed the close attention he paid to detail. My parents also had a great influence on my creative process because of how I saw them work, and how my father would always tell me to look at everything.

As for a representative Philippine design, I like the *butaka* chair. It's a lounge or accent chair from the colonial period. Some variations were used as birthing chairs. It has a relaxed incline for lounging, and long armrests. Its sleek, curved profile is timeless, and it showcases wood carving and weaving, which I think are the strengths of Filipino craftspeople.

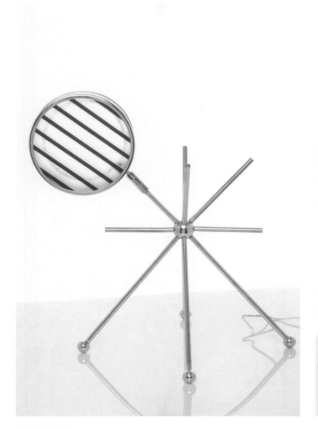

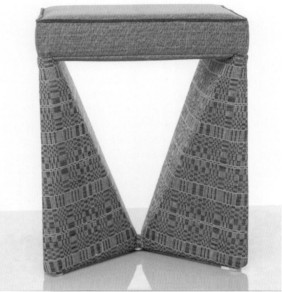

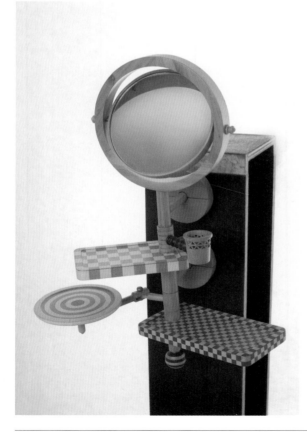

Facing page, top left
Asterisk lamp

Facing page, top right
Fold stools

Facing page, bottom left
Mwah, Moi! vanity mirror

Facing page, bottom right
Vases from the Spine
collection

This page, top left
Groink candelabra from the
Creatures series

This page, top right
Ooooma candelabra from the
Creatures series

This page, bottom
A piece from The Befores
series
*Image by Rob Leung
Photography*

Joseph Rastrullo

Back in high school, I learnt a bit about AutoCAD. Our professor asked us to design an interior space, and that's when I realized that I was interested in furniture design. But it wasn't until I met Budji Layug, by which time I was already studying industrial design, that I decided to pursue furniture design as a career.

I studied industrial design at De La Salle-College of Saint Benilde in the Philippines, then a master's in business design at Domus Academy. If it wasn't for both, I don't think I could've started my career as easily and early as I did. The most important thing I learnt about myself was that I have an interest in how things work in terms of system and process. By understanding the elements needed, it became easy for me to take on projects because I understood my clients' needs.

I first worked for Mercedes-Benz Philippines, handling their VIP events. After that, I started at the studio of Budji Layug and Royal Pineda. My experience there was about maturing my eye for design. Drawing 100 designs a day and having almost everything rejected — I enjoyed every moment. Budji has mentored me through my career, and I'm continually inspired by his drive for design.

For me, the challenge is finding the right talent and managing the team, especially if they don't have the same vision and passion as you do as a designer. And having done projects in Indonesia and Thailand, I've learnt that we face a lot of similar challenges. I'd also say that each country has its own advantages in the skills of its designers and manufacturers, and how each country's craft can shine based on the choice of material.

I'd say, though, that what makes Filipinos unique is that we've focused on a more artistic direction. Philippine design is still very commercial, but when a buyer visits, they can find designs that show mastery in our craft and how focused we are on detail, making a piece look unique while playing with a story to enhance our design. And personally, working closely with Manila FAME when I started my career was a big help. They hired me as a consultant, introduced me to manufacturers around the Philippines and allowed me to showcase my work in their events. That was my opening to bring my designs abroad and boost my career.

Currently, we have two brands. There's our design studio Rastrullo, where we focus on an artistic and customized approach to our pieces. We play around with chaos and let our lines loose. We were initially inspired by nature but eventually we started using forms that look good casting shadows, or colours that easily pop in a space.

The second concept, Manolo Living, focuses more on modernizing Philippine designs. There were certain designs that were used from tribal times through to the Spanish occupation. Manolo Living aims to retell stories from the past by recreating spaces for the modern Philippine home. We try to reinterpret Philippine heritage because we believe it doesn't only belong in the past but also in the future. We'd like to make time stand still and recreate those stories into people's spaces so we can be reminded of the past, because I do believe remembering the past helps shape our future and reminds us of where we came from, which makes us become better versions of ourselves.

We work with so many materials, from wood and rattan to fibreglass and other engineered materials. But I'd say I've developed my craft with metal; I love how it can follow my forms and details. I'm addicted to the lines I create, the shadows I cast and the finishes I can use in my forms.

My dream would be to collaborate on projects with the studio of the late Zaha Hadid. But, if I could be a bit weird, send me underwater or into space to design a resort or a design hotel. Besides crafting furniture, I'd love the challenge to maximize myself as an industrial designer.

There are forms I create for myself. But working with companies in Indonesia and Thailand, I learnt how to discipline myself. I learnt about their materials of choice and how things worked for them and their clients. It's always interesting to design for others. I find joy every time I see people use my products.

Expression of my personality, nationality or any traditions depends on the brand. Rastrullo focuses more on myself, while Manolo Living focuses on Philippine stories. For that, we're always thinking about how we can modernize Philippine designs and stories to fit into modern homes and architecture.

When I think of Philippine design objects, two come to mind. We have the *butaka*, known as a birthing chair because of its long arms. But I like the story behind the *mariposa*, which is known as a piece of courtship furniture. I think it shows how romantic Filipinos can be, especially in traditional courtship where the man shows off to the woman in her parents' living room, where they can easily watch over him.

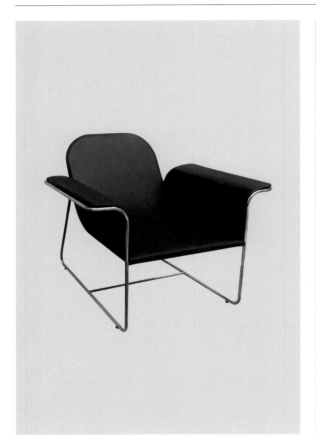

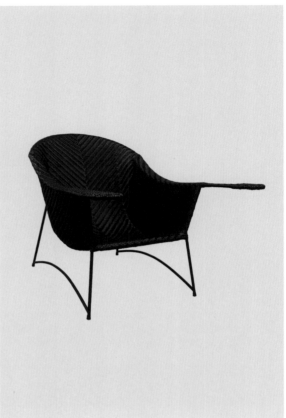

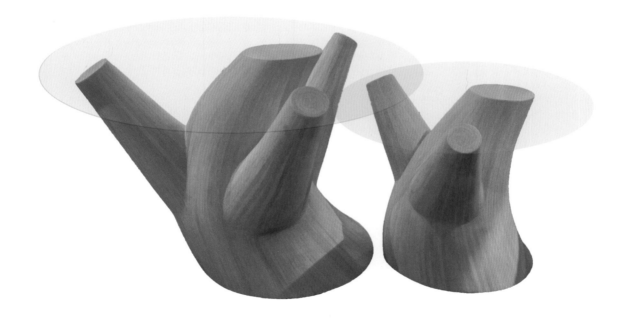

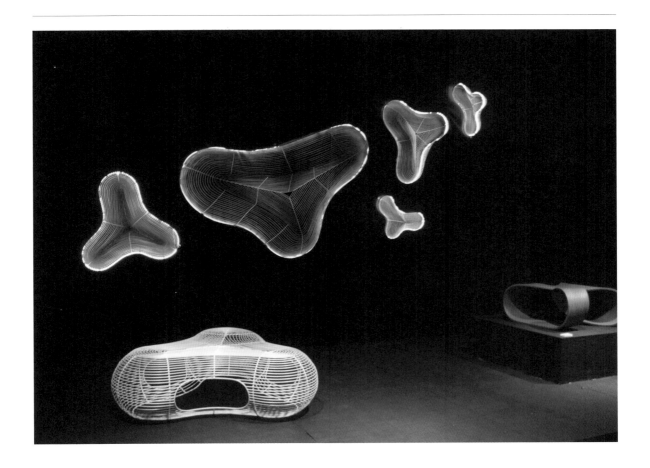

Facing page, top left
Margarita lounge chair

Facing page, top right
Remedios lounge chair

Facing page, bottom
Esther side tables

This page
The Banaue collection

Stanley Ruiz

I began to take design seriously as a career in my early university days. Back then, I worked on a number of side jobs and small design gigs and was able to support myself while I studied. I knew then that studying design was a practical choice, and pursued it with dedication.

I received my bachelor's degree in industrial design from the University of the Philippines. I also studied a range of design and media courses from drawing to jewellery design and media arts at several schools in New York. Aside from that formal education, I've done workshops in things like interaction design and ceramics, in Bali and New York.

During my university days, the industrial design curriculum was mostly craft-oriented. The programme was partly intended to support the craft and furniture export industries, which at the time were still booming but eventually declined in the mid- to late 2000s. It proved to be useful, since I've continuously worked in the home and furniture sectors since my student days.

Before I founded my studio, I was an employee for quite some time. I've worked with NGOs involved in crafts and fair trade, and I've travelled and seen the beauty of the archipelago because of this. After that, I landed a job in Bali, working for a multinational manufacturer designing products for the likes of Pier 1, Williams Sonoma, Freedom Furniture, Bayswiss, Habitat and others. Later I moved to New York, where I worked with Jonathan Adler, Real Simple and Soho Studios.

With all of this experience, I was able to learn both from the production side in Asia and the market side in North America. Due to the nature of my work, I was also able to travel to different places and experience various cultures. I've visited trade shows, factories, small workshops and many other places. I learned the language while living in Indonesia to imbibe the culture and communicate better with artisans.

As for the challenges of working in the Philippines, geography is one. We're an archipelago like Indonesia, and this poses a lot of challenges — practical ones like logistics, resources, cost and delivery times, as well as cultural and regional differences. But we have a lot of nice beaches and the countryside is beautiful. And I've been fortunate to receive some funding, in the form of exhibition grants, from government agencies under the Department of Trade and Industry, particularly the Design Center of the Philippines and CITEM.

My studio work is divided into two distinct parts: one is personal work, where I do my own explorations and experimentation, applying a more conceptual approach. The other is client-commissioned — this is the more strategic and commercial side of my practice, where I deal with clients and help them develop products, spaces and brand identities.

I don't aim for people to experience anything specific through my work. Any reaction is a bonus. And if my work enables people to think more deeply and perhaps ask questions, that's another bonus. As for materials, I like working with wood and clay for their warmth and natural character. Wood is a living material, and clay, while quite forgiving, is also unpredictable.

Since my student days, one of my dreams has been to design for IKEA. I think a project with them would force me to think better, get to the true nature of things and understand a product's reason for existence. It would challenge me to answer tough questions and address key issues. In the end, I'd come out of it as a better person and designer. I've designed products for a number of other global brands. Because most of them produce in Asia, I've learnt a lot in terms of the import-export dynamic and the design-production chain, from ideation up to the end user.

In terms of expressing my personality and nationality through my designs, I've been struggling to find the answer to this question since I started designing. Lately, I've been more conscious of injecting my personality into my work, but nationality is something else. I'm still looking for ways to express my Filipino-ness without being too literal, too obvious. I do think it's important to some extent that my design adheres to tradition, but it's my position that we all need to evolve, and we all need to inject something from our milieu into any tradition.

I've been inspired by other Philippine designers: Milo Naval, Dem Bitantes, Kenneth Cobonpue and Tony Gonzalez, to name a few. I've admired their work since my student days. I respect their dedication to the craft, for opening the doors to the younger generation of designers such as myself, and for the friendship and advice that they've given me.

As for a design that exemplifies the Philippines, the jeepney would be the obvious choice, but I think I'd go for any improvised seating, generically called *bangko*, found in most *talyers*, or repair or vulcanizing shops. For me, this object is representative of the peril and promise of my country.

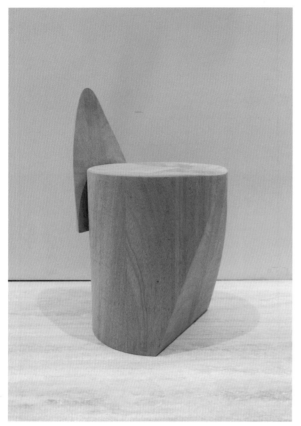

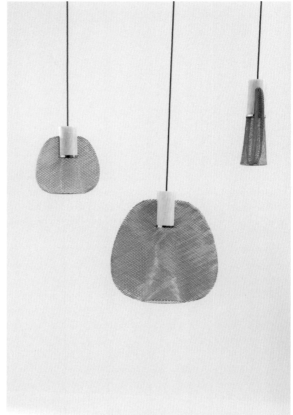

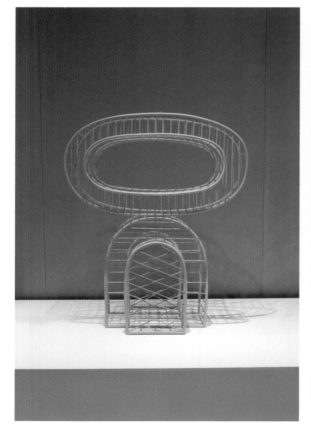

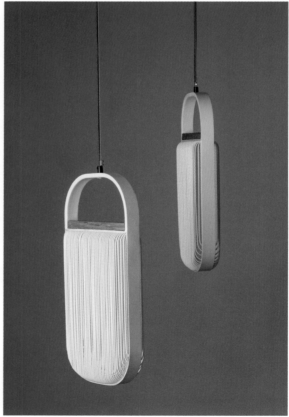

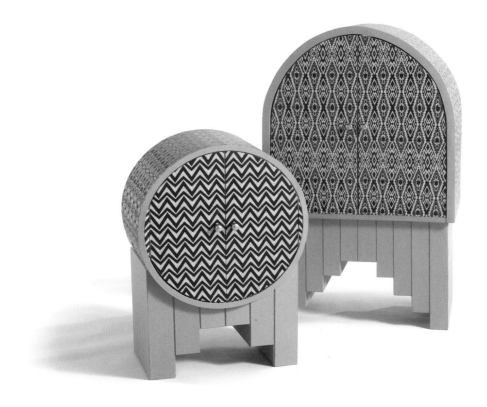

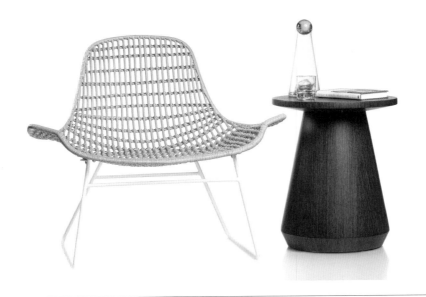

Previous page
Image by Buboy Cañafranca

Facing page, top left
Slice stool
Image courtesy of Stanley Ruiz/CITEM

Facing page, top right
Petiole pendant for Schema
Image courtesy of Schema

Facing page, bottom left
Line Assembly I
Image courtesy of Stanley Ruiz/CITEM

Facing page, bottom right
Flume pendants designed with Celia Jiao for Schema
Image courtesy of Stanley Ruiz/CITEM

This page, top
Cabinets from the Modern Primitives collection
Image courtesy of Stanley Ruiz/CITEM

This page, bottom
Shelter Island lounge chair
Image courtesy of Stanley Ruiz/CITEM

Jim Torres, Zarate Manila

Nobody in my family is into design or the arts, so entering a fine arts school was quite a challenge, and was accidental — I initially wanted to pursue architecture. But over time it became clear to me that I wanted a career path that involved creating and building objects.

I did my undergraduate study at the University of Santo Tomas, and am now pursuing postgraduate studies with Thames International College Business School in Quezon City. It's an innovation and creative entrepreneurship programme initiated by the British Council that aims to uplift the arts industry by educating creatives to monetize their crafts — to balance between the arts and business, creating a more sustainable industry. What I've learnt from school has been essential to the way I work. The disciplines of industrial design and design thinking play significant parts in my thought process.

I started in furniture design in 2014 as an in-house designer for Industria Edition in Pampanga, a furniture manufacturing company known for its hand-forged metal pieces. I stayed there for almost two years, which allowed me to explore material manipulation. My mentor there, Jude Tiotuico, taught me about being keen on details, which I always consider in designing. It also got me interested in creating designs with intricate techniques and processes.

Coming from a family with no background in the furniture business was quite a challenge — there was no one to consult with on my decision making in setting up a design studio. Financial capital was the biggest struggle, but in 2015, I joined CITEM's Red Box programme. Sixteen of us were chosen for the five-month incubation and mentorship sessions with designers like Kenneth Cobonpue, Budji Layug, Lulu Tan-Gan and Josie Natori. We then exhibited at Manila FAME in 2015, and I won the Grand Winner Award for Home Decor with my Harris lights in collaboration with Venzon Lighting Manufacturing.

I think the advantage of working as a designer here in the Philippines is that we have a lot of material resources and talented craftspeople. Unfortunately, it's a dying industry according to statistics — many design manufacturing businesses closed after the economic crisis in 2008. I think our government lacks a strategic plan in terms of addressing sustainability within artisan communities. Providing platforms like trade fairs and exhibitions like Manila FAME is not enough — I think it should provide what SMEs really need: financial assistance or loans for struggling businesses and emerging studios with high potential.

As the Red Box Grand Winner, my prize was international exposure at ICFF in New York. I think we need more of this kind of support for up-and-coming talent. It was a great help for me to start my brand. I think if we could get follow-up support like loans or incubation funded by investors, we could develop further and eventually compete globally.

Zarate Manila focuses on metal furniture, lighting and objects. We work with a small community of metal craftspeople in Pampanga. Our design DNA relies on marrying modern design with traditional, handmade production.

I have quite a unique, maybe crazy, way of creating designs. As the creative director, I want to be known as a designer who doesn't settle for what already exists, who at least tries to make a change in a pool of ideas. It makes me happy when people are interested in how I develop my designs and I get to share the story behind the production.

A dream would be to have an international showroom in New York City. I always see New York as a destination for me personally and for the brand in the future. My experience of my first international exposure at ICFF was an eye-opener. I realized that there's an audience that can appreciate my designs. They may look avant-garde and 'too much' for some, but that exposure opened a lot of doors and boosted my confidence to pursue Zarate Manila as a full-time studio.

I think what differentiates my crafts from other designs is the storytelling in my collections. I believe that even objects can tell inspiring stories and be conversation pieces. Furniture design is not just about aesthetics and function. And I definitely pay attention to traditions — that's why the word 'Manila' is in the brand name. I always want to promote the local, whether it's through aesthetics or values — I want to show it on a global platform. We have so many stories to tell as Filipinos. On that, I think the best representation of us in furniture is the peacock chair. It's an iconic piece from the 1900s, and often referred to as the Manila or Philippine chair.

Kenneth Cobonpue is the Philippine designer I most look up to. He dominated the furniture design field internationally, and he has represented our country well globally. As a Filipino designer, he's been a strong catalyst for our design industry. I also dream of collaborating with him in the future.

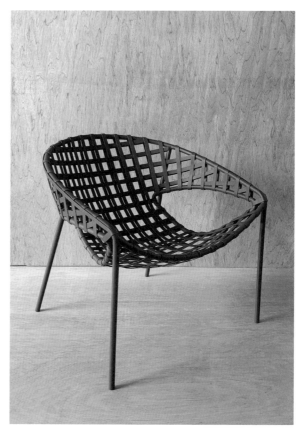

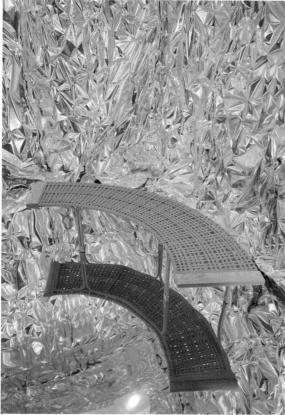

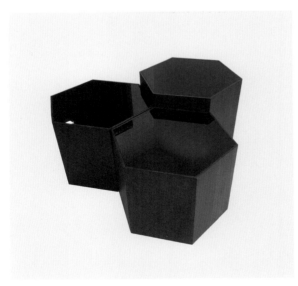

Facing page, top left
Aerial collection

Facing page, top right
BRIQUE lounge chair

Facing page, bottom left
CHEQUE bench

Facing page, bottom right
VERMEIL dining chair

This page, top left
ZEDD III chandelier

This page, top right
Harris pendant

This page, middle
Apollo pendant

This page, bottom
Bee side tables

Decha Archjananun & Ploypan Theerachai, THINKK Studio

When Ploypan was young, she would build Barbie houses from boxes, coloured paper, textiles and the like, and it inspired her to become a designer. Later, we both went into interior architecture, which meant selecting objects for our projects, so there's some background with products.

We did bachelor's degrees in interior architecture at King Mongkut's Institute of Technology Ladkrabang, then Ploypan studied her master's in interior architecture and furniture design at Konstfack in Stockholm, while Decha's was in design for luxury and craft at ECAL in Lausanne.

We use our knowledge of interior design for furniture and product design to have a clearer picture of space, furniture placement and so on. At ECAL, all the projects were brand collaborations led by guest designers such as Ronan Bouroullec, Pierre Charpin, and Edward Barber and Jay Osgerby. It was a great way to learn from a professional point of view, and quality was strongly emphasized. For Ploypan, studying in Thailand and Stockholm helped her to understand Asian and European lifestyles and ways of thinking.

Decha spent a year as a junior interior designer in a medium-sized firm, where he worked mainly on 3D visualizations and helping senior designers. Ploypan started her career as an interior designer. The company had three businesses: an interior design studio, an imported European furniture shop and a decorative items brand focused on local materials and production. She found it inspiring, and it made her want to know more about the product and furniture business.

The biggest challenge in running our own studio is balancing business and passion. We started with passion, and we want to keep that passion going while running the business. Fortunately, designers in Thailand are becoming more connected with each other and are sharing knowledge, which is good for the future of the design community here. Bangkok Design Week has become a popular event where people can be inspired. Thailand is also popular among travellers, and the tourism business has created opportunities for Thai designers. The varieties of materials available make for a great advantage as well.

We've also had government support. When we started out, we were part of an incubator for young Thai designers supported by a government association. After that, there was a project called Talent Thai that provided us a small space at a local furniture fair to exhibit our designs. We were also selected to show at MAISON&OBJET in Paris supported by the Department of International Trade Promotion.

We try to find new possibilities for an object by observing the people who use it, researching its history and being open to working with any materials. Material experimentation might be considered our identity — we think each material has specific applications and characteristics that affect its usage differently. We think our works have an international language together with a local touch, which we hope people will enjoy.

We've also done a foreign collaboration, which was an unexpected project with Tectona. We were nominated by Swiss design studio BIG GAME to participate in a competition among 11 international designers. One of the judges was Ronan Bouroullec, our favourite designer. We won the award and came up with the Batten collection, which is now produced and sold by Tectona.

We have a dream to have our own factory with different forms of low-tech production, and we've already done part of that with the Lanna Factory, a low-tech machine that lets people make lampshades.

The recognition of THINKK Studio's style is more special to us than displaying our respective personalities or nationality. In this era, we think of ourselves as global citizens, so we prefer to design something for the majority of people, to understand function and beauty — that's more important than a design that only fits one place. However, we think that a design with a traditional touch can bring a special character and beauty, so we often use traditional crafts in our designs. And while we don't think of one single person as our local hero, we're inspired in some way by many people. Korakot Aromdee from Korakot is one — he uses local crafts in his designs, which also creates jobs for people in his community.

We think a representative design would be seating made with local natural materials and craft. Thai people are creative, fun and friendly — we always want to welcome guests to sit and enjoy themselves in our homes.

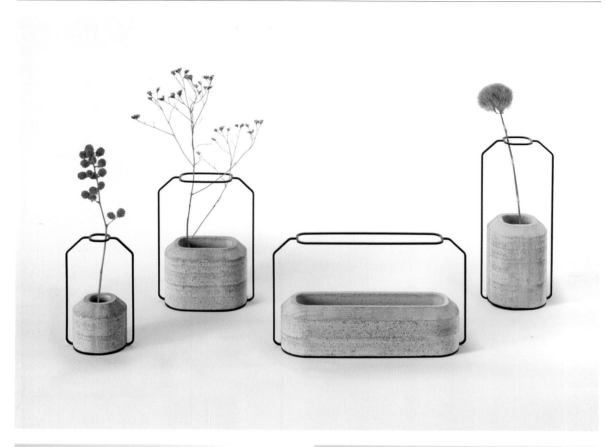

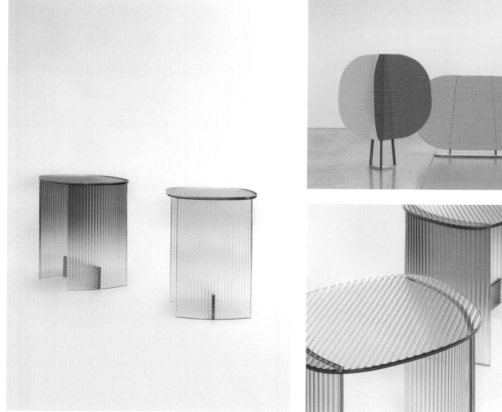

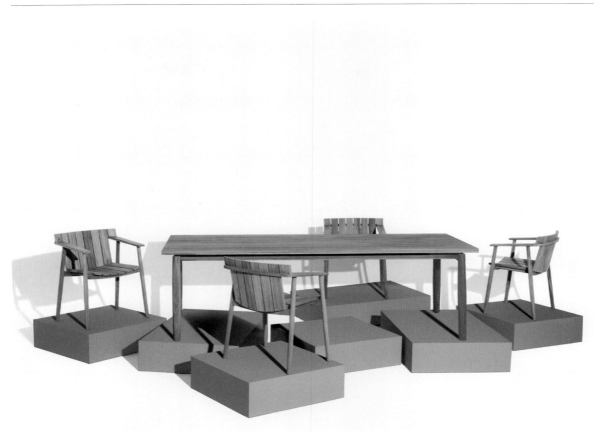

Facing page, top
Weight vases for Specimen
Editions

Facing page, bottom left
Fluted glass tables from the
Made in Thailand collection

Facing page, bottom right
Hide & Seek dividers
(above), Fluted glass tables
from the Made in Thailand
collection (below)

This page, top
Batten collection for Tectona

This page, bottom
Any Length stool

Ada Chirakranont & Worapong Manupipatpong, Atelier 2+

We've been interested in architecture and art since we were in high school, and both of us went on to study for our bachelor's degrees in interior architecture at King Mongkut's Institute of Technology Ladkrabang, then master's degrees at Konstfack in Stockholm, where Ada studied textiles. Worapong also has a master's in architecture from the Delft University of Technology and did a foundational art course at the University of Oregon.

We learnt a lot about practical design skills at KMITL, and developed more on the intellectual side when we studied abroad. We were also very inspired and influenced by the places and cultures we experienced in Europe.

We both worked for other companies in Bangkok before starting Atelier 2+ in 2010. Worapong worked at interior design firm IAW as a junior interior designer, and Ada worked at IA49. IAW's style and sense of detail were a particular influence on Worapong.

Teamwork, management and leadership are the most challenging aspects for us. You take on more projects but you still have eight working hours in a day and five working days in a week, and we want to maintain the best quality for our clients, so it's a big challenge.

It's a privilege to be Thai designers. You can still find good manufacturers to collaborate with, from small workshops to larger factories. You can find a place to make an affordable prototype even in the city. You can also still find places and people to experiment with different materials, techniques and crafts.

We explore design language by combining and scaling architecture, interior design and product design. Our works fall somewhere between art and design, traditional and contemporary, local and global, and Western and Asian. We love to explore new possibilities rather than limit ourselves to one definition — we enjoy working in a borderless field. We have a dream for the near future to create a space where we can have different design activities and nurture a community for young local designers.

Recently, we've been collaborating with different design studios, product design brands and manufacturers locally and internationally — we've been working with Design House Stockholm since 2015. It's great experience for us to work with international brands. Most local furniture brands in Thailand used to be OEM factories before, so there's a big difference when we work with international brands, where the branding is so important.

We don't have a favourite material. It's always very exciting when we work with a new project, new place, new material, new technique and new manufacturer. It makes us feel energized again.

Personality and nationality for us just come out naturally in our designs — we don't even think about it. All of our work reflects in some way how we think, what we love and where we live. And it's important for us to reflect traditions in our work — it makes a good ecosystem for the design industry.

The idea of representative design objects makes us think of everyday products related to agriculture and food, like mortars and wicker baskets. As for local inspirations, we admire Korakot Aromdee of Korakot and Suwan Kongkhunthian of Yothaka. It's not only their original design language but the fact that they've taken local traditional crafts to the level of global contemporary design.

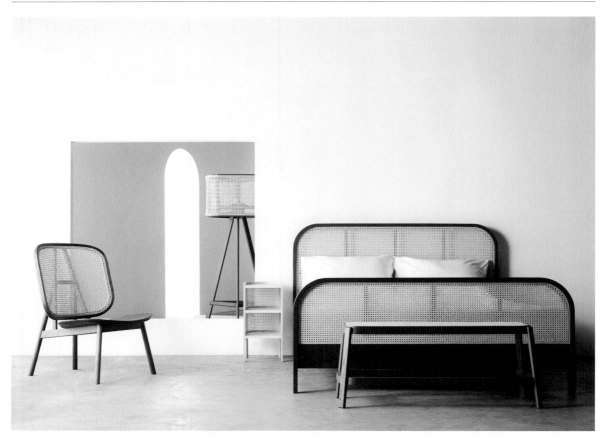

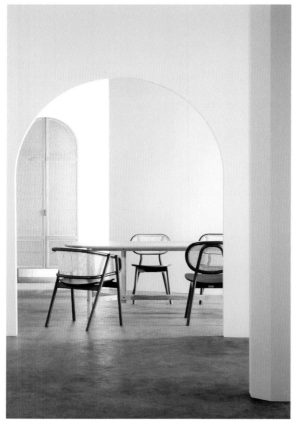

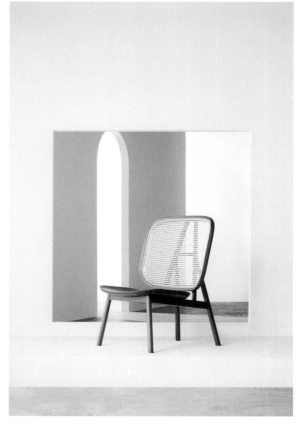

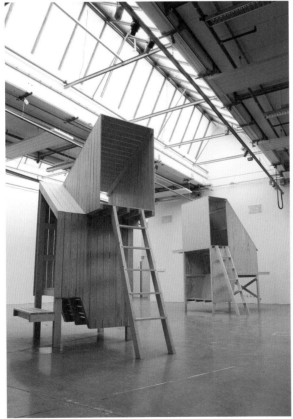

Facing page, top
Various Cane Collection
pieces

Facing page, bottom left
Cane Collection seating and
wardrobe

Facing page, bottom right
Cane Collection lounge chair

This page, top left
Greenhouse for Design
House Stockholm

This page, top right
Kiln wood and clay
collection with Yarnnakarn
Studio

This page, bottom
Playhouse for HOBS

Apiwat Chitapanya

I first knew I was passionate about art and design when I was in secondary school. My father, who studied fine art at Silpakorn University, has been a driving force and a true supporter of my artistic education.

I started studying art at a vocational level at the College of Fine Arts in Bangkok. After that, I earned my bachelor's degree in fine arts from King Mongkut's Institute of Technology Ladkrabang followed by a master's in applied arts from Silpakorn University. My studies allow me to see artistic and aesthetic ideas from a new perspective. They opened a world of imagination that I'd never seen before, and I can now bring those fantasies to the real world.

I don't have any experience working as an employee. Early on, I produced works for other brands, like decorative sculptures for hotels and restaurants, by using my specific techniques and materials. Even now, I don't consider myself as having a studio — I'm a freelance designer for brands that are interested and believe in my work.

Thailand is a resource for handicrafts, craftspeople and raw materials, so I have more opportunities to study and develop products of an international standard from those resources. I like working with various materials — I think each one is interesting and gives a different feeling. However, the material I'm particularly attracted to is metal. Its manufacturing process is interesting, and it not only gives a strong and stable feeling, but sometimes a soft feeling depending on the processes and techniques you use. It's a versatile material.

Much of our work is for MASAYA, a brass furniture brand with the fundamental goal of producing artistic and unique products. All our products are inspired by nature, with each one having its own story. We pay attention to details, and strive to deliver the best and most differentiated products in the market. The designs stem from everyday, fundamental shapes, which are enhanced into a product that fits every home. As with MASAYA's mother brand Asia Collection, the products are created to be majestic, combining brass, stainless steel, marble and one-of-a-kind wooden elements. It's modern furniture designed to fit into anyone's lifestyle.

I hope those who like my works can sense my spirit in them, and find new perspectives and experiences through interacting with them. I've dreamed about having my work exhibited at famous museums or at special projects in important places around the world.

I think individual personality and intuition implicitly create a unique identity in the work of a designer that makes it easily recognizable. It's not necessary for my work to fit in with local traditions, because they might put too many limitations on the design, but in general I think it's beneficial if a designer's work can keep a tradition alive and internationally known. I'm always impressed with furniture that can blend local wisdom with up-to-date production methods.

I've learnt how to think and how to work from many talented Thai designers, not one in particular. Their experiences have motivated me and made me move forward as a product designer.

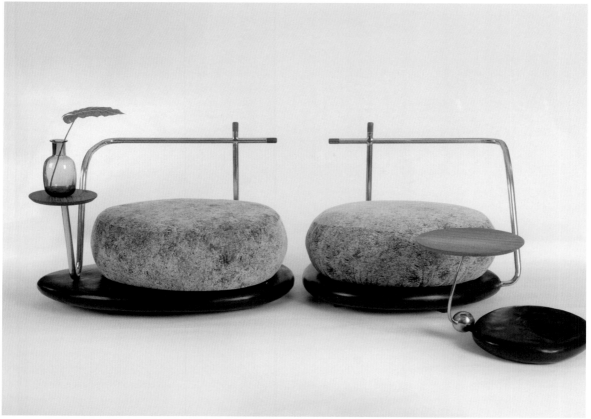

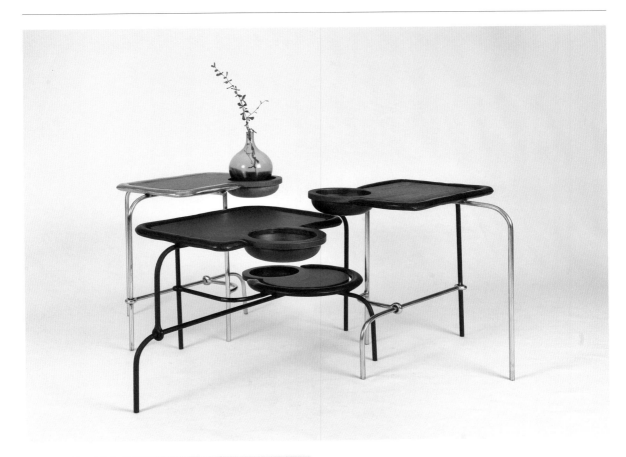

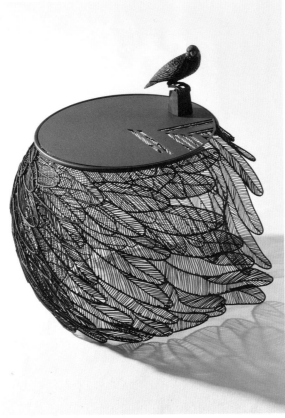

Facing page, top left
Screens from the Zen Stone
collection for MASAYA

Facing page, top right
Stick screen for DEESAWAT
and MASAYA

Facing page, bottom
Armchairs and side
table from the Zen Stone
collection

This page, top
Compound modular table
series for MASAYA

This page, bottom
Side table from the Feather
collection for MASAYA

Saruta Kiatparkpoom, PiN Metal Art

I received a bachelor's degree in visual art from Srinakharinwirot University, then started working as an artist. My family owns a factory that employs 60 people, and they wanted me to work for them in sales. I'd say they half-supported my idea: they let me be an artist, but I had to think about how to make money for myself. I found that being an artist in Thailand is quite difficult, and eventually I became a designer.

I also studied for a master's in applied art at Silpakorn University, which I've found very useful. Learning art allows me to design and create works for people who understand art, but even if people don't, they can still access emotions, feelings and beauty in the appearance of decorative works.

I work as an art teacher on the weekend and run my studio during the week. I started out as a supplier for interior designers, making decorative metal artwork to their designs. When I installed pieces, I started to wonder why they weren't my designs, so I tried to learn more about design. I wanted to prove to my family that art and design can be developed into a business.

Asia has strong artistic and cultural roots, and traditions of fine craft. This is the cultural capital we inherited from each other, and I think we should capitalize on those roots to create works — it's an advantage of being from Asia. The Thai government also offers support for emerging designers and for entrepreneurs. As a young designer, I was selected by the Department of International Trade Promotion for the Talent Thai programme to exhibit at trade shows in Thailand and abroad. I also entered their programme for entrepreneurs who want to show at trade fairs, and they supported me to show at MAISON&OBJET in 2018 and 2019.

My studio PiN is about transforming and reusing seemingly worthless steel debris to make artworks and decorative objects. The industrial manufacturing process of door and window parts creates a lot of waste, which is all scrap ready to be sold. We rethink and redesign the waste, and in addition to creating beauty there are benefits like reducing pollution — the material is more than just scrap.

I hope people who experience my work gain some inspiration about upcycling. Reused material can be beautiful and can have a higher value than if it's thrown away.

Currently, my working space is behind my family's factory. I'd like to have a small factory and showroom of my own for my products and production. I'm planning on that, as my pieces are getting bigger and bigger, and the space I have now isn't enough for large-scale projects.

I've also done some collaborations. In 2015, I made a feature wall for a retail space in Phuket: a 23-panel fish piece over six metres wide and a metre high, made in Bangkok over a month and delivered and installed over another month. That was challenging.

I think it's a very good thing if I can design or make something that retains the essence of my nature — where I live, where I stay, what value, what meaning, what beauty I find — and transforms it into an object that expresses the essence of Thai style and shape, made by hand. My designs can also help develop and promote the skills of workers from the factory, as they're skilled welders and my designs use those techniques. I think those types of objects are representative of Thai design: they use craft techniques, are delicate and draw on our expertise and skill.

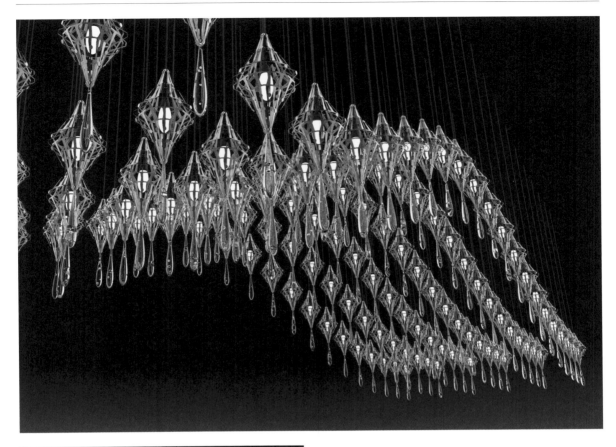

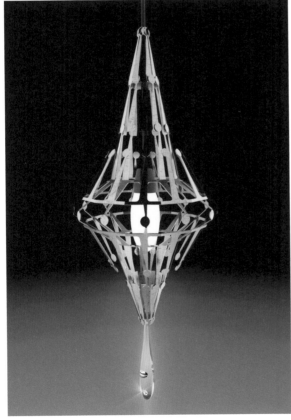

Previous page
*Image by Alexander Stephan
for Vivid Visuals*

Facing page, top left
Chad pendant

Facing page, top right
Tewa pendant

Facing page, bottom left
J-Dee pendant

Facing page, bottom right
Installation at
MAISON&OBJET Paris, 2019

This page
TienThong pendant

Wuthichai Leelavoravong & Siriporn Kobnithikulwong, everyday studio

We've enjoyed design since high school, and our families supported us in our choices. We both studied interior architecture at Chulalongkorn University, then Wuthichai joined the master's programme in furniture design at SCAD, while Siriporn went on to master's and PhD study in interior design at the University of Florida. What we learnt has been a vital foundation for our interior design projects, but we're still learning about things like construction details, materials and equipment, as well as working with clients.

We work in interior and furniture design. We don't want to choose either design field because they support each other — our perspective as interior designers enhances how we design furniture. When we design furniture or a product, we intuitively think about its context based on our interior design backgrounds.

Before setting up our studio, we both worked in large interior design firms. Working in those firms was a totally different experience to working in our studio, but it was helpful for us to see an entire organization and adapt to the system.

Running the business side is our biggest challenge: we have to be responsible for everything. We love working with our team, but that means we have to organize people and documentation, work on branding, marketing and sales, and make sure our studio is healthy physically, emotionally and financially. It does seem more convenient to work in our own country: we know where suppliers are and understand what clients are looking for, since we share the same cultural background. However, working in different countries can generate more excitement, energy and creativity to produce successful designs.

We've had some support from our government. When we started about ten years ago, we were selected for Talent Thai, which assists young designers to develop their products and establish their own brands by providing seminars, consultancy from coaches and experts, and opportunities to display, promote and sell products in local and international fairs. We had no experience in branding or business, so we learnt a lot. Also, after we received a DEmark award, the government supported us by providing spaces at international fairs.

Our furniture and lifestyle products aim to be simple, functional, creative, multipurpose and user-friendly, while our interior design work mainly focuses on functions and user behaviour.

Our philosophy is 'our designs make your everyday special'. We offer furniture or products that look simple and can be used every day, but we hide something special within them to create a little happiness, a surprise or a smile for users. Similarly, our interior designs often look clean and simple. When we describe them, we rarely mention a style or decorative elements — we emphasize how well they support user behaviour, solve design problems and respond to all requirements.

When it comes to materials or techniques, we start with a design purpose and then we study the characteristics and performance of each material to see whether it's suitable. People may think we like to work with wood and steel. Those are our main materials, but we don't limit ourselves to them. As for dream projects, having our own place where we have the freedom to explore and do what we believe in is already a dream for us.

We don't intend to express our personalities or nationality through our designs, but it's natural that they reflect our personalities. This may be because the core of our designs is our thinking process: the ways we interpret a design problem, solve the problem and develop the design as a solution, which is influenced by our personalities and environment.

We don't really pay attention to traditions. One of our main criteria is user behaviour: we'd like our designs to solve users' current problems and serve them better, so researching user behaviour is essential. We know that user behaviour has changed based on time and contexts, so if it's still influenced by a tradition, we'll take the tradition into account as a factor.

We admire all Thai designers who put a lot of effort into their designs, who bring Thai design to the international level, who keep Thai traditions alive and who employ design as a tool to help others. They inspire us to elevate our craft and be a part of enhancing Thai design.

We think the tuk-tuk is the design that best represents Thai culture — its look and function reflect Thainess quite well. It's not a good-looking vehicle, but it looks unique. It's not designed to be perfect, but it perfectly serves all the basic requirements of its users. The vivid colour schemes, simple structure and multipurpose functions clearly represent what Thai people are: we think of ourselves as lively, unsophisticated and very good at adapting to contexts.

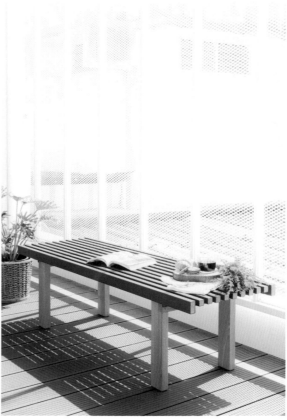

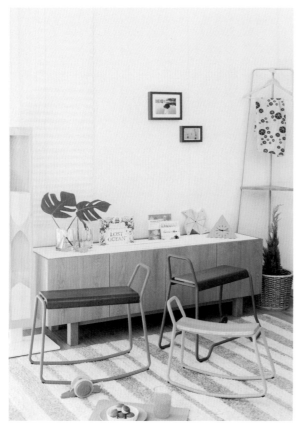

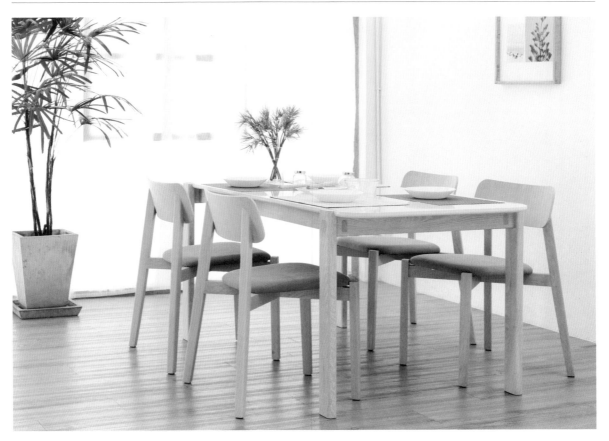

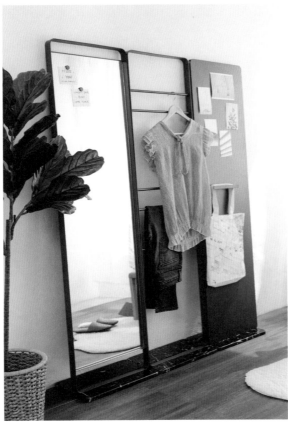

Facing page, top left
Fillie sofa

Facing page, top right
Fillie bench

Facing page, bottom left
Rocky Family chairs

Facing page, bottom right
Reline sideboard

This page, top
Warm dining table and (W) hole chairs

This page, bottom
Panel from the No Hole collection

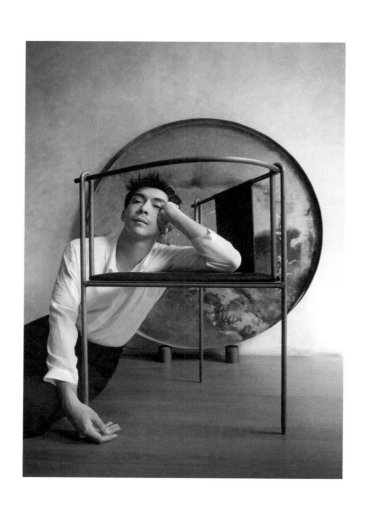

Charif Lona, Studio AOK

I've been interested in art as far back as I can remember. Every page of my mother's cookbook was filled with my drawings. I was born in a rural village in southern Thailand, and mostly spent my life after school outside with my cat and some paper. That was when I started to perceive the beauty of nature and learnt to draw what I saw. I wanted to attend art school, but my parents were worried it wouldn't lead to a stable career. They support me now though.

I did a bachelor's degree in fine art at Bangkok University. After working with Steven Leach in Bangkok, I moved to the UK for my master's in architecture at the Glasgow School of Art. I had a lot of questions about the design business and the direction of design work in Thailand, so I essentially went to find the answers. I also learnt from students in different programmes: photography students taught me the value of light and to see with different eyes; fashion students showed me embroidery, garment structure and so on; what I learnt from sculpture students and artists complemented my architectural approach.

Starting my career at Steven Leach was tough but amazing. After gaining experience in corporate and branding design, I started freelancing and worked part-time with Incredible product design and interiors studio. In the UK, I was an architectural designer with London Atelier, working on projects like housing in a conservation area and a revamp at Notting Hill market. In 2016, I moved back to Bangkok to open my studio.

I find the difficulty is balancing being an owner and a worker. The biggest challenge is making the team feel our culture, see things in the same way and believe in my vision to reach a goal together. Another is finding time for our studio design projects, which aren't for clients but aim to improve our skills and maintain our passion. At first, I thought about going back to London, but working in my own country has helped me develop faster than I expected. Fortunately, our clients are really interested in our work and believe in our process and style; they allow us creative freedom.

Studio Act of Kindness, or Studio AOK, specializes in architectural, interior and spatial design, with interests in art, fashion and furniture design. We're a kind of ensemble of friends and colleagues who work as designers, business and brand consultants, film-makers, textile designers and journalists. Mies van der Rohe once said 'God is in the details', and that describes our practice. We try to create a unique motif for each project, and involve ourselves, artists and clients in creating something kind, versatile and compelling.

I sometimes find myself feeling vulnerable, and I've been inserting this emotion into my work. I hope to encourage people to perceive the balance between aesthetics and function that creates emotional statements through the space and the object, versus allowing them to question themselves about what they see or the space around them.

I'm interested in using wood, stone and metal to oppose the perception of material itself with unexpected structures and details. I love raw and robust metal and wood, with their strength and unfinished look; I contrast it by creating forms that are vulnerable and delicate. These materials for me represent timelessness and sophistication. I've been learning about carpentry from different eras and regions, such as medieval churches, Japanese wood craft and sculpture; I appreciate how they benefit from the material and enhance its flexibility. I'm also in love with the rawness of composition, the material and ironic structure of Brutalist architecture. My dream project would be my urban design graduation project — I think Thailand needs to revitalize places with different methods and frameworks.

We've done some foreign collaborations, with teams from the US, UK and South East Asia, which I enjoyed. Our backgrounds and cultural influences led us to creativity and constructive criticism.

Expressing personality and nationality is essential; nationality and emotional expression are tools for what I want to achieve, though I interpret them to create something else. For example, traditional Thai artistic and philosophical motifs inspired me to see the task of work in different ways. I apply them in a modernist way or even using Western norms. In terms of traditions, I borrow from them to make long-lasting objects, but if I were too strict, my design wouldn't go any further. And in Bangkok nowadays, we're all open to non-traditional exchanges. I think that's how creative works benefit each other and create dynamics in the industry.

I look up to Trimode Studio and Saran Yen Panya from 56thStudio. I think their works offer the opportunity to challenge the design industry, and I love the energy and political design statements they keep creating.

I'm always interested in furniture and objects created by people who aren't working in the design field. I love how agricultural workers adapt their tools and natural resources to create the furniture they need. Sometimes it comes out 'wrong' in composition and scale, but practical for them. I think that's raw wisdom reflecting their principle of function and form, combined with culture, Thai folklore and identity.

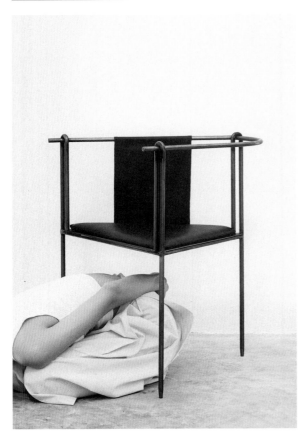

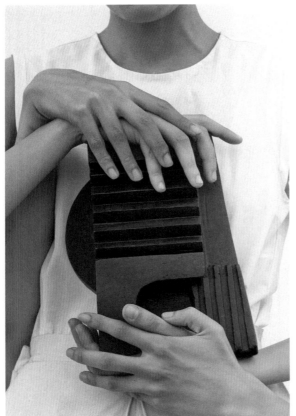

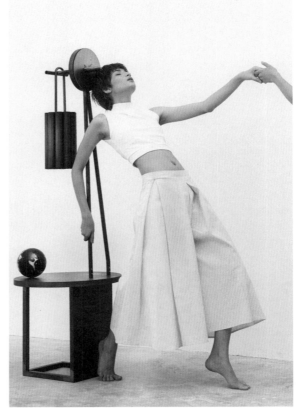

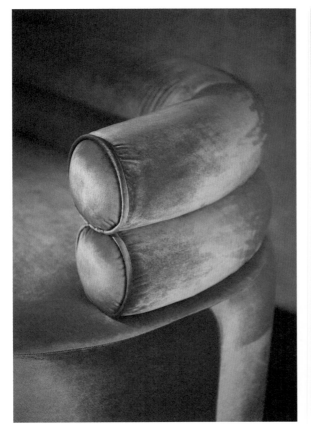

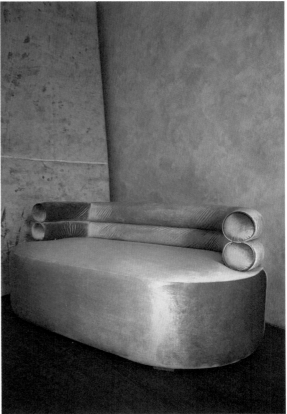

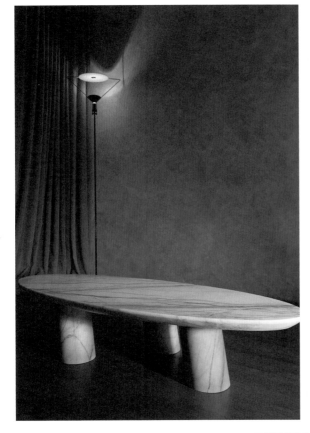

Facing page, top left
Triangle chair

Facing page, top right
Kindness 0001 collection

Facing page, bottom left
Kindness wax sculpture

Facing page, bottom right
Kindness lamp

This page, top
Kindness love seat

This page, bottom
New coffee table

Kamonwan Mungnatee & Lalita Kitchachanchaikul, Femme Atelier

Lalita has liked drawing since she was very young, so she decided to study industrial design as it sounded fun and exciting. Kamonwan had less of an idea, as there were many choices within the design field, but was impressed with the design students she'd met who seemed open-minded in the way they thought and lived. Both of our families have been supportive of our choices.

We're both studying at the moment, as well as running our studio — we're in our fourth year of furniture design at King Mongkut's Institute of Technology Ladkrabang. We enjoy studying there, even though it's high-pressure. We learn how to develop concepts and models one by one every week, so we can see and learn from our classmates' comments, and we experiment with our works in different contexts, which helps to make our works useful. We've also learnt a lot about working as a team and listening to and respecting others' ideas, which is crucial for delivering the best creative works. Developing and delivering a final work to clients is still our biggest challenge — it's a big step from being a design student to being a designer.

We think the advantages of working in Thailand are the capability of local artisans as well as the local materials, which are precious resources for us to make into new creative possibilities. Our aim is to make these simple local resources into valuable, world-class works.

We share and comment on our concepts, then work through the design direction together. We're interested in demonstrating value through the principle of emotive design, and defining new content in people's daily lives; our process is quite experimental. We hope our works give people a positive experience. A dream would be to work with global brands such as IKEA, and overall to create a work that encourages new ideas through interaction with different people's perspectives.

Our working style doesn't aim to primarily express Thai identity. We want to express ourselves in our works, which might imbue a Thai cultural or traditional influence unintentionally. We do think it's important as designers to keep Thai traditions alive, since nowadays they're disappearing from society little by little.

Doonyapol Srichan is a designer who has inspired us, since he's both a designer and our teacher. He's also a founder of PDM Brand, a design company focused on lifestyle products like furniture and home textiles. We respect him for his passion in teaching as well as designing. He inspires and influences us in design thinking, and always makes our work enjoyable.

To Lalita, Thai-style painted buses represent our local culture, a 'chillaxed' and flexible kind of lifestyle. On each bus, you can see different details like graphics, characters, lighting or even the songs playing while driving — she likes their uniqueness. For Kamonwan, Thai crafts are the best at representing our culture because they're made by combining local materials and skills. They show Thai neatness as well as fun, manifest in their colours, patterns and so on.

Facing page and this page
Stools and tables from the
Framemust collection

Anon Pairot

Before I was a designer, I started out in engineering. Then I turned to industrial design and got a scholarship to work with a big company overseas.

I did a degree in industrial design at King Mongkut's Institute of Technology Ladkrabang. We learnt information and theory, but for me the real knowledge came from real work and practice, which taught me to identify problems, possibilities and solutions. The learning system was like an application to send information from one generation to the next, but working in real life gives true knowledge from experience.

Before I founded my studio, I worked locally. There were limitations in modern technologies and knowledge, but they weren't problems for me — working within those limitations was an opportunity to use creativity.

As for challenges, I think doing whatever you want to do is the biggest challenge as you have different viewpoints from society reflected back, including on things outside the works themselves. But being based in Thailand, I've found that my understanding of the capabilities here has allowed me to be invited to work on projects internationally, from handmade products in the Philippines to industrial products in China, Singapore, Turkey and the Netherlands, and for collaborations with Fendi, Philip Morris and Grohe, as well as working on policy with the government here.

There has been more support for design from the government since 2000, but designers still need to work hard to promote themselves. I feel sometimes the government doesn't understand the importance of creativity and human capital.

My studio works by combining multiple skills — not only in design, but researching marketing, technology and mass communications. I've merged them all together with the arts and humanistic values. It means our work with clients can be very different, from working with factories to collaborating with architects and interior designers, real estate companies, galleries and museums. A recent collaboration was with British designer Samuel Wilkinson, based on international design and local craft. I also have collections with French lighting brand Forestier, Dutch-Chinese brand iLumi and a small project in the Philippines.

I think every person is creative enough to come up with good ideas for products and services. To me, the most valuable work is not about the best products but about achieving a goal. We're focusing on efficiency, non-polluting processes and building a sustainable economy in Thailand. While the world is changing with new technologies and new trends, my creativity is locally driven — I've long been focused on working with local technologies and materials. I'm interested in new ways to develop local communities and societies. These can be lifestyle-based at first, but may lead to creative changes on a bigger scale, such as new technologies and environmental sustainability.

I think expressing personality and nationality in design is important. There are two sides: one is personality, which is to be mixed with products, and the other is nationality, to reflect characters and ideas from cultures. Preserving traditions is very important too. What we do these days is like setting traditions for both preserving and developing ideas in contemporary ways. This is always good in design.

As for influences, for me it would be people from various fields because I think everyone is a designer in their jobs: craftspeople, artists, architects, engineers, researchers, scientists, marketing developers, fashion designers, writers, editors, musicians, directors and many more are all important in helping me explore the beauty of this world. Similarly, if there was a product I'd choose as an example of Thai design and culture, I think it would be traditional Thai kitchenware and cooking tools, hunting tools, fishing tools and even farming tools and equipment.

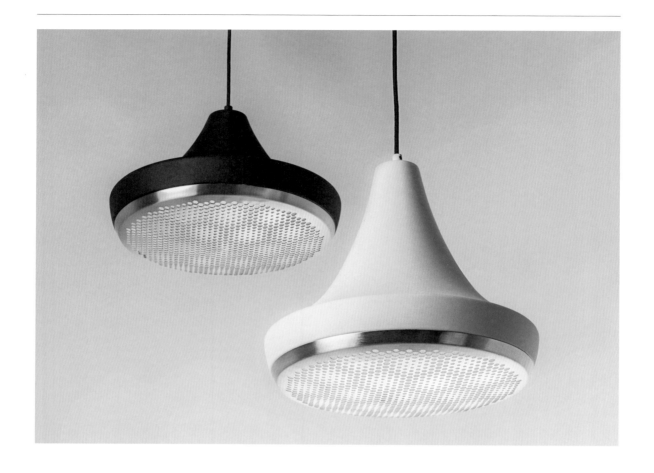

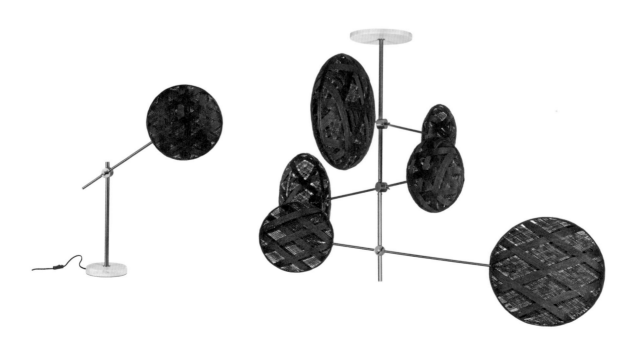

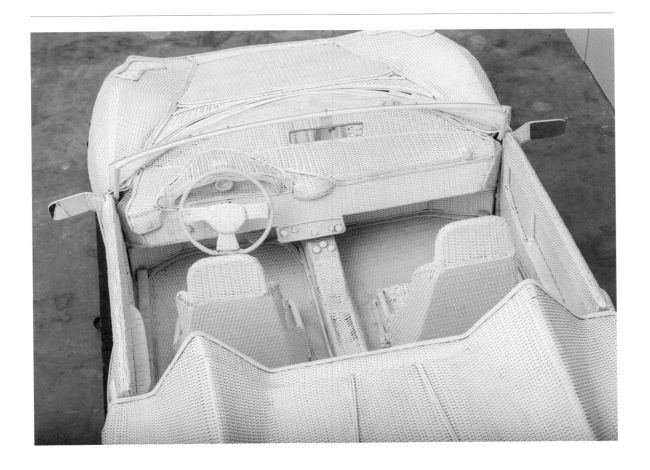

Facing page, top
Hive pendants for iLumi

Facing page, bottom left
Chanpen table lamp for
Forestier

Facing page, bottom right
Chanpen pendant for
Forestier

This page, top
Chiang Rai Ferrari at the
Venice Biennale 2017

This page, bottom
Ordinarian #001 for
industry+

Saran Yen Panya, 56thStudio

When I was young, I was obsessed with Disney animation and wanted to become an animator. Looking back, that was my first introduction to storytelling and visual culture. Later on, my interest grew more into communication design, and my parents have always been supportive of whatever I do. They even bought me a complete video set of Disney animations!

After a bachelor's degree in industrial and product design at Chulalongkorn University, I completed my master's in the storytelling programme at Konstfack in Stockholm. In retrospect, I'm very grateful for the fact that the course allowed me to explore the notion of communication design through various methods. This broad approach to narrative expression has become very useful for me to this day. I feel encouraged to jump between disciplines — from product design to graphic, to space, to experience design, and it's truly rewarding to be able to work in this particular way.

In the beginning, I was working three jobs in parallel: design manager at a famous Thai brand, art director for the Thai edition of *Wallpaper** and running a design studio of my own. I think it was a really good learning curve, since I got to sharpen different mindsets for each role and there were quite a lot of things I wouldn't have been able to do or learn in the beginning with just my own business.

Longevity is the main challenge. I realized not so long ago that, nowadays, it's relatively easy to be one of those up-and-coming design stars, but to maintain a high level of creativity and authenticity is definitely challenging. My goal has shifted towards reinventing myself so I can have not only a long career but also create meaningful works that will inspire people. But I've found being in Bangkok gives me a unique kind of energy — 'chaotic but beautiful', 'high and low' — and this mix influences me a great deal, not only aesthetically but in how I approach design and creativity as well. I've never experienced this juxtaposition so acutely in other Asian countries.

56thStudio is a multidisciplinary design unit that works graphically and three-dimensionally. Form follows story. Our aim is to explore objects that are not only functional but also communicative. Trying to combine all creative notions together, we proudly embrace pop and mainstream culture, and often hijacks existing forms to make a sarcastic commentary.

I hope people get a kick out of the way we turn something considered lame, tacky or cheap into something luxurious or refined. We want to push the boundaries of this kind of aesthetic to a point where it allows people to look at things differently: cheap or expensive, high or low.

We like to explore everyday Thai vernacular objects, and most of the time they're made of colourful plastic. I enjoy the shock value of people realizing that something they once considered mundane or cheap can actually be used beautifully in so many different ways. We're setting up a new business unit that takes forgotten Thai crafts into the design realm. It's been such a pleasure working with local craftspeople from all over the country. Witnessing their skills and know-how up close, we're very excited that our designs have been made by them and that something we made together can really support and prolong their crafts too. I think the only way to keep local traditions alive is to reinvent them and break out of the moulds or patterns. So not fitting in is progression, in a way.

We're very fortunate that most of our international clients and collaborators share our creative philosophy and approach, so we're surrounded by healthy discussions and constructive criticisms. They talk, we listen; we talk, they listen.

For me, what we do is not so much about personality or nationality, but rather my point of view or principle. I believe good design has to reflect some belief system, ideology or philosophy, and it may or may not be about the designer's personality or country of origin.

As for Thai designers, I've always been a fan of Chatpong Chuenrudeemol of CHAT architects. I think what inspires me the most are his work ethic and design principles. His dedication to the research programme Bangkok Bastards is very much what I've been trying to do with my own studio. For a representative Thai design object, I'd say the Cheap Ass Elites collection by 56thStudio, of course!

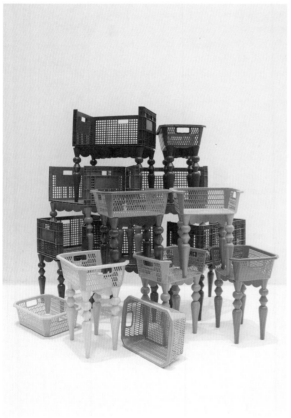

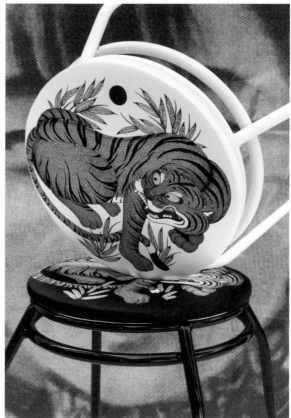

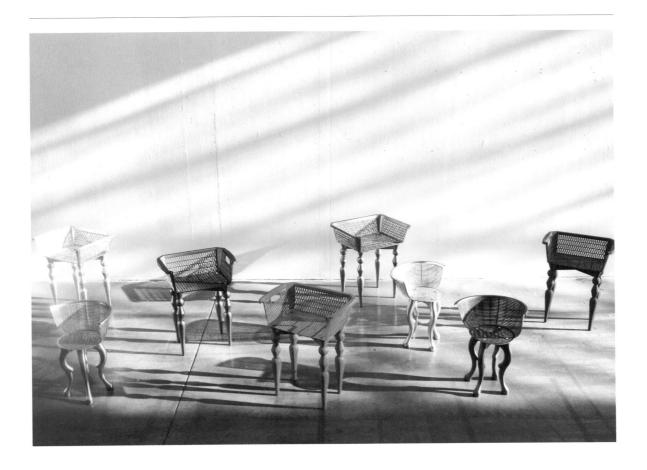

Facing page, top
Pieces styled after *The Simpsons* from the Caricature as Furniture series

Facing page, bottom left
Pieces from the Cheap Ass Elites series

Facing page, bottom right
Noodle stools

This page, top
Pieces from the Cheap Ass Elites series

This page, bottom
Chairs upholstered in Tribute to the Beatles textiles

Ath Supornchai

At the time I studied design in Thailand, I'd say it wasn't considered a 'needed' discipline, and most parents wouldn't have wanted their children to study it. I'm one of the lucky few who have been supported greatly by my parents, as they believe that people who study what they want will do well.

I went to King Mongkut's Institute of Technology Ladkrabang. School taught me all the necessary tools to become a designer, but being a good designer — which I hope I can be someday — is mainly about experience, not just design but life experience.

After I graduated, I worked as a product designer for THINKK Studio in Bangkok, and they're the designers I'm most inspired by. I was lucky to work with various kinds of materials, at scales from small objects to furniture, and with makers from craft to industrial. That experience helped me to explore what kind of designer I want to become. Currently, I'm a product designer for Neri&Hu in Shanghai as well as working on my personal furniture projects.

Since I'm balancing both of those things, time is my biggest challenge. But through working with Neri&Hu, I've had the chance to work with many well-known furniture brands, mostly in Europe and some in Asia, which I believe has shaped my taste and improved my skills significantly. So, every time I come back to a personal project, I always feel that I'm continuously improving.

Based on my experience as a freelance furniture designer in Thailand, I think the design market there is growing but I feel that design isn't yet a part of people's daily lives. There's still a big gap between rich and poor, and the idea that design is for rich people still exists. It's sad that we've just scratched the surface, because design is supposed to make life better, not just add more elegant or decorative objects to the world.

My projects are mainly furniture and decorative products. I try to bring craft, local materials and traditional knowledge to meet halfway with industrial production, with the idea of creating well-crafted pieces that exemplify a contemporary lifestyle. I'd love my work to be truthful and reveal how the materials were used and structured. I don't really have any favourite materials or techniques, but I hope to work with new materials constantly. I love it when things have their strengths and weaknesses, their own characteristics and individuality.

Besides the overall looks and comfortability of, say, a chair, I'm obsessed with things people don't really see, like how I structured what's under the seat of my chair or even what process I used to create a leg. Furniture for life on another planet would be super cool to design.

I believe that a design always tells some kind of story, and there's no right or wrong in those stories. Individuality plays a strong part, because the process of design mostly comes from experiences, and experiences always come from society and the surroundings of the individual. I've learnt that even though each brand I've worked with has its own market, philosophy, knowledge or style, its nationality seems to have its own 'personality', which impacts the overall feeling or even the way they approach different things in a good and interesting way.

Everything needs to evolve to survive, including tradition, and I believe that design is a method of achieving that. As for a representative Thai design, I think it's quite difficult for an object to define a thing as diverse as a country or culture. Even two iconic figures of the same nationality from past and present can have a completely different style of work. So, I'd say a country where design is just starting to become more important in people's lives, like Thailand, is even harder to define. Maybe in the future it'll be possible.

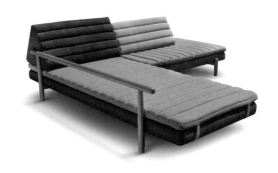

Facing page
Juliet chairs for VIVI
Decorative

This page, top left
Frame storage unit

This page, top right
Corolla chair (above), Kiri
sofa (below)

This page, bottom
Juliet chairs

Varongkorn Tienparmpool & Supattra Kreaksakul, PATAPiAN

Several years ago, we started to explore local artisanal weaving and learn how to work and share ideas with craftspeople. Almost three years later, in 2014, we were ready to launch our first product. Our families have supported us — they suggested and shared their experiences in working with communities, managing timelines and so on.

Varongkorn majored in visual communication at Rangsit University, and has worked in design and the creative industries for ten years. Supattra studied law, also at Rangsit University, then a master's degree in language and communication at the National Institute of Development Administration before studying painting in New Zealand. So, we have different skills and backgrounds but we have the same passion for art and weaving.

Our studies taught us basic theory and practice, but working confronts us with new problems to figure out by ourselves. We worked for other companies before starting our studio, which helped us to grow and learn how to collaborate, and we gained creative and production knowledge we couldn't get from school. This is important because product design isn't just sketching in a book — that would be easy. We work as a team to share our inspirations and find new ideas, then we prototype, test and iterate the prototype until it's ready to be launched. Moreover, working with multiple groups in crafting, we need to understand the production process clearly. We also need to understand their ways of life and the balance of nature. All this helps us to be sustainable.

The biggest challenge in running our studio is time management — not concerning the production process, but because of our ambition to pursue many things at the same time. We're in love with learning and we never stop experiencing new things, so we're sometimes overloaded. But the advantage of being in Thailand is its richness of handicrafts. Since we were children, we've been familiar with local handicrafts, which surround us in everyday life — that's important context for our work. Also, the skill and wisdom of Thai people are second to none, and craft is hidden in every community — it's passed down from generation to generation, and has become a way of life. So, we have a responsibility to preserve this wisdom. Fortunately, we've had some support from the government in marketing, both locally and abroad.

PATAPiAN is dedicated to art, objects and craft. Our products are reinterpretations inspired by nature, narratives and everyday life. We specialize in woven decorative items, including home decor, lighting, accessories and artwork, which are a unique combination of fine weaving and contemporary design. The concept of PATAPiAN is a symbol of a childhood memory, a local toy that uses traditional weaving techniques — Thai people are familiar with it and recognize it as something local. When we were children, we learnt the technique at school. Nowadays, we live in the digital age and traditional craft is going extinct. We realize the importance of traditional weaving techniques, and would like to preserve this precious craft in a contemporary context.

Those techniques are the core of what we do, and we focus on the simplicity of weaving because of the creativity in making it go from one to infinity — bringing a small element of one piece and weaving until it becomes a great work is impressive to us. Also, woven techniques are universal — each country has its own characteristic style that depends on its environment, culture and tradition, which is charming.

We hope PATAPiAN will last a long time and be passed on to new generations, as it's important for us to keep both traditional and developing woven techniques alive. Even though new technology is replacing humans, skilled craft can't be replaced by robots, and robots can't convey a way of life through craft.

It's also essential for us to make designs that express our personalities and have an effect on customers. As our pieces reinterpret stories and concepts through weaving, we might communicate our everyday surroundings or things that may interest us at that moment. So, the story of each product is based on experience, narrative, culture, way of life and imagination. We hope our products will communicate directly to customers without someone narrating the story.

Suwan Kongkhunthian is an inspiration to us. He's a Thai designer working under the Yothaka brand, exporting water hyacinth furniture. His works have a strong identity and finely crafted detail.

To us, all of our designs represent Thai culture. One that stands out is the Round collection, a series of home decorations composed of containers, vases, a mirror and pendant lighting. We were inspired by Thai pagoda architecture, and applied a coiling weave, which requires stiff materials to form a shape, then soft materials woven in coils around the object. Metal materials indicate strength while bamboo is soft and cosy, and the combination of metal and natural offers a new perspective on weaving.

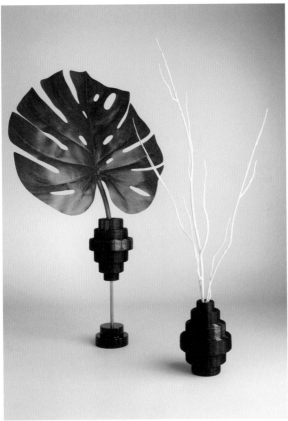

Facing page, top left
Tall vase from the Round
collection

Facing page, top right
Short vase from the Round
collection

Facing page, bottom
Mirror from the Round
collection

This page, top
Pieces from the Round
collection

This page, bottom
Vases from the Round
collection

Saif Faisal

From an early age I've made things with whatever I could lay my hands on. By the 11th grade, I knew for sure I'd take up something in the creative field. I was very particular about pursuing automotive design, but later industrial design seemed more fitting — I felt it allowed me to be a multidisciplinary creative rather than specialize in a single field. But when it came to convincing my parents I had a really tough time.

I studied Architecture at the RV School of Architecture in Bangalore. To be honest, I feel like not much I learnt in academic study has been helpful — there had to be a lot of unlearning. However, I had a wonderful opportunity to learn a great deal working on a racing car project in the mechanical engineering department. It was the Formula Student project — our team participated in events across the globe. There I learnt the beauty of essential design and cutting-edge technology.

I did my internship at an architectural firm in Bangalore, but most of my learning I credit to the Formula Student days. Later I picked up woodworking as well to learn joinery. Being an autodidact, I was able to learn quite a bit on my own, and I learnt a lot by collaborating with industries and craftspeople.

I think designing is the easiest part of the process — the toughest thing is challenging the status quo in an Asian country that's not Japan. I feel it would've been much easier if I'd set up the studio in Europe or Scandinavia. The contemporary design scene in India is lagging, as the notion of design being a luxury for the privileged still prevails. That means the necessity of design is overlooked to a great extent. Happily, that's changing. I hope the beauty and importance of design is appreciated in the future. The advantages I feel here are the way frugality is valued and the huge variety of craft and making traditions.

As an Indian designer, I admire Bijoy Jain of Studio Mumbai, though in general I'm quite inspired by the polymaths of Persia, Iberia and Mesopotamia. I try to embody the frugality and the human values of the deep-rooted Oriental culture, and the Japanese, Nordic and Scandinavian design essence in terms of their poetic expression, essential design and celebration of natural materials. The objects I design aspire to simplicity, substance, timelessness and beauty; poetic expression is as significant as the functional attributes. With my essentialist approach the focus is always to be sensitive, thoughtful and meaningful. I believe in sustainable aesthetics and longevity in terms of use and relevance in time and space.

I've been involved in a few collaborations with foreign brands, like the Loup fruit bowl for New York's OTHR, the first mass producer of 3D objects. This was a great experience, as it felt like being a part of a pioneering step towards industrialization of the technology. I've also developed three kitchenware pieces for Progetto.Studio from the US. These designs are fresh interpretations of the very functional, practical articles one uses every day.

Through my work I hope people experience thoughtfulness and a bit of humour and curiosity. I aim to showcase the beauty of natural materials that are not just sustainable but also age gracefully. A dream project would be some kind of integration of applied philosophy and design to make life more sensible, thoughtful and meaningful.

The values and principles I've developed as an essentialist are quite important to me, and the objects I design have to be very relevant and meaningful. I believe nationality is a quantitative identity — and India is many countries within one, with its cultural diversity and expanse — so for me, cultural context is more meaningful. I don't try to fit or preserve tradition all the time, but when working with a particular craft I believe it's important to keep it alive and innovate it so it becomes more relevant in this modern world and changing times.

For a design that expresses India, it has to be the Qaiser series, for which we collaborated with Bidriware artisans in our quest to bring something new to the craft. Our explorations and experiments led us to the development of a very unique process: selective oxidation. The oxidizing process in Bidriware is done with a unique and rare mud found only in the unlit areas of Bidar fort in southern India — it's one of a kind. The traditional technique is to do Damascene metal work with gold and silver and apply the mud, which exclusively only oxidizes the Bidri zinc-copper alloy. What we developed is to mask the negative patterns with heat-resistant laminate, which allows for oxidizing of only the exposed areas, leaving the masked areas brilliant and shiny. This simple technique marks a departure in the craft of Bidriware after 700 years of existence.

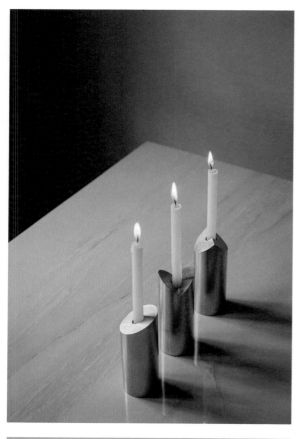

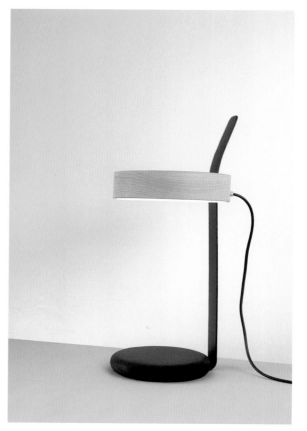

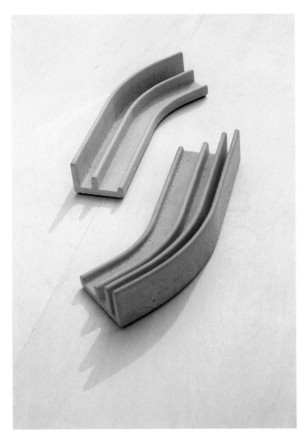

Facing page, top left
Euclid candleholders

Facing page, top right
Counterpoise table lamp

Facing page, bottom
Fibonacci organizer

This page, top left
Poise table lamp

This page, top right
Alfredo table lamp

This page, bottom
Extrude desk organizer

Manasa Prithvi, Ira Studio

My desire to pursue a career in the creative arts began forming when I was at school. Later, I believed a career in design would suit me well, and this evolved into setting up my own business and combining my love for crafts and interior product design. My parents were very supportive of whatever made me happy.

I did my bachelor's degree in fine arts in India, and my master's in visual design at the University of the Arts London, after which I started Ira Studio. I think my education has been immensely useful. It taught me to question the 'whats' and 'whys' of designing and creating, and helped me push the boundaries of my work. It enabled me to question every stage of the design process and helped me create products that were not just beautiful but also responsible, as well as connected with emotion and reason. It helped me understand where my product would fit in the market, and the purpose of my work.

I worked for an interior and product design studio in Chennai right after I finished my bachelor's, and was like a sponge absorbing everything I could about design and business. During my master's in London, I worked part-time for Aesop, and there I learnt the importance of brand language and communications. It also helped me develop my aesthetic sensibilities, and my enthusiasm for neatness and order fit the role well. My dream would be designing a store for Aesop, or working alongside my favourite designers on collaborations.

My biggest challenge is finding the right artisans and craftspeople. While they really are the backbone of my business, working with them can be challenging, particularly in terms of delays and quality control. As Ira Studio is a small business, I do most of the work on the business side of things too, and for a designer to take on the many roles a business requires can be overwhelming.

I've grown up to love the local arts and crafts of India, and am greatly inspired by them. The soul of our work is craft and the handmade process, and it's an advantage being here — it would be a challenge to work with them remotely from other countries. The other advantage is that we understand the craftspeople and their culture. This is important because in India, crafts are not just for pleasure — they're a source of sustenance for the artisans, often intertwined with their socio-economic and cultural backgrounds. Understanding these aspects helps us communicate better and work in tandem with the artisans to bring out the best results for both sides.

That's critical for us, as Ira Studio at its core is about minimally designed, functional products that celebrate the handmade process. It's modernism rooted in the culture of handmade. We work with independent artisans to create contemporary products using traditional handmade processes, which takes us to different parts of India. The processes and techniques are age-old skills passed down from generation to generation, and our work focuses on preserving these traditions but reinventing their end use to be relevant to our age. All our products are one-offs or limited editions, which embraces the honest qualities of handmade processes. We believe the unintentional marks of these processes are inherent attributes that make each piece unique. It's hard to pick a favourite of the different processes and materials we work with, but I'm always drawn to the texture of beaten brass. It's the simplicity of it combined with the warmth and beauty of the imperfect hand-beaten surface. I hope that people who experience our work feel the honesty of a handmade product, and that it can be passed on through generations as something timeless.

Because my design sensibilities have been moulded by my culture and the environment I grew up in, I believe they naturally reflect my personality. But a lot of designers, myself included, are quite global in our design language because our markets are global. I feel it's a good mix of the two. I believe that tradition is the future, and it's a big part of our work, but tradition for tradition's sake doesn't interest me. It should be relevant to the times we live in or it could disappear or end up in museums.

Inspiration often presents itself from various other creative spaces. I'm inspired by people who share a similar design sensibility and philosophy, and don't conform to rules created by trend-based markets. Nipa Doshi, Bijoy Jain, Charles Correa and fashion designer Sanjay Garg are a few.

There's no dearth of unique objects that are quintessentially Indian and are extremely clever in their designs. Most of them are designed to be utilitarian, affordable and fuss-free. I believe in terms of furniture, the charpoy bed represents India best. The southern Indian coffee tumbler and *dabra* are personal favourites as well. They serve multiple purposes and are designed with culture and the environment in mind.

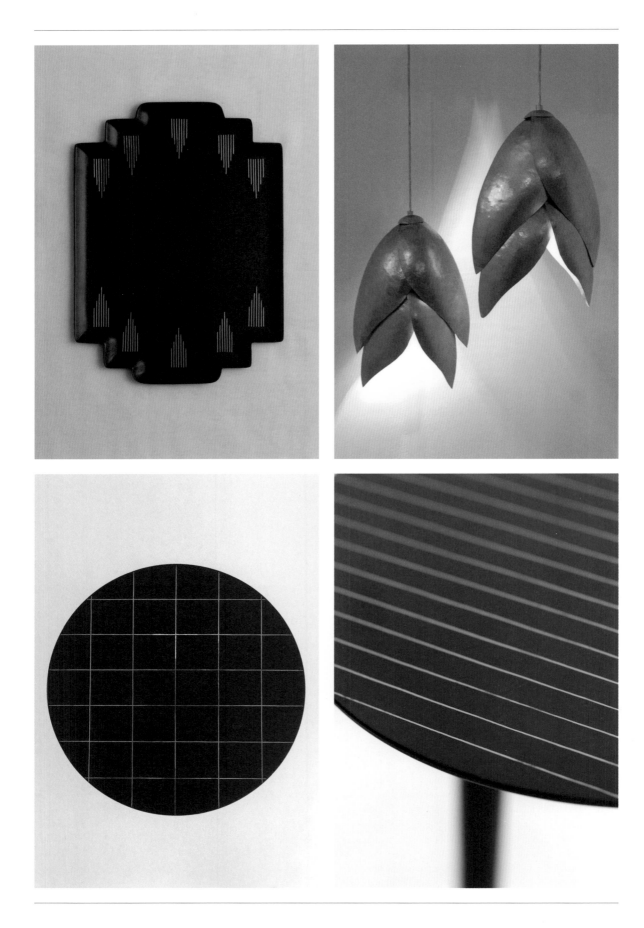

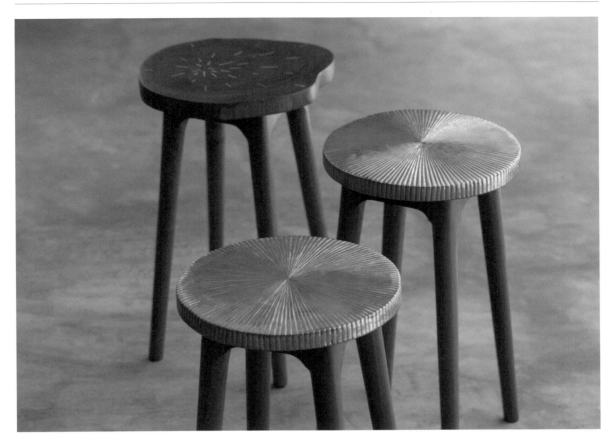

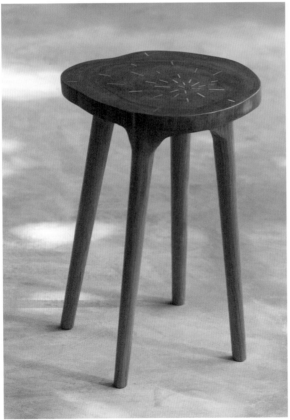

Facing page, top left
Agra tray

Facing page, top right
Hammered brass pendants

Facing page, bottom left
Chandigarh table

Facing page, bottom right
Jaipur table

This page, top
Tekku brass stools

This page, bottom
Tekku wooden stool

Farah Azizan & Adela Askandar, Kedai Bikin

When Adela was 15, her parents engaged an architect to design their new home. He was patient and idiosyncratic, and she enjoyed watching him sketch. Later, she felt stuck in the science stream, and thought architecture would allow her to straddle the sciences and the arts. When Farah was at university, she had a call from a primary school classmate who asked whether she remembered them writing essays about wanting to be architects. Farah didn't remember, and jokes she didn't even know what a wretched existence it would be, but she naively stuck by it.

Farah's undergraduate degree was at Nottingham University with the second part at the Architectural Association in London, and Adela studied architecture at the University of Cambridge. School didn't teach us about running a business, but everything else was somewhat applicable. The process of studying the site or situation and processing it with regard to the brief to arrive at the initial design intervention was definitely an important aspect. The processes we went through in making, casting and forming things were also important to help us formalize those initial ideas into tangible creations.

We both worked for other companies in London and Kuala Lumpur before launching Kedai Bikin. Adela felt that Kuala Lumpur's work culture had made her start to lose herself, so she started freelancing and doing other creative work. That's when we started working together.

For us, the main challenges are managing cash flow, ensuring that quality meets our standards and convincing clients that good design and skilled craft come at a price — we imagine these are common. We also have to design interventions in an environment that's constantly and rapidly evolving in terms of communications, cultural influences and lifestyle, which may be a challenge in every country. To tackle it, we need to stick to certain principles so that what we do is meaningful within our environment, and we need to be very clear about the intentions of each project before we embark on it. We do have access to skilled craftspeople at a reasonable price, and we've received support from government-supported foundations for some product development. In general, though, there's a lack of support for the arts, in particular furniture, objects and industrial design.

Studio Bikin is our architecture and design consultancy, and Kedai Bikin is our retail arm where we design and produce our own line of furniture, and have grown a portfolio of goods by local designers whose works we feel resonate with what we do. We've been focused on constructing what we design, as that's when the magic happens for us: the experimentation, the organic adjustments to suit certain issues and conditions, crafting parts of the building — it makes the work intense. It's almost like a lifetime apprenticeship — you learn something new in each project, from the builders, the other consultants and the clients themselves. We're blessed to have everyone in the studio helping to achieve that — they're all amazing in contributing to the built form.

Concrete is one of Farah's favourite materials, as it can take on the form of almost anything you can make the formwork out of. Brick is salt of the earth, and transmits the patina of age beautifully, especially here in the tropics. Many of our earlier projects didn't have the budget for fancy materials, but we also liked the buildings to use those simple materials that age well in our climate and develop their own characters. To make these materials work, we put a larger proportion of the budget towards labour — this allows craftspeople to make a better living through their skills, which are becoming scarce. It's one way we can all hopefully keep some traditional skills alive, instead of replacing these beautiful polished, cast and washed finishes with imported materials.

We'd love to work on projects that have a larger social engagement, such as libraries, cinemas, public housing, schools and so on. Farah dreams of designing a mosque or a marina. The environment has also always been part of how we work; we never consciously established that we'd meet environmental certifications, though we're open to that, but it's important that the design approach is environmentally sensitive.

Farah is generally more flamboyant in detailing, while Adela is more restrained. In Malay, we have a lovely term associated with cooking, *air tangan* ('the touch of the hand'). We possess as individuals our own creative flair that makes a particular design unique because of what we can bring through our own personal development and experiences.

As for tradition, we started with the idea of crafting and building our ideas as a means of exploring how we can resolve a brief while rethinking certain conventional ways of looking at spaces. Spatial layout and experience are primary, and still form the crux of each project. We try to find inspiration within the locality of each project, so are more inspired by certain projects than a certain designer. Our Grandaddy lounger is a homage to the string lounger found in typical homes — almost everyone we've spoken to reminisces about a family member taking permanent residence in that chair — and the kopitiam (coffee shop) chair, a tropical derivative of the Czechoslovakian bentwood chairs found in old local coffee shops.

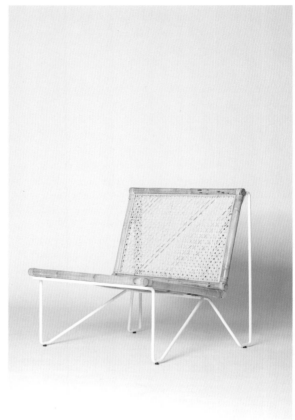

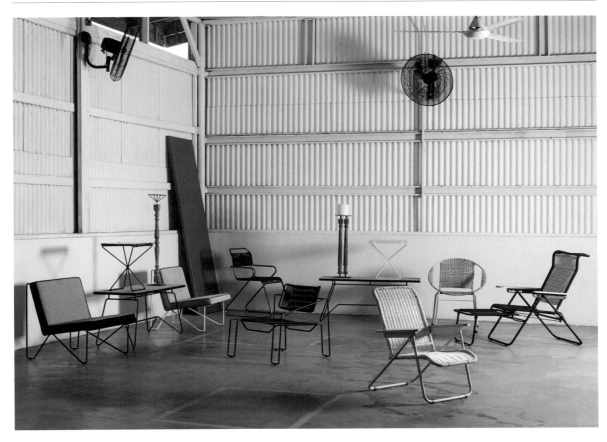

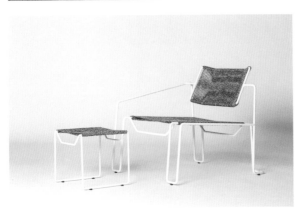

Facing page, top
Mr Gould chair

Facing page, bottom
Merdeka Tropicalia chair

This page, top
Left to right: Mr Gould
upholstered chairs with XX
side table in steel and Mr
Concrete Chintz coffee table,
Big Bend chair (rear), Ms
Gray chair (front), Traveller
chair, Merdeka chair,
Grandaddy lounger

This page, middle
Left to right: Traveller chair,
Shell chair, Merdeka chair,
Traveller chair

This page, bottom
Ms Gray chair with string
stool

Wei Ming Tan, Aureole Design

I practised as a graphic designer for a couple of years after returning to Kuala Lumpur from the UK. But my passion for furniture and lighting design spurred me to explore beyond the two-dimensional — even more so as part of a design collective in 2007 producing custom furniture, lighting and interior pieces and exploring diverse fields like hospitality, fashion and culture.

I majored in typography design at what was then the London College of Printing. As I shape and develop Aureole, I continue to draw influences from my graphic design background where geometry, forms, proportions and balance come into play.

My partners in the design collective were gathering a team of multidisciplinary designers to design and produce home accessories and interior pieces tailored to specific needs. The manufacturers were supportive and patient in advising us on production techniques. I thoroughly enjoyed this experience; it also gave me the platform I needed to extend my skills further, and paved the way to forming Aureole in 2013.

Aside from capital, I'd say my main challenge is production volume: without a large volume, production costs are high. And in Malaysia, the product design industry is moving at a slow pace compared to our neighbouring countries. This could be due to lack of industry and government support for both local material resources and craftspeople. These constraints make production difficult, and that lack of demand leads to the high production costs. But between western and eastern Malaysia, I feel blessed that we have rich resources of cultural craft, techniques and materials.

Aureole approaches design within the context of simplicity — be it in the purity of lines or the unadorned elegance of a material. Within this, the richness of Asian culture inspires the process before being translated into a form that allows its design and material to accent the finished product. I also enjoy exploring the application options for natural materials, like new forms and usage. I hope people experience joy through my work.

My dream would be to be able to collaborate with different craftspeople from other regions and countries, participating in cross-cultural exchange and producing a collection together.

I think my designs should express my personality, because having a brand identity is important. As for local traditions, this is primarily based on my material selection. If I'm specifically working with local artisans, it's important to ensure that tradition is preserved.

I'd say the design that most represents me is the Geometry light series. It represents my personal journey when growing up. The fondness I have of paper folding came from watching my grandmother fold joss paper into intricate forms for ceremonial religious burnt offerings. The series explores that in the form of ceramic ware and polished terrazzo, which was commonly used as flooring in buildings constructed in the 20th century, and its vivid colours were also found in pre-cast outdoor garden settees. Along with a fondness for their hues, I enjoy the randomness of the aggregate's stone speckles and how it transforms after it's cast.

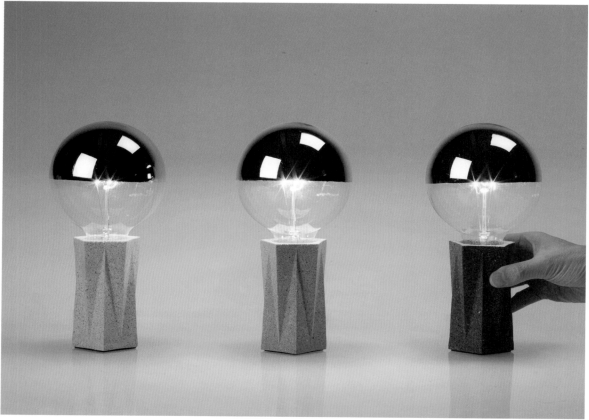

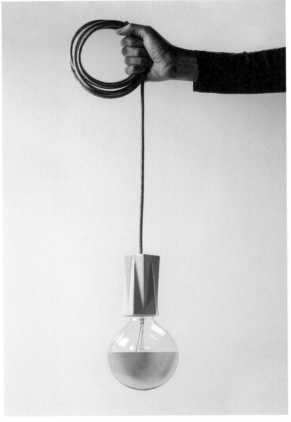

Facing page, top left
Dǒugǒng bench

Facing page, top right
Fan hand mirror

Facing page, bottom
Geometry terrazzo table
lamps

This page, top
Dǒugǒng collection

This page, bottom
Geometry ceramic pendant

Olivia Lee

I always juggled multiple ambitions as a child, including inventor, writer, scientist, artist, architect, journalist, entrepreneur, graphic novelist and philosopher. I had a hard time picking just one because so many interests and disciplines called to me. If I think about it, they did have some things in common: they required investigation, questioning, ingenuity and finally a creative output. I only learnt of industrial design in my early 20s, and I suddenly found a name that best described what I enjoyed doing. This is how I knew I'd found my path.

My family has always been supportive. They watched me grow up and they knew my heart. They could see that I was determined and had no delusions about the work needed to start a practice.

I studied at Central Saint Martins, and I remember this phrase from one of my tutors on the dynamics of being in design school: 'You only get out as much as you put in.' It meant that the more you tried, experimented, applied yourself and stretched your thinking, the more you'd learn and grow. There was no way to sit passively and expect to be spoon-fed into becoming a great designer — you had to be proactive and take charge of your process. This has proven to be an important adage not just in design, but also in my personal and professional life.

After graduating, I remained in London and worked for British industrial designer Sebastian Bergne for two years. What I admired most about Sebastian, beyond his body of work, was how adamant he was about finishing work by 6 p.m. As a family man, it was really important for him to make it home for dinner with his wife and young children, so we all had to complete our work and close up for the day. He imparted to us the principle of working in a focused and efficient manner: given this amount of time, plan your tasks properly and meet your deadlines. At a time when I had many peers who worked in design firms where 'overnighters' were the norm, Sebastian showed me that it's possible to achieve success in a design career and have a meaningful, healthy life outside of it.

I need to be extremely vigilant with how I expend my time, attention and creative energy, as I wear the creative, commercial and operational hats. From that vantage point, everything can seem important and urgent, so knowing how to delegate and prioritize becomes critical. I've learnt to become more protective of and strategic about my time.

As for Singapore, it's a really well-run city. Things get done, fast. Most administrative business matters can be processed within a week. There's a certain peace of mind knowing that the operational aspects of a studio can be dealt with efficiently so that more time can be spent on imagining and creating. There's support too: I received a DesignSingapore scholarship that funded my studies at Central Saint Martins, and I've also received government grants that supported my design exhibitions in Milan. Singapore is in the heart of South East Asia, a region abundant with rich cultures, craft and a burgeoning new entrepreneurial generation. The energy in this part of the world is palpable.

I describe my practice as a multidisciplinary studio grounded in an industrial design approach. The practice pivots from product to spatial design, research insights to ideation, with the desire to instil wonder in all experiences. This has led to memorable collaborations with Hermès, The Balvenie and Wallpaper* Handmade, ranging from retail scenography to bespoke furniture pieces. I hope by instilling wonder my work helps people to escape into another world. A dream would be to design the food, uniforms, products and interior of a commercial spaceship.

I think it's essential for my designs to address and then go beyond the requirements of a design brief in new and delightful ways. I find designs that express ideas and introduce new ways of thinking much more interesting than designs that purely express personality or nationality. It's also important for my designs to ask questions and to stir positive emotions, drawing from local tradition if and when meaningful. I believe that designers should be free to define, reimagine and dispense with tradition if necessary.

Dr Milton Tan inspires me most. He was an architect and the original head of the DesignSingapore Council from 2003. He was a force, painting the vision for design as a cultural driver for Singapore. He was worldly, charismatic and enigmatic, and made all of us fresh young DesignSingapore scholarship recipients really feel like we had a place in contributing to the vision. Despite us being scattered around the world, whenever he was in the same city, he made it a point to check in and take us out for a meal. When DesignSingapore hosted the 26th Icsid World Design Congress, we realized how loved and respected he was by international business people, academics and creative thought leaders. This showed me it was possible for a Singaporean to stand in the international arena of design and business leadership as a champion for creativity. Dr Tan passed away in 2010, and is greatly missed.

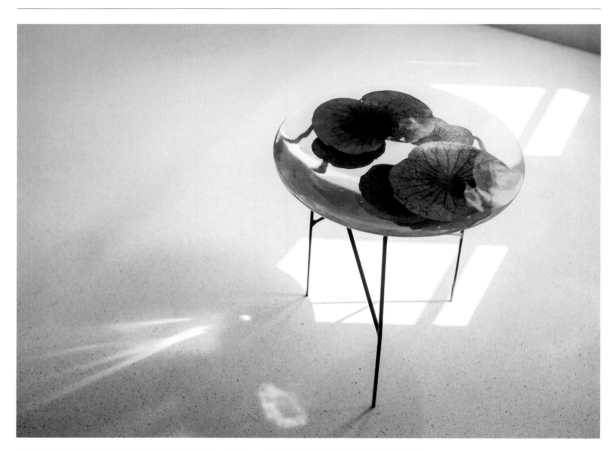

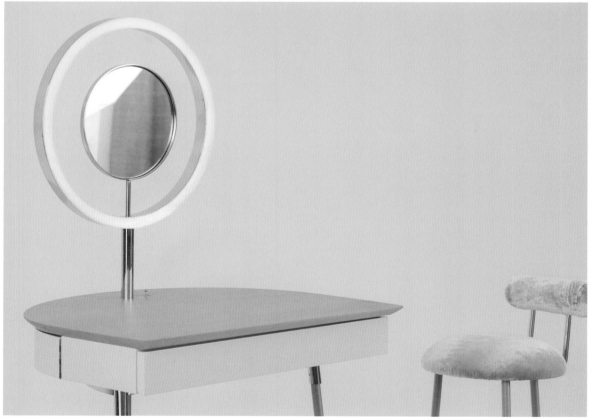

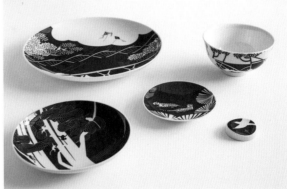

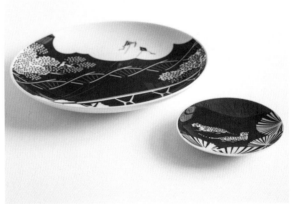

Facing page, top
Float side table for industry+
Image courtesy of The Primary Studio

Facing page, bottom
ALTAR vanity set from the Athena Collection

This page, top left
Detail from The Marvellous Marble Factory

This page, top right
Majesty of Nature series for Temasek Holdings and Supermama

This page, bottom
Instruments of Beauty: Divine Tools collection

Priscilla Lui & Timo Wong, Studio Juju

We've been interested in the arts since we were young. Timo was technically inclined as well, while for Priscilla, a chance visit to a design exhibition exposed her to the possibilities of applied arts.

Both of us studied industrial design, Timo at Nanyang Polytechnic and Priscilla at the National University of Singapore. Timo found he was able to refine and redefine his approach to design, and continues to see those fundamental skills from school as a large toolbox that needs to be constantly repacked. For Priscilla, looking back, it was crucial to learn to appreciate beauty and have an opinion while understanding other perspectives — it makes one culturally open to possibilities and opportunities.

After that, we worked at the Design Incubation Centre, helmed by Patrick Chia. We were the main designers for the Objects Around The Tablescape collection under the d.lab brand, which was showcased at MAISON&OBJET Paris and sold at La Rinascente, Rossana Orlandi's space, Le Bon Marché and others.

One of the challenges of being a designer is creating a timeless piece and being very free in that pursuit. It's the same challenge we've faced: how to be timeless and full of freedom in a practical, time-starved modern economy. It would be a dream to design something that can be used for a very long time and is of significance in times to come. As well as that, the challenge of working from a young nation like Singapore has always been seeking the relationship between design and the Singaporean identity. This search is where it's an advantage to be free-thinking — it allows us to step back and forth to define our practice. And while it's a good time to be working here, the biggest challenge is to be resourceful enough to work across the Asia region, if not internationally.

We've had some overseas collaborations. Italian brand Living Divani produced our Rabbit & Tortoise collection of coffee tables. They pursue a great sense of atmosphere and ethereality in their products, and have excellent standards of craft. When the design is perfectly made, the piece is able to do exactly what you hope in a real space.

We describe our work as free-spirited and relevant, and hope that through it users experience delightful emotions, a sense of thoughtfulness and a level of refinement. We like working with a variety of materials and techniques. It's especially enjoyable when we identify the most suitable material for a specific design and push its boundaries to achieve our vision. For example, we recently designed a series of outdoor seats called Chocolates, for a welcome area at a compound. We used a combination of fibreglass moulding techniques and high-gloss coating to achieve the form and durability we needed. The seats are finished in an assortment of chocolate hues, evoking the endearing emotion of a welcome offering of sweet delights. Another example is the Cleansing Plinth that we did for Wallpaper* Handmade. The design is realized in fine Alexandrian White, a Dolomitic marble that lends itself to intricate carving. Distilling the cleansing ritual to a singular, essential form, the design aims to express a sense of monumentality and quietness.

We hope our designs express our voice — it's essential as it gives a soul to the design. But we don't think it's important to deliberately express our nationality. We feel it will be inevitable: as we draw inspirations from around us, the idea that we're from Singapore will gently come across in our designs. Similarly, we don't prioritize traditions, but it's important that our design is contextual and relevant to what it's answering.

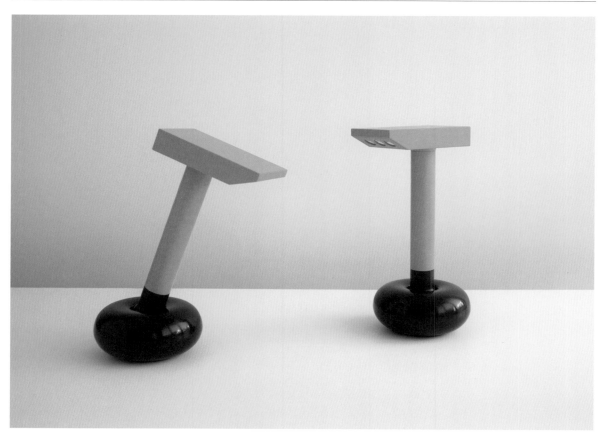

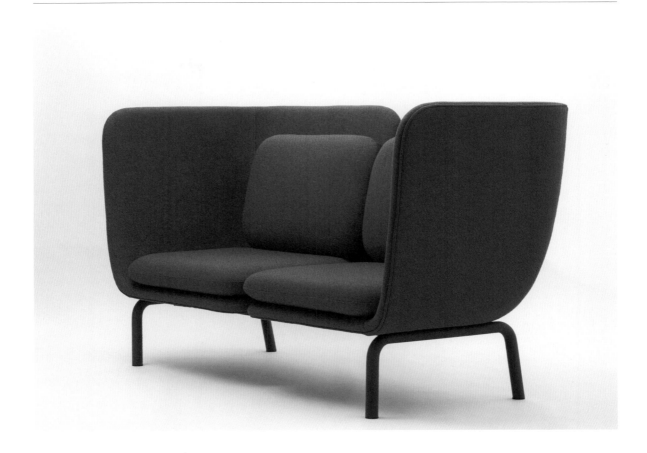

Facing page, top
Duck lamps

Facing page, bottom
Cleansing Plinth for Wallpaper* Handmade
Image by Jovian Lim

This page, top
Juju sofa
Image by Studio Periphery

This page, bottom
Stools from the Lulu collection
Image by Studio Periphery

Kiat Ng & Karen Chiam, DAZINGFEELSGOOD

Kiat was quite a rebellious teenager, and grew up with loud music, skateboarding and visual arts; he dabbled in IT but changed to furniture design. Karen aspired to become either a fashion merchandiser or graphic designer, and took up visual communication at the Nanyang Academy of Fine Arts. Her final-year project integrated both disciplines in a campaign with Singapore Fashion Week to promote Asian designers, which won the best display award and led her to realize how versatile design communication could be.

We started at NAFA in 2002 as classmates before we went into our respective majors of furniture design and graphic design. Back then, there was a foundation year that exposed us to many art and design fundamentals, such as painting, pottery, lithography, technical drafting, and 2D and 3D principles. We didn't understand how relevant they were until we started working in integrated job roles; we realized these experiences actually scaffold an awareness of how to develop our design acumen.

Both of us worked for other companies before we started DAZINGFEELSGOOD. Kiat was a design drafter at a local timber furniture company. He was curious about how things were constructed, where they were made and how they were marketed. He then worked in sectors including architecture, manufacturing and construction, retail and art research, developing broad industry understanding and an ability to adapt. Karen worked in the advertising industry before switching to retail, conceptualizing ideas and doing graphic design for fashion and lifestyle stores, as well as visual merchandising setups, digital design and content creation for social media, event management and marketing; the fast pace helped develop her technical and management skills. In 2015, we decided to pursue our passion for design together, and started DAZINGFEELSGOOD.

Managing clients and outcomes is a challenge. Most of the projects we enjoy are self-initiated, which we term 'food for our souls', but to sustain the studio, we also have to ensure that client projects meet the clients' expectations as well as our own. We've also worked with manufacturers in the region to produce prototypes, and sometimes the unfamiliarity with foreign countries was challenging, but these experiences add idiosyncrasies we find interesting. We both enjoy learning new things or new ways of doing things — we see it as progressing ourselves as designers.

DAZINGFEELSGOOD is a multidisciplinary practice working across furniture, graphics and spatial disciplines. Our approach is governed by a mental algorithm that we use to constantly redefine and re-evaluate design subjects. It often revolves around the translation of form and function through recurring themes of logic, origin and reduction. We believe that design, as much as art, should be emphatic and integrated into everyday life to improve experiences. Good design is not only about form and functionality, it should create experiences and evoke emotions.

Our preference in materiality and process tends to incline towards the origin of a project context, so very often it's associated with rawness and expresses brutality, though in a literate way — it's something we like to call 'non-design'. We enjoy this systematic way of formulating our process, and by conditioning a certain way of thinking towards design, it sort of forms that algorithm for every project that makes it consistent yet unique in its way.

In 2017, we collaborated with Bolia, which chose to produce our Latch coffee table after it won third place in their design awards. The year-long process, from drawings to modelling to prototyping, was well coordinated despite the distance.

As for dream projects, in a sense, DAZINGFEELSGOOD itself is our dream project, hence the moniker that connotes a sense of dreaminess. Prior to this, we felt like labourers, but we haven't stopped believing and dreaming, and it's great 'dreaming' together as a couple.

Design should express personality. We believe each brand should have a uniqueness that can be identified through its works. And personality traits should give project outcomes a certain sense of consistency. They shouldn't conform to any visual style or categorization, but be in the roots of the studio's philosophy. We focus on crafting our studio's personality, which reflects a combination of us — of our culture and origins of growing up in Singapore. Ideally, design should also fit in with tradition, because tradition denotes a sense of existence and originality in every culture, be it in the context of an individual or a community. Every country should have its own cultural identity, otherwise it becomes banal.

A representative design for Singapore would be the captivating, anonymous concrete benches that are commonly seen around older Housing Development Board estates. They're associated with the prevailing wave of Brutalism in Singapore during the 1970s. We actually regard our late founding father Lee Kuan Yew as the greatest 'designer' in Singapore; we often have this conversation when we're viewing the established cityscape.

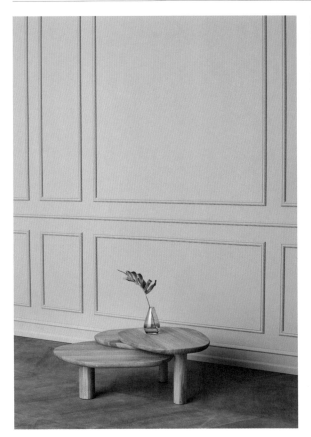

Facing page, top
Latch coffee table for Bolia
Image courtesy of Bolia

Facing page, bottom
System side tables

This page, top
Latch coffee table for Bolia
Image courtesy of Bolia

This page, bottom
Tarp beanbag chair for W. Atelier and Zanotta

Melvin Ong, Desinere

I'd always enjoyed art classes growing up, but never thought of pursuing a creative career until my A levels. I loved drawing charts and graphs during maths classes and illustrating diagrams for my biology lessons, but didn't enjoy the content very much. It was then I realized I needed to pursue what I felt more passionate about. My family was fairly supportive. I'm sure they had doubts, but when I applied to the Nanyang Academy of Fine Arts, I was offered a scholarship and that reassured my parents.

I completed a diploma in interior design with a furniture design major at NAFA before pursuing my degree in product design at Central Saint Martins. I think the fundamentals I picked up are still very much applicable: things like research methods, design processes and material explorations. Having these principles instilled in me allowed me to adapt to working in various fields of design, even in areas that I wasn't specifically trained in. Importantly, what I really learnt was to keep an open mind, adapt and not be afraid to venture into something unfamiliar.

After my master's, I worked at branding agency Brand42 in London for about two years. I had the opportunity to work on projects with international clients like CNN, Guinness and Bacardi. It was interesting because even though I was trained in product design I ended up doing a lot of graphic design, illustration and even web and game interface design. It was Brand42 that allowed me to see the importance of being multidisciplinary and looking beyond the bubble of product design. Since starting my studio, I've also worked with Chris Lefteri Design on several projects, and with both I think there's a certain openness and boldness towards the experimental that I really appreciate. My boss at Brand42 would always tell me, 'I'd rather do something wrong and interesting than something safe and boring.'

I think the biggest challenge for me is overseeing everything from the business side to the creative direction and realization of a project. A studio is a business, and managing a business is not really my forte, so it's still a big challenge for me to switch between these two aspects.

I feel that within the creative community in Singapore there's a collective spirit for growing our industry. It's always a joy to collaborate with peers, and I think this unity and kinship amongst local creatives gives us an edge as we tap into each other's expertise and resources. Also, when I first started out, the DesignSingapore Council helped to fund my exhibitions overseas. I was able to showcase my work at design shows in Tokyo, Milan and London with partial funding from them.

A lot of my work stems from quiet reflections from my day, from pausing and taking a sensory measure of the world. My work tends to have a handmade element because I see every project as an opportunity to learn a new skill or process, and I feel that taking time to make something helps one to have a better understanding of the nuances of a particular material and process — and from there to explore how it can be pushed further to arrive at something fresh or unexpected. I hope when people experience my work, they appreciate its materiality. I want to create things that are carefully considered and that last.

I try not to get too comfortable doing the same things, although over the years I've been associated with paper pleating. I'm trying to do less of that now, but when I first started with paper, I was charmed by the idea of how such a subtle and understated material can be transformed into something ethereal and mesmerizing. My dream project is a bit different — as a pop culture fanboy, I'd love to design a car for a movie.

I don't really aim to express my personality or nationality — I kind of let things take their course, with the concept as the core focus. I also haven't done anything related to traditions so far, but it could be something I look into in the future.

A Singaporean designer I admire would be Jerry Low and his work with JotterGoods. I met him several times when I was just starting out — he's a very humble and down-to-earth guy. His attention to detail and user-centric approach with JotterGoods stood out to me.

I also think that while the Eames plywood splint isn't Singaporean, it can be a reference for us. It was very innovative, and paved the way for Charles and Ray Eames to create their iconic moulded plywood furniture. I think in many ways Singapore has the ingenuity and vision to innovate — there's a lot of potential waiting to be tapped and nurtured with the right platform and support.

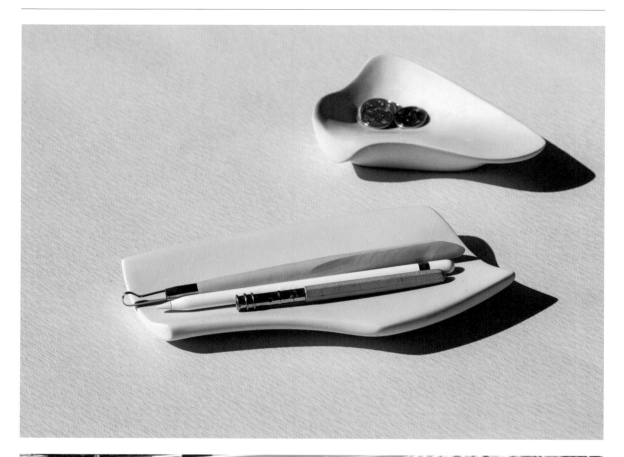

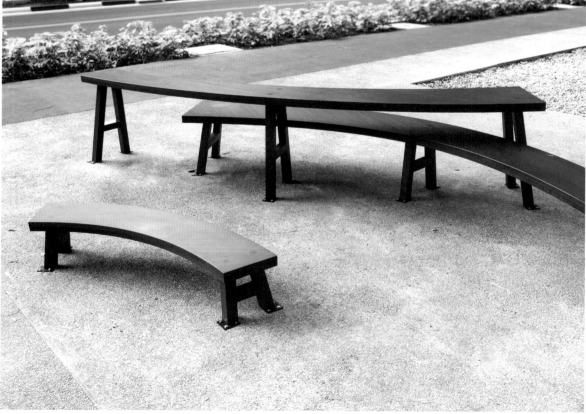

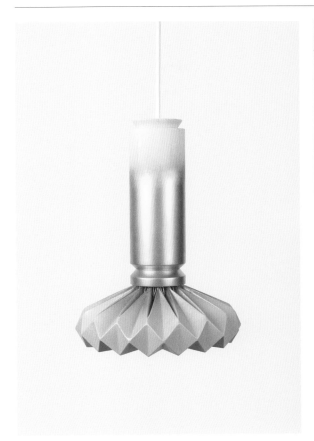

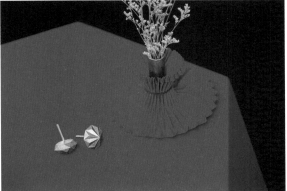

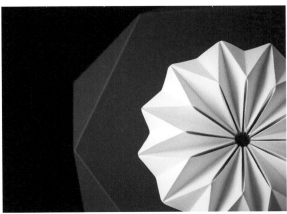

Facing page, top
Canopée des arbres
accessory trays

Facing page, bottom
Familiar Strangers bench

This page, left
One in the Lueur series of
pendants, designed with
Tinge

This page, right
Monolith side table with
Fraise ornamental paper
collar (above) and pleated
paper table accessory
(below)

Gabriel Tan

I realized I wanted to be a designer during my military service in my early 20s. I borrowed books on industrial and furniture design, and read them at night between training. My father was a banker who always dreamed of being a chef, so he was glad I found a profession that I was truly passionate about.

I studied at the National University of Singapore. I did learn some valuable things, but what really helped was taking part in international competitions, which gave me huge exposure at a very early stage. I was sponsored to go to Tokyo Design Week, Future Design Days in Stockholm, the IDSA Conference in Austin and Milan Design Week in my second and third years, which gave me a more global perspective and deeper understanding of industrial and furniture design.

I then interned at Lunar Design in San Francisco and freelanced at Fitch in Singapore. I really wanted to experience the industrial design scene in the Bay Area, and my time at Lunar was a great experience working with some of the brightest minds in their fields. I learnt from the company's flat and decentralized organizational culture — there was a shared sense of responsibility whether you were an intern, designer or design director, and I learnt how they harnessed the talents and personalities of diverse individuals and specialists to generate great work.

The main challenge of being based in Singapore is that it lacks a history of craft, so to be able to work with certain materials or specialized skills I have to venture overseas. The advantage is that we're very well connected through our airport — that means people I want to meet are often stopping over here, and it's also easy for me to go to Europe, the US or other parts of Asia to visit clients, factories and collaborators. I also had early support from the DesignSingapore Council to exhibit at Salone Satellite, which helped a lot, as the friends and contacts made during those first years are still a large part of my life and career today.

I love to work with both craft and technology, and to collaborate with diverse talents. Ariake and Origin, brands I started in Japan and Portugal, are both about local craft and building a collection that can be exported to the world. Turn is a brand focused on new technology in door handles. Sahara acoustic panelling, which I launched with Swedish brand Abstracta, is also about technology. I believe in making things happen and thinking ahead for the companies or manufacturers I want to work with. I hope people will feel that they get a holistic and complete experience when they encounter my work.

I don't have a favourite material or technique, although many people guess that it's wood because I've designed a lot of furniture in solid wood. So far, I've worked with wood, stone, metals, upholstery, cork, leather and ceramics, and I'm launching a new glass product soon. Each material is a new experience, and deep research and knowledge are needed before being able to work with, rather than against, the strengths of the material.

My studio is focused on international collaborations. Due to the size of the local market, I realized early on that I'd either have to produce my own work or set up to work with international brands. Most of the international clients took a few years of meetings and discussions to secure, but it's generally easier when you meet a brand that speaks the same language as you or your project. Our cork acoustic panels were about sustainability, on top of the obvious visual and tactile qualities. So, when I started to speak to people at Abstracta — who are highly interested in sustainability — they were extremely positive.

I don't think too much about expressing my personality or nationality through my designs — I believe it comes naturally. Most designers' work evolves over their lifetimes due to age or wisdom, or changing influences in their lives, or even evolving personalities. If I were too conscious about personality or national identity, I'd produce repetitive work. But it is very important to keep local traditions alive. They're part of the shared knowledge and heritage of a people, and if we lose them, our children or grandchildren will never get to experience an amazing skill, product or craft.

Of Singaporean designers, I believe Patrick Chia and Nathan Yong have done a lot as the first ones to go international. They allowed my generation to see that it didn't matter if we didn't have a history of craft and design, that as long as we persevered, we'd find our own positions in the global design industry. I'd say it's impossible to define Singapore with an object. We're a country of immigrants from two generations ago, so many historical pieces are associated with one culture or another of our forefathers, and it wouldn't be fair to pick out one to represent all. I think that's an opportunity, and gives designers from Singapore a blank slate.

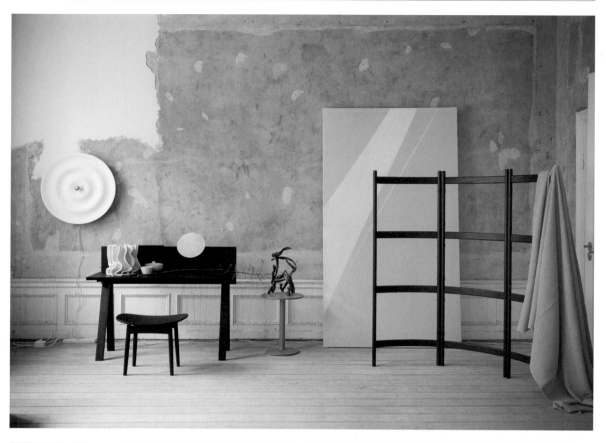

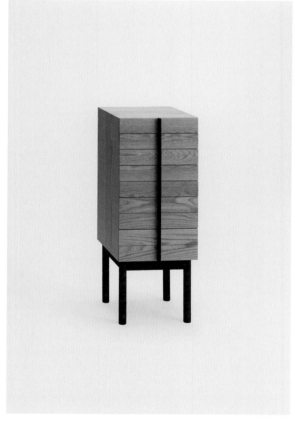

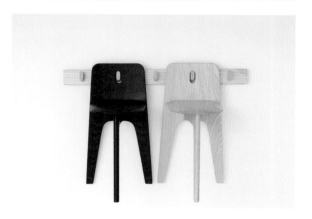

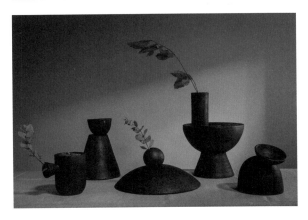

Facing page, top
Shoji screen for Ariake

Facing page, bottom left
Column chest for Ariake

Facing page, bottom right
Column chest for Ariake
(above), Stove chairs for Blå
Station (below)

This page, top
Fruit Altars series for
Wallpaper* Handmade

This page, middle
Edge bedside table for
Design Within Reach

This page, bottom
Charred Vases series for
Origin

Hans Tan

I was initially accepted into business school. Then, while I was doing my national service, in a leap of faith I applied for the industrial design degree at the National University of Singapore without any background or understanding of design. I got accepted, so I changed course, only telling my parents when things were set in stone. It was through the four years of undergraduate study that my passion developed — in the third year, design started coming together in my mind like a puzzle solving itself. After that degree, I did a master's at Design Academy Eindhoven.

At school, I was very much influenced by conceptual design and the Dutch design scene, in particular how artists and designers in the Netherlands used design as a medium. When I came back to Singapore, there wasn't much of a movement in terms of people seeing design as not just an end but something to communicate ideas. Design was a lot less ideological and very focused on being commercial and utilitarian. If I wanted to do experimental work, the only option I had was to set up my own practice. I thought this was a significant move because design was burgeoning in Singapore and I wanted to provide an alternative perspective. My challenge at the start was learning to say no to things — now it's learning to say yes.

When I speak to foreign friends, they're usually surprised and envious of the support our government provides. With support from the DesignSingapore Council, the sector has matured and is developing further into an important economic driver. I was awarded one of the first batch of DesignSingapore scholarships for my master's in the Netherlands, which played an exceptional role in my formative years. On the flip side, there's a clear distinction between design and art in Singapore, and design is regarded as less of a cultural driver.

I see myself as a designer and an educator. My studio work tiptoes on the boundaries between design, craft and art. The practice deploys design as a medium, making use of utility as a pretext for visual discourse while maintaining a keen focus on developing materials and processes. Embedded narratives in the works comment on design and its industry as a phenomenon, especially in the context of heritage, consumption and waste.

I believe that design not only helps us do, it helps us understand. We usually see design as something utilitarian: it enables us to sit, travel and pay for things. But it's also a medium that can help people understand the world in a different way. There are significant issues with the things we use. For instance, a vase doesn't just hold flowers, we can also read off ideas about decoration and of it being a vessel or holder, or its relationship to the space around it. This relationship between decoration and utility is an age-old problem that designers tackle. I use this phenomenon to embed intentional narratives in objects.

I'm particularly intrigued by our relationship with porcelain. I expressed this in Vase Porcelain, which came after a field trip with students to Kyushu. We visited exquisite porcelain producers that had hundreds of years of history, and we visited the TOTO manufacturing plant. These two industries, one of precision industrial manufacturing and the other impeccable craft, are fundamentally responding to the same material. The seeming contrast and subtle similarities were beautiful. I wanted to capture our dramatic shifts in perception of the same material — an immaculately crafted vase we'd pay a lot of money for compared to the toilet bowl we use daily. The work also plays with our cognitive bias of associating porcelain with vases by separating the porcelain and vase.

Most of my works are self-initiated and self-produced. It's not typical for us to work with clients, unless it's a commission that aligns with our explorations. So, I only work on dream projects — or more accurately, I make every project a dream.

I don't believe it's important to express personality, but it is for nationality. I'm interested in creating conversations about being Singaporean — it's one of the core trajectories in my work. I strive to create the opportunity to discuss and think deeply about who we are and the issues we encounter. That said, I don't simply imbue objects with a local identity through visual semblance, and people often misunderstand the role of nostalgia in my approach. Although nostalgia has its place as it drives an appreciation of history, it stops there. It's not about bringing back an image, but about finding the position where past and present coexist purposefully.

My inspirational figure is not a designer, but a historian. In my student days, I attended TK Sabapathy's class and learnt how to read a painting and a sculpture. That was when I was first exposed to the idea that objects have an influence on how we see the world. When you read off an object, you not only read its narrative, you can read where it's from, who used it, which part of history it belongs to and who it was reacting to. I discovered we could do that with design objects as well.

The Merlion I think is representative of Singaporean design. It's an artificial construct designed as an icon of Singapore with little connection to our origins, yet in many ways it's permeated the everyday consciousness and become authentic to us.

Facing page, top
Spotted Nyonya vessel

Facing page, bottom
Singapore Blue vase

This page, top
Bundled vase series

This page, bottom
Striped Ming vessels
numbers 13,14 and 15

Hunn Wai, Lanzavecchia + Wai

At age five I 'decided' to be a car designer because I was obsessed with Matchbox cars, especially the Audi Quattro rally car and the Alfa Romeo Alfetta GT. I feel mine was always going to be a profession to do with creativity. My family supports the belief of going into a profession you have strong interest in and talent for; I was and still am a huge science, culture and art nerd, and design allows me to pursue all these vectors.

I did my bachelor's degree in industrial design at the National University of Singapore followed by a master's in conceptual design at Design Academy Eindhoven. In the bachelor's course, I was instructed in classical industrial design: essentially, to manifest an abstract, meaningful intention into a real-world, contextually relevant product. The master's took me towards the conceptual, honing my understanding and skill of using design as an instrument for critical questioning to reveal new pathways of seeing, meaning, perspectives and possibilities. Both equipped me to see and manipulate the multiplicity, plasticity and definitions of design in my practice.

Right after NUS, I worked with a Singaporean design office developing mobile phones. The seasonal and rapid nature of the category made me question my purpose in design: was I just to be a contributor to consumer cycles? That pushed me towards the conceptual design of the Dutch variety, towards Eindhoven. I worked with Dutch artist-designers during my master's, and was inspired by their autonomy and bravery in manifesting their visions of design and the impact they wanted to make. I learnt that everything can be designed, from my way of thinking to my vision, my way of working, production of concepts and contexts, and how they'd be presented. It was possible to create our own worlds and prosper.

I see challenges as opportunities for growth, and in this respect I'm being actively challenged to learn and grow as a business owner and creative director. I aim to create and nurture a studio culture where everyone working with us has opportunities for growth and can develop their interests and skill sets in meaningful projects. We see that as crucial.

Singapore is a major hub for goods and services, logistics, ideas, fantastically driven and gifted people, and their ideas and cultures. Everything works, the government is transparent, and it wholeheartedly supports the design industry. From daily business operations to flying around the region for project meetings and production line inspections to networking and making connections, I really can't ask for more. Singapore for me means proximity, efficiency and liveability. The challenges are the lack of scale of the domestic market and the lack of a manufacturing hinterland, simply because of our country's size. But Singaporeans are an internationally connected lot — the region and international markets can easily satisfy those points.

Design is one of the main drivers of economic development the government is building up, and they've supported me substantially, for which I'm eternally grateful. I received a DesignSingapore Scholarship to Eindhoven, and they've supported our showings at international platforms like Milan Design Week, as well as overseas business missions and business development programmes.

Our work is driven by questions: where did this brand or company come from, where are they now and where would they like to go? What is the life of this future product going to be? Who are its users? How is it going to be made? Does our manipulation and application of form, line, shape, texture, material and typology construct a narrative that confidently drives the stakeholders' and our intentions? What are the impacts? For whom? I hope our work surprises and delights, and helps people to imagine new worlds and ways of living, thinking and being.

I don't have favourite materials, only what's relevant for the project at hand. However, I do appreciate leather and wood for their inherent material properties, as well as the graceful strength of metal.

Expressing our personality in our work means we're committed to a vision that brings value to the brand, the project and its users. This attracts particular brands, clients and users that identify with that 'personality', and we get to continue the good work. We thrive on being up-front and building relationships, and we like being in the thick of the action — expressing our personalities is core to enabling that. I think expression of nationality is ensured by virtue of owning who we are and using what we've inherited culturally and intellectually in the most organic and implicit manner. As for tradition, it depends on the context and the impact desired. It's a powerful ingredient when used succinctly, because it immediately connects with a certain culture and allows those people to more easily access the intended value.

Patrick Chia is a designer I admire. He was my tutor in my early NUS days, and advised, 'Don't be satisfied with nor limited by success within our borders. Seek out challenges and claim success on an international level.' He was himself one of the first Singaporean designers to gain recognition internationally.

Previous page
Hunn Wai (left) and
Francesca Lanzavecchia
Image by Davide Farabegoli

Facing page, top
Scribble tables for De
Castelli
Image by Massimo Gardone

Facing page, bottom
Pebble desk / vanity table for
Living Divani

This page, top left
Cabinet from the Clockwork
series for EXTO

This page, top right
Circus cloche for Secondome
Edizioni

This page, bottom
U tables for LaCividina

Denny Priyatna

When I was in high school, I decided to study either product design or fine art because I like making three-dimensional works. My family supported my decision.

I completed a bachelor's at the Bandung Institute of Technology and a master's at Central Saint Martins. For me, design is about suitability, so not all the knowledge I learnt can be applied to everything, but it's definitely beneficial. Sometimes I look back at what I learnt and see whether it's suitable for my current project. I also believe that some of it has already shaped my mind and become subconscious.

I worked at several companies before doing my master's and setting up my own studio. All of them were different: one was a large manufacturer and the others were small studios. Some had their own workshops, where I liked to spend time.

In addition to working full-time, I also freelanced to build up my network, and participated in exhibitions and competitions. I spent most of my salary on developing new products. At first, it was difficult to do several things at the same time, but the recognition I received and the reputation I built helped when I launched my brand.

The main challenge is learning the non-design skills, such as marketing and financial management. Having good ideas isn't enough to succeed. And the challenge of being in Indonesia is that product or industrial design is still new. Sometimes we need to inform or educate people about design and its benefits. We're still considered a manufacturing country, and we've traditionally replicated other people's products. It's difficult to rebrand the country's image to also being good at developing original designs — it takes time, but I hope we can do it. The advantage of being here is that we have a lot of resources, such as materials and craftspeople. We also have many cultures and traditions to draw inspiration from. I myself have been involved in some workshops and incubator programmes where I could collaborate with local craftspeople, communities and other designers.

Our studio is inspired by the imperfection and uncertainty found in nature. We try to embrace a life that's full of surprises and curiosity. We explore the dualities of materials and the juxtapositions of things to create products that can offer sensations and experiences. Our long-term vision is to fill this world with unexpected excitement. Our product types range from commercial to conceptual and experimental designs.

There are already many pieces of furniture and design objects that offer comfort, but I hope my products can offer unique sensations and elicit emotions. I like it if people's perceptions change when using my products. For example, some people feel surprised when they sit on the Appalstered or Eum seats, which may look uncomfortable at first.

As for materials and techniques, I don't have any preference because I like exploring various kinds. At the moment, I'm exploring the weakness or 'dark side' of materials. It's like trying to find a diamond in the rough — challenging yet exciting.

A dream would perhaps be to create a product that would be an artefact in the future. Sometimes I wonder what kind of objects will be in museums 100 years from now. I don't expect my designs to be timeless, but I hope they'll be worth study. I think it's important to reflect traditions, but not all the time. It's good to preserve or uplift them, but I believe we can also take inspiration from what we have today and bring something fresh to the scene.

I like my designs to express my personality and nationality. The design market is getting saturated, and I think one of the ways to tackle this is to create products that are unique and different by incorporating local elements or our own personalities. That can also add intangible value and create an emotional connection between the product and the user. Sometimes it's hard to combine both attributes, but I always try to express at least one of them.

As for local inspirations, there are some influential product designers in Indonesia, like Imam Buchori, Singgih Kartono and the late Irvan Noe'man. I seek inspiration from them, but I try not to get too attached. The design world is always changing, so I can't always follow the same patterns. Similarly, an object reflective of Indonesian design would depend on the context. There are products that represent the quality of materials and craftspeople, such as the Magno radios by Singgih Kartono and the Linger bench by Alvin Tjitrowirjo. There are also products that show innovation and technology, such as the Accupunto chairs by Yos and Leonard Theosabrata.

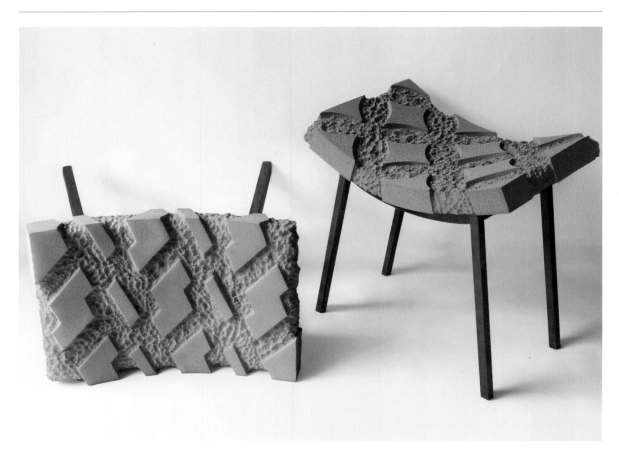

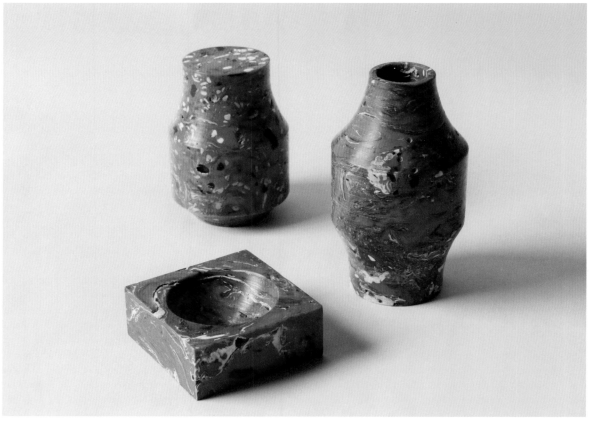

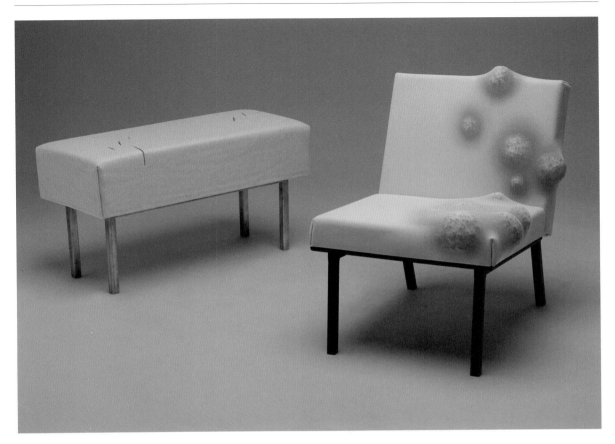

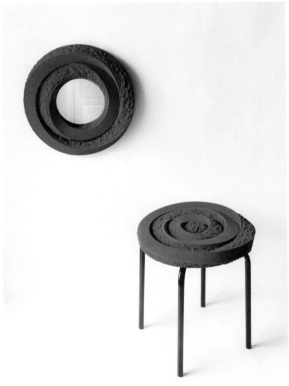

Facing page, top
Eum stools

Facing page, bottom
Pilia collection

This page, top
Appalstered 2: Damage
bench and Appalstered 1:
Disease chair

This page, bottom
Spira series

Sashia Rosari, SORS

I knew I wanted to have a career in design quite early on, and my family has always been very supportive. I studied industrial design at Swinburne University in Melbourne, and during my third year I decided I wanted to seek out a role in the furniture industry.

What I studied gave me a fundamental understanding of design in general and an introduction to software that I still use in my design process today. I also did an industry placement during my third year — a one-year internship for four days a week, with the other day spent in classes. That was the most useful thing I experienced throughout university, as it provided me with real work experience before I even graduated.

I started my career with Jardan Australia, a family-owned furniture design studio and manufacturer, as a junior designer right after I graduated. I gained valuable knowledge and experience by seeing the complete design process from ideation through development, prototyping, production and all the way to launch. Afterwards, I moved back to Indonesia and joined PTT Family, which is behind Potato Head, working on products and interiors. I got to collaborate with amazing talents like architects, designers, artisans and mixologists, and learnt a lot about designing for the hospitality industry.

Since I've been out on my own, finding the right manufacturer has been the trickiest part. I have a few criteria, and finding makers that can meet most of them and maintain consistency can be quite difficult. I think in terms of craft we definitely have the talent here, particularly for furniture. Woodworking is a common trade. It's also a challenge, though, to convince them to collaborate with young designers, as our orders might seem minuscule compared to the export orders that a lot of manufacturers are accustomed to.

SORS is a Jakarta-based furniture design company. We release a concise range of furniture yearly for the residential and commercial markets. We also collaborate with designers and architects for projects that require custom furniture. I hope people will consider my furniture pieces as intimate additions to their personal spaces — something to be enjoyed for the long term. Our pieces are designed to be ergonomic and timeless, and that's what we're hoping people feel about them.

I enjoy working with all sort of natural materials and handcraft techniques, as it creates a sense unique to each piece. For example, by using hand-woven *tenun* fabric for some of our upholstery pieces we highlight the little imperfections created by the handmade process, while at the same time showcasing the material's natural sophistication.

I hope to one day have the opportunity to collaborate with architects and designers to create furniture for an iconic public building in Indonesia. Finn Juhl designed the furniture for one of the chambers at the UN Headquarters over 60 years ago. The project was as a donation from the Danish nation to the UN, and as a result Denmark received further international recognition as a design nation. That's very inspiring to me. I want to provide good-quality design for spaces with a similarly significant purpose for our nation's progress and at the same time help build a strong, recognizable association between Indonesia and good design.

I'm not sure whether it's essential for me to express my personality through my work, but I feel that if I apply my core design values and principles then the end result will somehow do that. I often create a certain persona for each piece of furniture I'm working on. I imagine what they'd be like if they were people, and develop the details based on that. Sometimes the pieces don't necessarily reflect my typical aesthetic preferences, but as long as the design expresses my core values as a designer then I'm happy. In terms of nationality, as I spent most of my young adult life in Australia, I'm still absorbing and learning what it is that makes a particular design 'Indonesian', and I'm excited to explore this further. As for influences, there are too many to choose from — there's always something inspiring about each encounter with a fellow designer.

I don't think our design has to necessarily fit a local tradition, but it would be great if we could help keep certain local traditional skills and techniques alive through our designs. I think it's quite important for designers to include this consideration in their design processes. We're equipped with the skills to help promote local traditional trades and techniques that might otherwise go extinct.

Although it's not a type of furniture or a design object, I think a *warung* is a great representation of our culture's ability to make do with what's available and create something useful for the surrounding community. A *warung* is a small booth or stall that sells a limited selection of everyday needs from snacks to medicine and cigarettes, and all sorts of other goods depending on the scale. It's often a small, makeshift structure, sometimes completely collapsible or knock-down to make it easier to pack up and move if the local government tells the owner to do so.

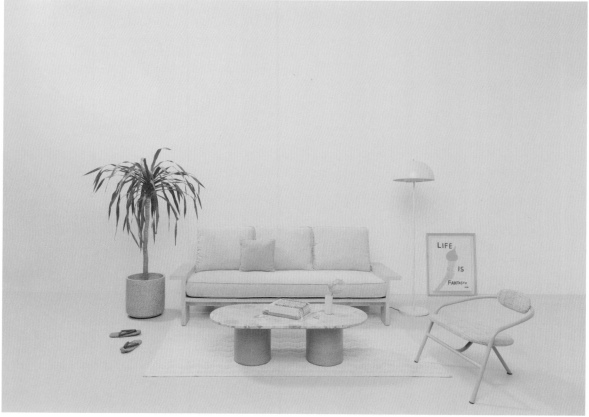

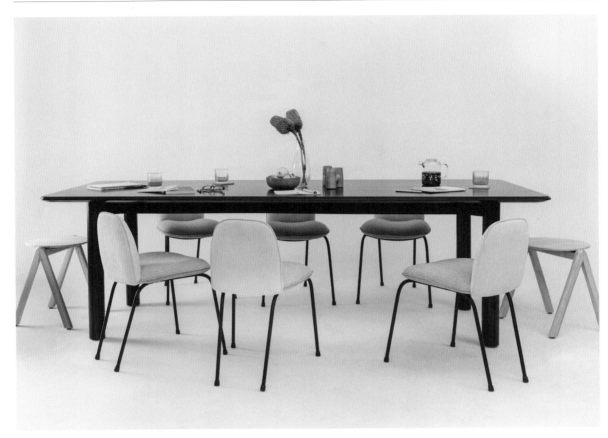

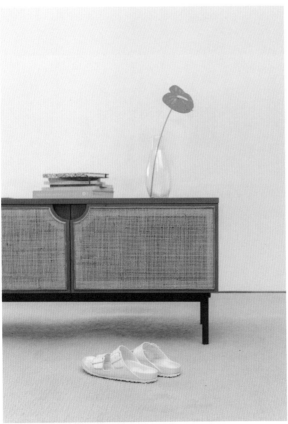

Previous page
Image by Chris Bunjamin

Facing page, top left
SF sofa

Facing page, top right
Percy dining chair

Facing page, bottom
SF sofa, Klee coffee table and
Herbert armchair

This page, top
Wolt dining table, Miri
dining chairs and Kilroy
stools

This page, bottom
Orlo sideboard

Alvin Tjitrowirjo, alvinT

I dreamed of becoming a car designer from when I was very young — I nearly failed school several times because I liked drawing more than listening to my teachers. I went to RMIT University in Melbourne to study industrial design, and chose furniture design as my specialty. I was chosen by my professor to exhibit my work at Salone Satellite — from then I knew I wanted to become a furniture designer, and I did a master's degree in product design at the Istituto Europeo di Design in Madrid. My parents were very supportive, and I'm thankful for their belief that their children didn't have to follow in their parents' footsteps and that doing something we love is very important.

I think my bachelor's degree gave me the necessary hard skills, and my master's degree sharpened my thinking process on specific areas I wanted to explore. However, my real-life working experiences and my environment contributed a lot — the latter made me think about how to create a nurturing environment given that Jakarta is not the most creatively nurturing space to live. Combined with my travels, these have given me a lot of knowledge about how to carve out my career as a designer-entrepreneur so as to not just survive but to do good for society.

After I graduated, I worked at a furniture factory for five months. Although it was brief, that experience gave me an insight into the furniture industry in Indonesia. It actually gave me the motivation I needed to start my own career — the fact that Indonesia has been known as and focused on being a manufacturing resource only, and didn't really want to invest in design.

I think there's a lack of appreciation for local talent and locally made products in Indonesia — there's a preference for imported branded products. Given that it's also a very capitalistic country, people see value based on a price tag instead of understanding what value actually means. That means larger companies have the upper hand in penetrating the market with their bigger budgets. This hasn't been improved by the government or the private sector, and therefore the market hasn't been educated properly. Compared to countries that promote creative industries and local talent, we're still lacking the necessary strategic support to compete in the international market. There's a lack

of appreciation for originality and there's no regulation of sales of cheap, low-quality designer knock-offs.

But I do think there are some advantages to being here as well. Material and human resources are still easily accessible. There are a lot of less-explored crafts, materials and cultural products that can provide inspiration, and plenty of problems that can inspire solutions.

I've received several forms of support, including exhibitions in other countries, but I don't think they were executed strategically and they didn't yield the expected results. Our government lacks the necessary knowledge and interest in understanding how this industry works and the challenges the designers are facing. I'm looking forward to seeing changes soon.

Our studio works on a wide range of commercial projects such as food and beverage, hospitality, workspace, residential, products and design strategies. I hope people who encounter our work will experience the local content infused into every project executed, in terms of both material and craft. I also hope they experience it as bespoke given the customizations we do, as well as being immersed in something new and different from what they're used to. My main local inspirations have been Yori Antar and Jay Subyakto.

If I could pick a dream project, I'd like to design an airport because I feel that it would be a good platform where design can be fully utilized to emulate the truest balance between hospitality and function.

Overall, what I'm trying to do is to create a new perception of what contemporary Indonesian design is, by respecting its cultural roots but with a progressive spirit. The problem we're having here is that we're slowly becoming a monocultural society due to religious influence, so my goal wouldn't necessarily be to create work that fits in the current local tradition but hopefully to create a new and better platform for future cultures. As an example, I'd say that my Linger bench represents the culture of Indonesia: it celebrates craft at its highest level, it dignifies humble natural materials like rattan, which are under-appreciated, and it celebrates being different.

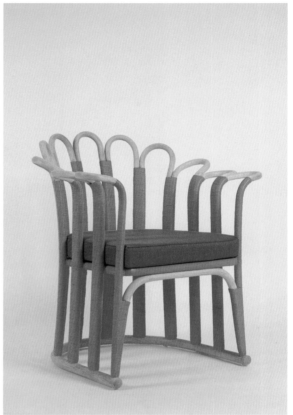

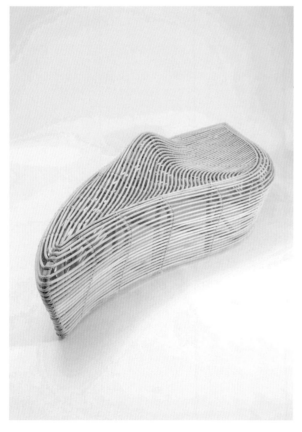

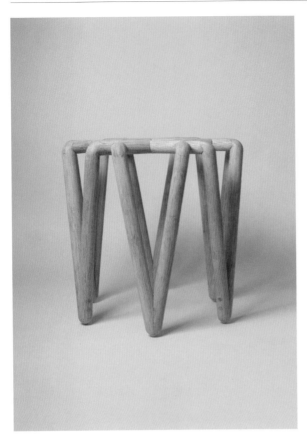

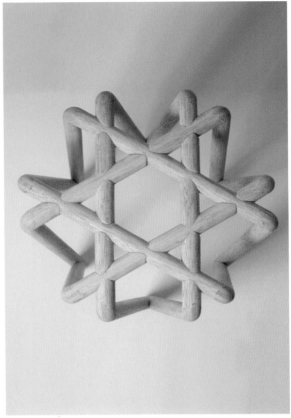

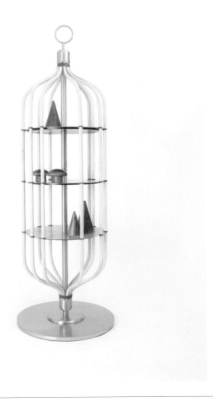

Facing page, top
Malya chair

Facing page, bottom
Linger bench

This page, top
Loop stool

This page, bottom
Angan floor shelf

Felix Sidharta, Cassia Studio

I was drawn to design because I'm very drawn to the creative world. I've always been curious about how things are made, and I love drawing, so I chose industrial design as my major. I studied at RMIT University in Melbourne. My family was very supportive of the choice I made.

At university, I found furniture design particularly fascinating, which pushed me to focus more on that. I then worked as a product and furniture designer at a local design firm in Jakarta. During that time, I started to have aspirations of growing the local design scene; that brought me back to my hometown, Surabaya, where I started Cassia Studio.

School definitely had a huge impact on the way I think as a designer. We were taught problem solving, attention to detail and to keep being curious about everything.

Even so, there are things that I've learnt — and am still learning — only by working in the field. Before starting Cassia Studio, I worked at alvinT as a product designer. Alvin Tjitrowirjo, the founder and creative director, has been a major influence on me, and working for someone else was another platform for me to learn about the design industry and the creative market in Indonesia. Also, at school I was very driven by my own way of thinking and idealism, but in the field, I've needed to find a balance between what a client wants and my own ego.

In my opinion, design is a trust-based industry. A good design is a result of trust and collaboration between the client and the designer. Since Cassia Studio is only three years old, one of our biggest challenges is gaining trust from potential clients. But market education is our biggest challenge. In Surabaya, the design and creative industries are often overlooked and considered as something low-cost and easy. There are only a few Surabaya-based product and furniture designers, as most studios are based in Jakarta. As a young designer, I try to educate my community and my clients through my designs. It's important to let them know that good design can bring value to their businesses.

In contrast, being a large and growing country is definitely an advantage in our industry. Working in a time where the creative industries are becoming more acknowledged, I've found it beneficial in creating higher demand and more opportunities to create and collaborate. A dream project would be a collaboration with a foreign brand or with an international designer or architect.

The Indonesian government helps, and established an organization called BEKRAF ('creative economy agency'). In 2017, BEKRAF joined Salone del Mobile in Milan, and I was fortunate to be chosen as one of the designers to exhibit works at its pavilion.

Cassia Studio focuses on product and interior design. Our interior design department works on residential and commercial projects like cafes, restaurants and offices. Our product department has designed pieces such as interior accessories, art installations and customized furniture.

For me, a well-designed object should create conversation and connection. I really hope that through my work, people in my community can further appreciate the creative industries. We're not restricted to one specific material; we believe in the unique potential of any kind of material. We've worked with materials such as wood, rattan and metal for different concepts and functions.

I see it as essential for my design to express my personality. For me, an item is a result of how a designer responds to something, so naturally it should express the designer's personality. Nationality, on the other hand, is something we were born with or choose, so when a product reflects our personality, it will certainly reflect our nationality.

I live in a country with an abundance of culture and traditions, and many of these traditions have shaped my character as a designer. For me, tradition should not only be placed in a glass box and admired — it should be something we use every day while at the same time being respected and relevant through the generations.

One of these traditions is the creation of batik *tulis* ('written batik'), which is widely known as a cultural object. To produce the patterns, craftspeople use a tool called a *canting*, which looks like a pen with a wooden holder. The *canting* has a small pipe made of copper or brass, which is filled with melted wax, and the patterns are then drawn with wax on the fabric. The tool is unique, because it's a traditional implement that was developed around the 12th century and is still used today with the same design. This shows that its design is well aligned with its function — a great example of the term 'form follows function', and a significant heritage object from Indonesia.

Facing page, top left
Split tray

Facing page, top right
Split trays and containers

Facing page, bottom
Diadem vase

This page, top left
Dining chairs for Botanika
restaurant

This page, top right
Daun chair

This page, bottom
The Fallen Leaves lighting
installation for Botanika
restaurant

Eva Natasa

I've always been a creative person, so when I was in my last year of high school I told my parents I wanted to go to design school. Unfortunately, they were against it and sent me to study economics. I did that for a year before I quit and enrolled myself in a design school. It took my parents quite a few years to understand that design is really my passion, and they've accepted it now.

I did a bachelor's degree in interior design at the Kent Institute of Art and Design in the UK and a master's in industrial design at Istituto Europeo di Design in Milan. School shaped my way of thinking, and gave me the foundation I use every time I approach a design brief.

I worked with Design Group Italia in Milan after I graduated. It was a wonderful group of people, and I learnt the design process from the start to the end, how to manage time properly and how to be professional. But I think the most important thing I learnt was how to collaborate and work in a team.

In Indonesia, there's no structure or support for start-ups in the design field — we have to do everything by ourselves. In our case, we work with wood, and the timber industry can be unpredictable. I do love wood though, because it's a living being. It's like being with a good friend. And what I like about working in Indonesia is that there's lots of room for experimentation, and easy access to the abundance of natural materials. There are designers here I look up to, like architect Budi Lim.

Every day is totally different. Sometimes we work to develop products for our brand, sometimes it's design projects for clients, sometimes we just do things for fun and follow our intuition. I'm living my dream.

I hope people who interact with our work experience good design, passion and the pride of local design, materials and craft.

I never consciously try to inject my personality or nationality into my designs, but since I always put 100 per cent of myself into everything I do, I think both translate. I would like to help keep traditions alive, but push them forward instead of fitting in with them. One example of an object that I think represents Indonesia is our traditional baskets — they represent the country, its culture and its way of life. They've always been a part of everyday life.

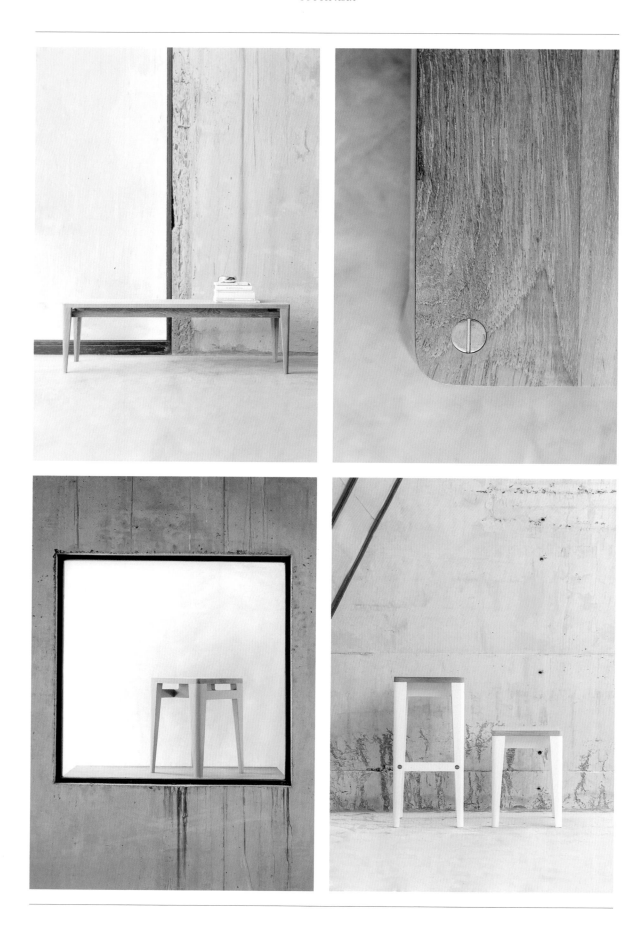

Facing page, top left
Lula bench

Facing page, top right
Lula stool

Facing page, bottom left
Lula Cloud stool

Facing page, bottom right
Lula Cotton stools

This page, top
Lula Cotton, Cloud and
Stone stools

This page, bottom
Lula square table and stools
All images by Evelyn Pritt

Budiman Ong, Ong Cen Kuang

Growing up in a small town in Indonesia far removed from the design world made it a very sweet revelation that design is actually something you can do. I came across an art and design foundation course while studying English in the UK, and that was the start of my design journey.

Deciding to make lamps was a visceral experience for me — I was drawn to it subconsciously. I think it was derived from my upbringing, my heritage, my surroundings and my education. Maybe happy childhood memories playing with animal lanterns have something to do with it, which is a lovely thought. My family fully supported my decision. My dad told me to do what makes me happy.

I was fortunate to study at Gray's School of Art, at Robert Gordon University in Scotland. The curriculum was very much focused on conceptual ideas and hands-on experience. For as long as I can remember, I've been fascinated with making things by hand — it's fundamental to me. And the art and design faculty has amazing workshops and instructors for ceramics, glass, metalwork and textiles. The period I spent there was like a game — I had a lot of fun playing, investigating and experimenting, and I believe this is still very much what I do now.

Before I started my own brand, I spent six years at jewellery brand John Hardy, which is located in Bali. I worked under their then-creative director Guy Bedarida, who prior to working with John Hardy had been the head designer for Van Cleef & Arpels US. I learnt about what a quality product is, and I was able to experiment with many different materials in crafting accessories and homewares. I designed mostly one-off products with luxurious materials like jade, exotic skins, rock crystal, red coral, silver and gemstones. I travelled all over Asia sourcing materials, working with makers and feeding my fascination for working with different materials.

Running a studio is definitely fun. The biggest challenge I'd say would be the human resources. We realized many years ago that the artisans we work with are of the utmost importance. They're the ones to whom we need to pass along our values and our design integrity. If they're able to understand what we're trying to achieve and they're happy working on that, then we're in good shape.

I love Indonesia. I'm very blessed to be based in Indonesia, especially in Bali. Here, craft is valued and still very much part of life, and raw materials are abundant. There's also a great variety of handmade crafts in different parts of Indonesia that I can hone in on and develop into our products.

We create original, handcrafted pieces that allow the materials' intrinsic characters to speak for themselves. I like to think of our creations as timeless and innovative, some fusing traditional craft with modern elements, resulting in pieces infused with stories and soul. I believe they're very tactile and inviting for people to touch. They're pieces with emotion. It would be ideal if people were able to see them not just with their eyes.

My goal is to push boundaries in material selection and in the way I create with them, and to change perceptions of each material's value. I'm inspired by materials, my surroundings, nature and my Asian heritage, whereas my Western education and my design knowledge help to shape the aesthetics. For example, our Alur zipper lamps still amaze me, and they represent an ongoing journey for me. Their delicate light dispersal is unmatched because of the unlikely design and construction — they signify a new chapter.

My dream project would be to build a material museum with all the unique materials that the world has to offer. It would be great to experience finding them all and then sharing them.

I think it's important to be inspired by local traditions, but I don't think my work should always fit in with a local tradition. However, to be able to keep a local tradition alive by somehow injecting local wisdom into my work would be incredible. There are a few traditional pieces I think represent Indonesia and me — the kebaya dress for the country, and bowls and chopsticks for my own culture. And if I were to choose an Indonesian designer as an inspiration, it would be House of Irsan. Their works are amazing, intricate, out of the box and always visually very strong.

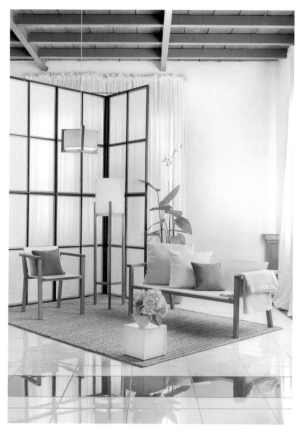

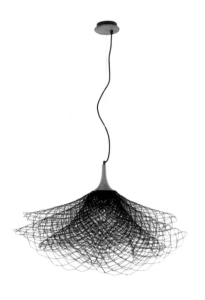

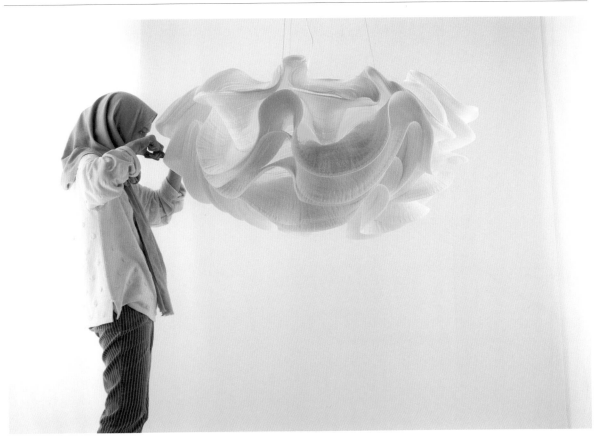

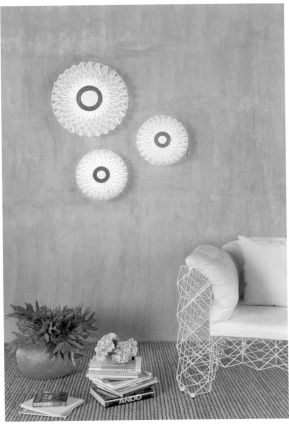

Facing page, top left
Bento floor lamp and
pendant

Facing page, top right
Kain pendant

Facing page, bottom left
Matahari wall sconce

Facing page, bottom right
Rantang table lamp

This page, top
Kelopak pendant

This page, bottom
Matahari series

Index of Designers

d/a

Editor-in-Chief
Suzy Annetta

Managing Editor
Philip Annetta

Deputy Editor
Simone Schultz

Art Director
Jeremy Smart

design anthology

Founded in 2014, *Design Anthology* is a global interiors, architecture, design and urban living platform, with print and digital properties across Asia, Australia and Europe
design-anthology.com

First published in the United Kingdom in 2020
by Thames & Hudson Ltd, 181A High Holborn,
London WC1V 7QX

First published in the United States of America
in 2020 by Thames & Hudson Inc., 500 Fifth Avenue,
New York, New York 10110

Design in Asia: The New Wave © 2020 *Design Anthology*,
a division of Fifth Black Media
Foreword © 2020 Aric Chen
Introduction by Suzy Annetta

British Library Cataloguing-in-Publication Data
A catalogue record for this book is available
from the British Library

Library of Congress Control Number 2020933171

ISBN 978-0-500-02361-7

Printed and bound in China by Artron Art Printing (HK) Ltd.

Be the first to know about our new releases,
exclusive content and author events by visiting
thamesandhudson.com
thamesandhudsonusa.com
thamesandhudson.com.au

14C, E.Wah Factory Building
56-60 Wong Chuk Hang Road
Aberdeen, Hong Kong

47 Coppin Street, Richmond
Victoria, 3121, Australia

The *Design Anthology* team would
like to thank the following people
for their assistance in curating this
list of talented designers:
Aric Chen, *M+* and *Design Miami/*
PC Ee, *industry+*
Zsofia Ilosvai, *Design Pier*
Kim Tay, *The Artling*